DRAWING
FASHION

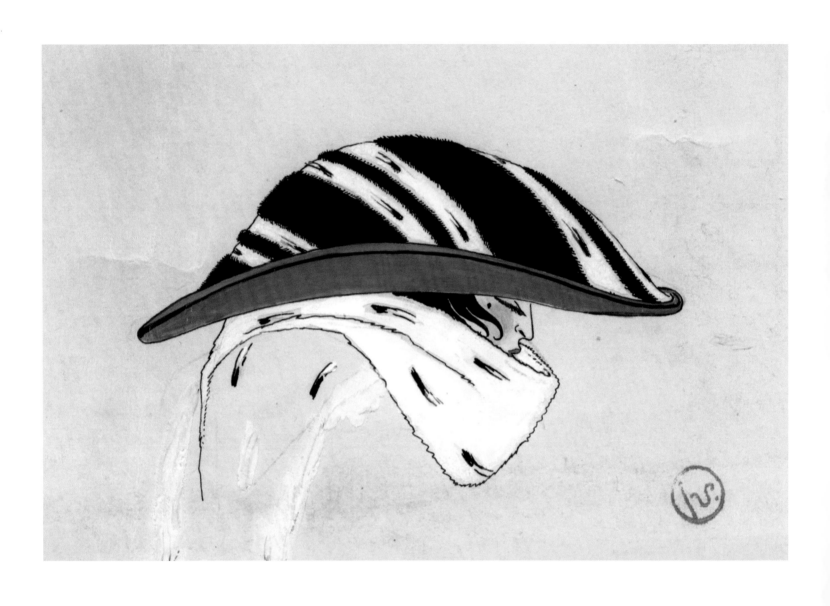

DRAWING FASHION

A CENTURY OF FASHION ILLUSTRATION

edited by
JOËLLE CHARIAU

with essays by
COLIN McDOWELL
and
HOLLY BRUBACH

PRESTEL
Munich · Berlin · London · New York

We would like to thank ESCADA for their support of
this publication.

ESCADA

This book has been published to coincide with the
exhibition 'Drawing Fashion', held at the Design Museum
in London from 3 November 2010 to 6 March 2011

Photo Credits
Pasquale Battisti: p. 18
Patrick Demarchelier: p. 17
Phillippe Dianoumoff: p. 15
Hearst Communications, Inc./ trunkarchive.com: p. 17
Juan Ramos: p. 15
Seeberger: p. 21

Front cover: Mats Gustafson: *Black Coat*, 2010,
see pp. 167 & 231

Frontispiece: Georges Lepape: *Chapeau de Poiret*, 1912,
see pp. 29 & 224

p. 7: François Berthoud *Untitled*, 2004, C-Print,
45 x 35 cm, Fashion by Comme de Garçon, Published
in *10 Magazine UK*

Editorial Direction: Katharina Haderer with
Stefanie Eckmann
Design and layout: Luise Stauss, Naomi Mizusaki,
New York
Proof-reading: Jane Michael, Munich
Production: Christine Groß, Friederike Schirge
Printing and Binding: APPL aprinta druck GmbH & Co. KG,
Wemding

Prestel Verlag, Munich
A member of Verlagsgruppe Random House GmbH

Prestel Verlag
Königinstrasse 9
80539 Munich
Tel. +49 (0)89 24 29 08-300
Fax +49 (0)89 24 29 08-335
www.prestel.de

Prestel Publishing Ltd.
4 Bloomsbury Place
London WC1A 2QA
Tel. +44 (0)20 7323-5004
Fax +44 (0)20 7636-8004

Prestel Publishing
900 Broadway, Suite 603
New York, NY 10003
Tel. +1 (212) 995-2720
Fax +1 (212) 995-2733
www.prestel.com

Library of Congress Control Number: 2010937043

British Library Cataloguing-in-Publication Data:
a catalogue record for this book is available from
the British Library; Deutsche Nationalbibliothek
holds a record of this publication in the Deutsche
Nationalbibliografie; detailed bibliographical data
can be found under: http://dnb.d-nb.de

Printed in Germany

ISBN 978-3-7913-5102-5

FSC
Mix
Produktgruppe aus vorbildlich
bewirtschafteten Wäldern und
anderen kontrollierten Herkünften
Product group from well-managed
forests and other controlled sources
Zert.-Nr. SGS-COC-004238
www.fsc.org
© 1996 Forest Stewardship Council

Verlagsgruppe Random House FSC-DEU-0100
The FSC-certified paper LuxoArtSamt was supplied
by Papyrus, Germany.

CONTENTS

ACKNOWLEDGMENTS

Joëlle Chariau would like to thank:

The talented and visionary fashion artists of the present and past who can be found in this book and the accompanying exhibition – particularly those who contributed to the project first hand: Mats Gustafson, François Berthoud, Aurore de La Morinerie, Paul Caranicas, heir to the Estate of Antonio, and Aldo Zavagli, heir to the Estate of René Gruau.

Katharina Haderer and Stefanie Eckmann at Prestel for their tireless efforts.

Luise Stauss and Naomi Mizusaki for their inspiring art direction.

The fantastic exhibitions team led by Nina Due at the London Design Museum.

Holly Brubach, Colin McDowell and Renate Stauss for their commitment and enthusiasm.

Janina Joffe for providing invaluable assistance and support throughout the development and realisation of this project.

Andreas Bartsch, Dr. Christian Elleke and Stephan von Petersdorff-Campen, for their generous loans.

Her friend and colleague, Jean-Philippe Arnoult as well as her friends Inès Jourde, Nina and Nicolas Peter and Valérie and Tom Meggle for their support throughout.

And, of course, the sponsors of the whole project, BMW and ESCADA.

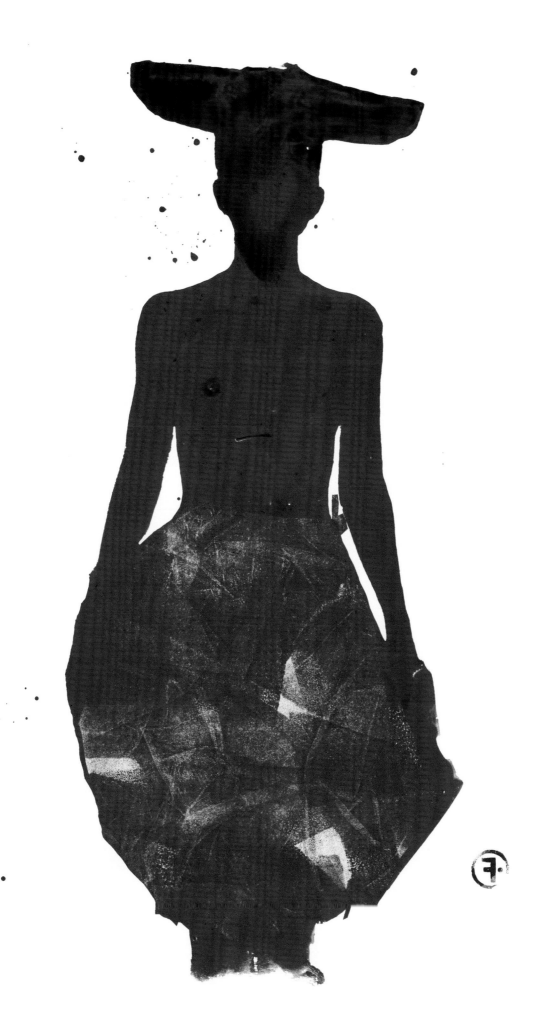

ESSAYS

DRAWING FASHION

by
COLIN McDOWELL

Drawing fashion is a neglected, almost forgotten, art. But, as the work in this book shows, it is as vibrant as any other modern art form and deserves its place as such.

Why should illustrating fashion be seen as inferior to other forms of drawing? We look at the carefully delineated representations of clothing – especially women's clothing – in the sketchbooks of Rembrandt, Bronzino and Holbein and admit that, although they were often studies for major painted works, they can stand as works of art in their own right. The subject – the clothed body – is no less valuable than the drawings of, say, horses by Stubbs or Delacroix. Nor are the works less valued because they are labelled studies. They are in fact complete works in themselves.

Fashion drawing as a genre was slow to develop. Dependent on social advancement for its growth, even in the Renaissance, a period of growing richness and grandeur in women's as well as men's dress, most clothes were created rather than designed. A member of a royal family or a grand lady did not go to a couturier for her wardrobe, making her choice from a selection of sketches. Instead, her lady companions, working with tailors and mercers, sourced clothes from which she would make a choice; an ambassador or traveller would tell her of the fashion developments in other courts and societies and then she would discuss her ideas with her tailor, who was almost always male. It was an intimate process requiring no go-betweens and little contact with anyone outside her immediate household. And, if there were drawings (which I think unlikely) they would usually have been rough sketches or a tailor's technical plans.

This was not an age of shopping, but one of acquiring. For the rich and well-born, shopping did not exist and neither did shops. It was only at the end of the seventeenth century that wealth began to affect the social pattern sufficiently for the middling folk, not aristocrats but middle-class professionals, to be able to dress for pleasure rather than purely for protection or to signify their position in the hierarchy of rank. Projection of one's status, class and wealth became a legitimate purpose of dress for men and women, and the mode was copied from the tastemakers who hovered in and around the courts.

But many aspiring fashion followers had no direct contact with such people, so how could they know what to wear? They looked for sources of information that were cheap and reliably up to date. And they found them in drawings done at court to illustrate the latest styles being worn by the grand and famous. Sold comparatively cheaply, and as times moved forward even hand-coloured, these drawings told a woman what she needed to know in order to keep up with the *ton* at her own level.

Thus the fashion drawing was born. But it was still rudimentary, even primitive. Early fashion drawings were working drawings for tailors and dressmakers. They made no attempt to set a mood or show clothes in context. They did not set out to seduce the viewer into a world of wealth, power and – to use a word entirely unknown until much later – glamour. They were carefully observed impressions of how a collar was draped, a waist cinched and a skirt hung. And if there were few examples of colours or printed fabrics, that was because they were so costly that only the very wealthy needed to know about them.

Throughout the eighteenth and nineteenth centuries drawing fashion developed into a semi-autonomous art form as it moved away from its original purpose as a technical aid to become a delineation of all things that go to make a fashionable figure. The popular breed of dog, the parasol in the latest style, the coiffure, millinery and gloves were carefully chosen to create the mood of current fashion. Accessories to the fashionable woman's toilette – a coach, folly or country seat, a close representation of the most fashionable streets and squares – all helped to build a picture of desire and even envy for eager provincial eyes, as anyone who has read the novels of Jane Austen will know.

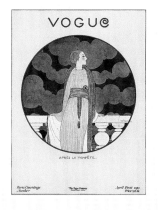

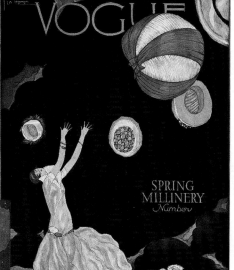

La Gazette du Bon Ton was published with interruptions between 1912 and 1925. It was the first luxury magazine ever to appear and its influence was huge. It was purchased in 1920 by Condé Nast (according to the story, as they were staying in Paris, his wife asked him to buy her a magazine. He came back having acquired the *Gazette*). In 1925 the entire staff of artists and their brilliant art director Jean de Brunhoff, merged with *French Vogue*.

(clockwise from top left)
Georges Lepape, *Vogue* cover, April 1, 1919;
Georges Lepape, *Vogue* cover, March 1, 1925;
Georges Lepape, *Vogue* cover, September 15, 1920;
La Gazette du Bon Ton cover, 1920;
Georges Lepape, cover for the programme of Jacques Offenbach's operetta *Ba-ta-clan*, 1913

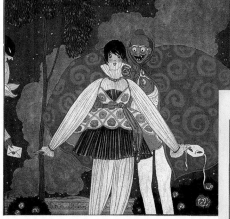

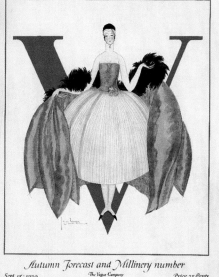

The 1930s marked the end of the era that Lepape had initiated 18 years previously: the departure from the rigorous geometry of Art Deco and from the Oriental themes introduced by Les Ballets Russes, for the softer, more delicate lines that would lead to romantic expressionism and open fashion drawing to surrealistic influences.

(clockwise from top left) Pierre Mourgue, *L'Officiel* cover, December 1946; Georges Lepape, *Vogue* cover, July 1, 1938; Bernard Blossac, in *L'Officiel*, December 1946; Eric, *Vogue* cover, November 15, 1934

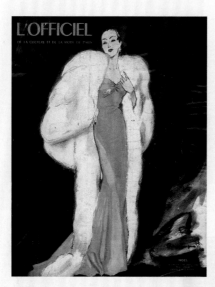

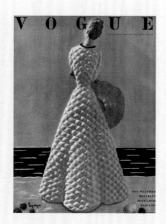

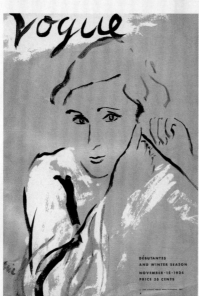

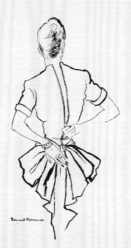

But, most importantly, the ultimate accessory also began to appear: the beau, the man about town, the *flâneur*, the *boulevardier* all came into the picture to create the illusion on the page of the fashionable social life lived to the highest level of sophistication and style. In fact, illustrations of the latest modes for men became equally as important as those for women in the late eighteenth and early nineteenth centuries. A lady and her escort, a gentleman with his paramour became a standard form of fashion vignette printed and bound with increasing sophistication in the burgeoning fashion magazines read by women of even the middle class, in the same spirit as modern magazines are read by women who are far past the days when their content would have any practical application to their lives.

In a sense, by the end of the nineteenth century every commercial artist was a fashion artist. Whether satirists or cartoonists, who followed the earlier lead of Gavarni or Constantin Guys or illustrators of novels and magazine serialisations such as Charles Dana Gibson, creator of the "Gibson girl", or specialists in producing carefully observed commercial illustrations for advertising such as J.C. Leyendecker – the precursor of Norman Rockwell at the *Saturday Evening Post* and the man who invented the male equivalent of the Gibson girl, the man in the Arrow collar. All were consummate draughtsmen; many were able to represent the texture, sheen and even weight of a fabric with an authority and conviction only slightly less powerful than that found in the work of Goya, Winterhalter or Ingres.

But, in all of them, fashion drawing was secondary, no matter how consummately done. Modern fashion drawing as a legitimate art form in its own right was the product pre-eminently of Paris which, before World War I, shared with Berlin the honour of being the home of European costume – and, it must be admitted, led the field with total conviction. Glamour, sophistication, the new woman: all were introduced to the early twentieth century by these artists, and often with

another new aspect of modern fashion: humour. Conde Nast and Randolph Hearst published, respectively, *Vogue* and *Harper's Bazaar* as society magazines chronicling the privileged not only so that they could enjoy a narcissistic re-run of their social world but, more importantly, to act as primers of behaviour for those who aspired to their eminence. And it was the latter who made the magazines bestsellers, of course.

The first decades of the twentieth century saw the first flowering of fashion illustration as an entity in its modern sense. The business of drawing fashion became a vocation as the dissemination of the latest modes became an increasingly lucrative business. Magazines and folios, often containing work of the highest calibre, were produced not only in Paris – by now the unquestioned centre of high fashion – but also in Berlin, London and New York. But the best work came from French-based artists, a situation that continued until the fifties, when the geography of fashion began to swing towards New York and the plutocratic élite who in the eighties would eventually become the legendary 'ladies who lunch', whose voracious appetites for haute couture were personified by women like Mona Bismarck who, in 1964, ordered 140 garments from Cristobal Balenciaga.

The first sixty years of the twentieth century, the highpoint and also the slow but hidden decline of fashion illustration, are what the Joëlle Chariau collection, illustrated in this book, consists of. And, as you will soon discover as you turn the pages, with a true collector's eye she has amassed some of the best drawings by some of the greatest fashion illustrators of the last century, some of whom happily carry on in the field: Benito, Lepape, Marty, Erté from the early decades; Bérard, Eric and Gruau from the mid-century; and Antonio, Mats Gustafson and François Berthoud from the period pre-millennium until now.

In all cases, the work of these men was published in the best magazines and to the highest possible quality. *Art Goût Beauté*; the cahiers of Paul Poiret (*Les Robes de Paul Poiret recontées par Paul Iribe* and *Les Choses de Paul Poiret*, illustrated by Georges Lepape); *Vogue*; *Harper's Bazaar*; *La Gazette du Bon Ton*; *Le Journal des Dames et des Modes*; *Modes et Manières d'Aujourd'hui* – all used the very best fashion illustrators and presented their work not only handsomely but with an air of authority. And, of course, fashion illustration did have an authority that frequently denied the fuzzy early efforts of the fashion photographer, a species whose threat to illustration grew in tandem with technical advances in film and camera technology until the perfection of colour in the late thirties let the sun in on their black and white world. That, together with experiments in techniques such as Man Ray's solarisation, moving figures in the work of Munkásci and the subtlety of Blumenfeld's experiments with colour, gave a sense of immediacy, the authority of cinéma vérité and the drama of news reportage which no illustrator could counter with traditional figure drawing.

But they fought back, of course, and did so very well. Christian Bérard chose to work in a semi-abstract way, concentrating the viewer's attention on what he considered the essence of a garment, and nobody had a greater understanding of the central truths of correctly conceived fashion, although his technique of giving only the most rudimentary features of a model's face earned him the nickname of 'Faceless Freddy' from Randolph Hearst, who finally sacked him from *Harper's Bazaar*.

During the thirties, other techniques developed, and none more powerfully than the masterly assurance of a drawing by René Gruau, one of the twentieth century's longest-lived and most creative figures in any area of fashion. His fluid, dark outline became a unique 'trademark' which, to this day, makes a Gruau instantly recognisable. Alongside him were the great illustrators who dominated the pages of French, British and U.S. Vogue from the thirties to the fifties seen by many as the great decades of fashion drawing. Eric, Bouché, Bouët-Willaumez: with their very different techniques they captured the elegant esprit of high fashion with a verve that in retrospect has an authority lacking in so many fashion photographs of the time. Whereas the lens presents the clothes with stiff formality, the artists hand sparkles with personality, wit and the one thing photography even now has not managed to supersede the style and individuality of the man behind it."

The fashion artists in this book all know how to draw (and indeed how to paint), either through natural talent or through hard study and practice. In this, they shared common learning with artists from the past – and not just the obviously comparable ones such as Watteau or Boldini but also figures like Tiepolo or Gainsborough. And, almost always, they worked from a model who would wear the clothes in the way the couturier had shown them. So the first drawing, or *croquis*, was a portrait not just of the clothes but of the woman wearing them: her way of standing; how she held her head; the gestures of her hands – all the characteristics that made her a unique individual and her way of wearing clothes unlike that of anybody else. One of the greatest losses is that so few *croquis* survive. They were the heart and soul of a drawing and they gave fashion drawing probity as art. That is now largely gone. Most modern fashion drawings are digitally engineered and there has been no model for the artist to draw. It is cheaper, of course, but so are the results.

But, luckily, we have the final versions of earlier work from the twentieth century. Even though so many of these failed to survive the need for speed in production, especially in newspapers, and were damaged in the printing process or were simply not valued enough to be saved from being thrown away or destroyed once the image was safely on the page, as this exhibition shows, we have enough to see the skills of the artist and how he reflects the mood of the times.

René Gruau's gently encompassing black line can be seen as a soft, Oldenburg answer to the growing mechanisation of the twentieth century, an answer to the functionalism of the Bauhaus or the monumentalism of Léger's middle period.

Interestingly, Antonio Lopez, born in Puerto Rico but brought up and working in New York in the sixties, the most vibrant urban landscape ever seen, took much of the energy and vibrancy of America as a starting point of his drawings – which even occasionally also echoed Léger.

All art, including fashion art, articulates the mood of the times and the energy of the moment. Just as Gruau's work reflected the confident elegance and assurance of the upper classes in the fourties and fifties, so Antonio perfectly captured the new younger woman of the sixties using, as he did, his friends, the models Pat Cleveland and Jerry Hall – although rumour suggests that very early in his career, when he used to go to Charles James in the Carlyle Hotel to draw the maestro's clothes, they were often modelled by young men picked up in Times Square. True or false, the real world in which Antonio's genius grew lay in the exciting, challenging streets of New York City – just as the elegance of Paris, where Antonio lived for seven years, was always the stimulus and background for Gruau's work.

Now, of course, fashion is entirely international, with no fashion city dominant as Paris and New York were in the past. And current fashion illustration reflects this. Artists like Mats Gustafson and François Berthoud are world figures. They both share a common belief that drawing fashion cannot be approached in the same way as photographing it. Whereas Gruau and Antonio could, for all the freedom of their line, be called figurative illustrators who, in a sense, competed with the camera in the way in which their drawings were a literal and (certainly in Antonio's case) often remarkably detailed interpretation of the clothes they saw before them, with Gustafson and Berthoud the viewpoint is different. They both work not only with shape but also with volume and surface. Berthoud frequently creates an area of pure colour on the page and leaves it without any added detail – and even when that is added, it is minimal. Gustafson is a master of the wash, or often the layers of wash, as many of his most ethereal and evocative interpretations are multi-layered. His chosen medium is ink or water colour used sparingly, almost intellectually. He shows us the spirit of the clothes in subtle surface interplay. Timeless and eternal, they are unique, although frequently plagiarised by lesser copyists of his technique.

Berthoud is more diverse in both technique and subject, restlessly looking for ways to make fashion drawing a relevant and exciting element of modern fashion. And he succeeds, whether in carefully controlled line drawings, almost photographic delineations of fabric, subtle washes of colour or bold, elemental brushstrokes. Whatever the technique, the handwriting is always uniquely his own.

And it is this unique and individual quality of the hand that makes the art of drawing fashion of value and interest to us today. Whereas the techniques of photography become less and less individual and the stylist's contribution is the thing that increasingly differentiates one magazine spread by a photographer from the next one by a different photographer, an artist's hand is instantly recognisable. It is this individuality that is celebrated in this volume.

Drawing fashion will no more die than figurative painting will. Its use is currently not as widespread as it once was, but there will always be a need for, and response to, the drawn image in its many modern manifestations. It will not, and must not, be like what has gone before, but it can be guaranteed to stimulate those who look at it with eyes unclouded by preconceptions. Modern fashion drawing is about discovering the essence of style, now as it has been for more than a century.

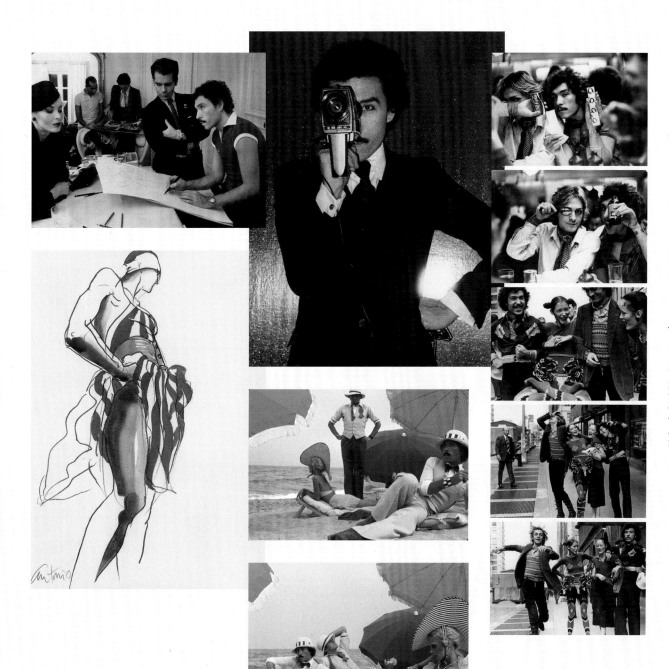

(*clockwise from top left*)
Antonio drawing model Eija wearing Karl Lagerfeld for Chloe in the apartment at 134 Boulevard St-Germain in 1973. Lagerfeld is looking on. Grouped at the back around a book are Juan Ramos (left) Jacques de Bascher, and Suzi Wyss (seated);
Antonio with his 8mm. movie camera in his bedroom in the apartment at 64 Rue de Rennes. Photo by Philippe Djanoumoff, 1975;
In a series of photos by Juan Ramos from the mid 60s, Antonio, Corey Tippin, Cathee Dahmen and Jane Forth cavort in a Horn and Hardart Automat on 57th Street in New York, and then outside heading up 7th Avenue towards Central Park;
Juan's 35mm slides of Antonio, Corey Tippin and Donna Jordan on the beach at Saint-Tropez in 1971, where they spent the summer every year with Karl Lagerfeld from 1970–73. Some of the clothing and jewellery was vintage art deco;
Antonio, *Japanese Stripes*, 1982 (see pages 133 and 230)

OF THIS WORLD BUT NOT IN IT

by
HOLLY BRUBACH

The eighteen artists represented here, most of them best known for their fashion drawings, inhabit a neighbourhood somewhere on the outskirts of that gated community fine art calls home. It's one thing for Chuck Close to paint a portrait of Kate Moss or for Tom Sachs to pose questions about our obsession with luxury goods by branding his work with Chanel and Prada logos; it's another, evidently, to be complicit in that obsession, commissioned to turn out advertisements and editorial images of the season's new collections, making work that, either explicitly or subliminally, helps to sell trench coats, sandals, lip gloss, perfume. Let him who is without sin cast the first stone. Long-standing accusations that fashion drawings are "commercial" have surely lost all their sting in an art market godfathered by Andy Warhol and dominated by the likes of Damian Hirst and Takashi Murakami.

For most of its history, this genre has been known as "fashion illustration," a vaguely pejorative term that, upon closer examination, is really a double-barrelled insult. "Fashion" – flighty, superficial, here today and gone tomorrow; "Illustration" – as if the artist came by the material second-hand, merely drawing a picture to represent someone else's idea, without any underlying intellectual argument or comment on the culture that produced it. No wonder this work has been overlooked and undervalued.

Joëlle Chariau has been exhibiting fashion illustrations since 1982, waging what must have been in its early stages a lonely campaign to bring them to the attention of a larger audience. Her gallery in Munich has become the genre's pre-eminent showcase, patiently making the case that these drawings deserve our serious consideration – and not, like yellowing playbills, as mere relics of their era, prized for the information they contain. (Which is not to say that they don't contain information: there are muffs here, and parasols, and cocktail hats – articles of dress now extinct for decades.)

If the fashion illustrations that constitute "Drawing Fashion" teach us anything, it's that a work of art can take style as its subject and, against all odds, survive the built-in obsolescence of the clothes it depicts. René Gruau's cover for *International Textiles,* to name only one example, seems no less compelling now than it must have been when it was published in 1951. The suggestion of a coat in the same colour as the textured background, the model's sidelong glance and the proud tilt of her head, her white-gloved hand flinging a black stole over her shoulder – all this is striking for its economy of expression. Unlike the women in paintings by Ingres or Manet or Sargent or Alice Neal or John Currin, rendered three-dimensional in attentive brushstrokes, floating in a sea of texture and light, these women and the landscapes that surround them are graphic, described in strong lines and flat shapes.

Today we encounter these drawings framed and hanging on the wall in the hallowed space of a gallery. But in their original context we would have come upon them at the newsstand or inside a magazine, where the articles and images unfolded according to a sequence carefully orchestrated from start to finish, front to back. The majority of these drawings were created to be seen on a page, at close range, allowing for the sort of one-on-one experience traditionally associated with books and letters. This, I think, accounts for a certain appeal peculiar to fashion drawing as a form: the intimacy, with the image held in the viewer's hands, and the urgency, the need to stop us in our tracks before we turn the page.

The 154 works here span roughly a century, a time when fashion drawing flourished. Not coincidentally, it was also the golden age of magazines: their heady rise, their lavish heyday, their abrupt decline brought on by a global economic crisis and the rise of new, electronic media.

Though magazines had been invented in the eighteenth century, it was not until the twentieth that they finally came into their own, reaching people who were widely scattered but like-minded and speaking to them as if they were assembled in one room. Fashion, formerly the work of

individual artisans, was becoming an industry, producing new merchandise in unprecedented quantities to fill a new arena, the department store. Department stores were inventing the culture of shopping, a new national pastime. Cosmetics companies were devising products for a mass market, fostering demand that was created by the cinema, a new entertainment. This cluster of businesses catering to a female audience found in magazines the perfect vehicle.

The imaginary women in these drawings enact the changes that transformed real women's lives over the course of the century. Viewed chronologically, they also engage in a kind of time-lapse striptease for an audience of successive generations. First ankles, then calves, knees, thighs, midriffs, abdomens, breasts, and eventually crotches are revealed with an audacity that in retrospect seems innocent and poignant. Little by little women came into their freedom, they discovered their own bodies, shedding their clothes until there was nothing left to take off.

Fashion magazines have certainly come in for their share of the blame in women's increasing obsession with their bodies and their appearance, and indeed it would be hard to argue that *Vogue* or *Harper's Bazaar* was instrumental in securing their equal rights. But fashion magazines were, I think, instrumental in implementing those rights, by portraying sexual freedom as glamorous and completely feasible. In Antonio Lopez's drawings, beginning in the early sixties and continuing into the mid-eighties, we read in the women's body language a new-found sense of their own strength. By the time we get to François Berthoud's images from the nineties, rendered in the stencil contours of linocuts and monotypes, the women have been transformed: now they are the aggressors — provocative, aware of their erotic power and wielding it, in lingerie and swimsuits with overtones of bondage. In an act of violence, subtle but shocking, a foot in a spike-heeled ankle-strap shoe crushes a daisy. He loves me, he loves me not … To hell with him.

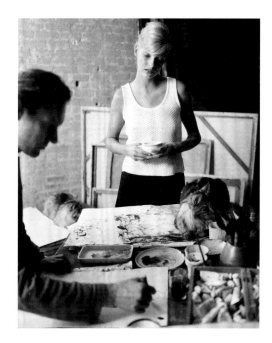

(*top*) In 1999 *Harper's Bazaar* commissioned Mats Gustafson to draw the iconic model Linda Evangelista in the season's spring fashion. It resulted in a series of portraits and figures made in light ink washes. The strong and linear beauty of Linda seems to have had a lasting impact on his work. Patrick Demarchelier photographed the session; (*bottom*) Mats Gustafson *Linda Evangelista*, 1999 (see pages 157 and 231)

Although both artists are producing monotypes using a hand press, an almost archaic technique, they need completely different surroundings. François Berthoud's studio is extremely well organized; he goes back and forth between his old press and his highly sophisticated electronic equipment. Whereas Aurore de La Morinerie needs the presence of nature and is therefore surrounded by a profusion of plants, animals and objects.
(*top left*) François Berthoud, *Untitled*, 2000, Monotype, oil on paper, Fashion by Givenchy; (*bottom right*) Aurore de La Morinerie, *Défilé*, 2009, 32 x 40 cm, Monotype

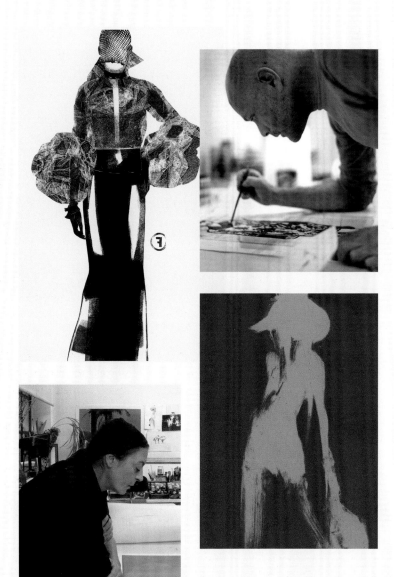

There is something not just titillating but mildly astonishing, even shocking, in the behaviour of the women Berthoud portrays. Not because we're prudes — by now we've seen it all. But we've seen it all in fashion photographs, not in fashion drawings, and it comes as something of a surprise that a woman in a *drawing* is exposing rage or a mean streak or a hunger for sex, if only because these women have traditionally been so well-behaved, such models of decorum. Admittedly there was that night in 1983 when two of Antonio's girls got drunk and rowdy. But apart from that, since 1912, they've been on their best behaviour, which is more than you can say for the women in fashion photographs — bad girls who break the rules with such regularity that we've come to expect it of them.

As twin forms that grew up together over the course of the twentieth century in the pages editors had to fill, fashion drawing and fashion photography went their separate ways early on — playing out the intertwined destinies of most siblings, becoming rivals, competing for attention. Each came to specialise in what the other was incapable of doing, or incapable of doing as well, to such an extent that tracking the progress of fashion drawing alone, without taking into consideration parallel developments in fashion photography, tells an incomplete version of the story.

During the 1920s, technical limitations confined fashion photographers like Baron Adolph de Meyer and Edward Steichen to the studio, where they recorded their subjects in black and white, in poses patiently held for the duration of a long exposure. Meanwhile, Georges Lepape was experimenting with lavish colour and bold geometric forms: the spirals of Art Nouveau, the arcs and triangles of Art Deco tile large areas of his images, in patterns that extend all the way to the edges. The picture plane is full, and every square millimetre has been considered.

And then, in the thirties, fashion photography and fashion drawing essentially traded places, each adopting what had been the other's speciality.

Martin Munkasci moved his camera outdoors, integrating the model and the clothes in some larger composition. As airline travel made even the farthest corners of the world accessible, fashion photography got a passport and went "on location." And fashion drawing, for its part, retreated to a format of stylised, often full-length portraits. In the work of Christian Bérard, Cecil Beaton and Bernard Blossac, the figure is seen against the blank background of the paper itself: the figure *is* the drawing.

The fallacy that lies at the heart of any photograph – the pretext that this is a split-second eye-witness account of a real-life occurrence – has worked to fashion photography's enormous advantage, lending it credibility and introducing options that drawing simply does not possess. Melvin Sokolsky's astonishing photograph of a woman floating in a bubble above the streets of Paris still prompts a double-take on the part of the viewer; a drawing of a woman suspended in a bubble above the streets of Paris would be just the product of the artist's whim.

Richard Avedon, in his photographs of running, leaping, pivoting models, captured the frenetic exhilaration of the sixties, when women's bodies were finally freed from the constraining styles and underpinnings that had reined them in; a drawing could simulate motion, but without the energy, the thrill of an instant frozen and preserved. As sexual liberation tackled long-standing taboos and fashion photography seized on transgressive subject matter, it became apparent that the threshold for obscenity was far lower when it came to drawings. Photographs could get away with more, as Helmut Newton's did in featuring exotic permutations of eroticism – lesbian, sado-masochistic, fetishistic. By "just reporting the facts," photography could indulge in episodes of voyeurism which, in the context of a drawing, would readily be mistaken for figments of a lewd imagination.

In the eighties, fashion drawing found itself at a loss, incapable of expressing what turned out to be one of the defining aesthetic developments of the twentieth century: the overthrow of beauty

and, in its place, a perverse fascination with the awkward and the ugly. With beauty and elegance now outmoded both in fashion and in art, fashion drawing seems at times like a throwback to an earlier era. Mats Gustafson's work in particular, which continues to celebrate elegance and grace, is suffused with an elegiac quality. Seen in silhouette, veiled in tissue-like layers of gouache, his women look to be direct descendants of Gruau's, the images reverberating with the distant echo of refinement and high chic that characterized mid-century Paris.

Oddly enough, this tradition of fashion drawing has been driven by an overwhelmingly male point of view. These are images of women, for women, by men. Aurore de La Morinerie, the sole female artist represented here, is also the most recent to emerge, in the final years of the twenty-first century's opening decade – a fact all the more remarkable when you consider that women have been making their mark as fashion photographers for over sixty years now. The women Morinerie depicts have a ghostly quality, their silhouettes indistinct, as if their skin formed a porous boundary between them and the world, as if their vision of themselves were more ambiguous than men's vision of them.

With fashion photography apparently better suited to portraying so many aspects of contemporary life, what was left for fashion drawing to claim as its own? Consciously or subliminally, artists like Gruau, Antonio (as he was known, by a single name), and Gustafson steered their work in a different direction. Apart from the handful of portraits included here (not fashion drawings but drawings of particular women by fashion artists), the women in their images are not real women – not even when we recognise the model. Instead, these women are idealised, indeterminate. Even the clothes they wear are rendered in terms that grow increasingly vague until finally the details disappear. With photography so much more adept at documenting a garment's details – the texture of a tweed, the lustre of pearls or the shimmer of

satin – artists took to interpreting fashion more freely, capturing the spirit of a dress and the style in which it was worn.

All fashion images – photographs and drawings alike – encapsulate their moment, giving expression to the shared hopes and anxieties that defined it. And while these drawings are no exception, they somehow manage to be timely without being topical. It is, in fact, striking – the utter absence of any reference to the events that dominated the news. World War I impinges, but only briefly, in a bar full of men in uniform, where Benito's coquette chats with an officer, or in the cockade that Lepape's patriotic demoiselle prefers to all the flowers in the garden. Otherwise, what takes place beyond the confines of fashion barely registers. Events that will reconfigure national boundaries, discoveries that will change our understanding of the universe, inventions that will revolutionise our everyday lives are all happening offstage: the automobile; aviation; the Great Depression; a Second World War; television; a man on the moon; computers; the internet. While the women in fashion photographs enthusiastically participated in their era, revelling in the tangible and the material – the latest cars, the famous restaurants and favourite nightclubs, even a rocket at Cape Canaveral – the women in fashion drawings gradually withdrew from their surroundings and ascended into the realm of the empyrean.

Like all goddesses, the ones portrayed here inhabit a continuous present, their youth and their allure intact. The culture that worshipped them has vanished, its monuments and landmarks and customs as remote as those of any ancient civilisation. Oblivious, they continue about their business: dressing up, checking their makeup, gazing at the ocean, going for a walk, going to the opera, skiing, skating, fishing, going dancing. They are of this world but not in it, residing on another plane where no one has trouble finding a cab or pays taxes or goes to the dentist, where artists meditate on the chimerical nature of female beauty and each woman stands for all women.

JOËLLE CHARIAU

interviewed by
RENATE STAUSS

Gallery owner Jöelle Chariau has pioneered the collection, exhibition and publication of cartoons and fashion art worldwide. She has been instrumental in building some of the most reputable collections on these subjects. For the very first time 'Drawing Fashion' presents the outstanding compilation of fashion illustrations put together by her over the past thirty years.

Renate Stauss: Your gallery Bartsch & Chariau was founded in 1980 and has been described as the 'Mecca of Graphic Art'. How did you come to specialise in graphic art in general and in fashion art and fashion drawings in particular at a time when nobody seemed to be interested in these genres?

Jöelle Chariau: I think it all happened by chance. Although art was not a special interest of mine at that time, I had the opportunity to work for an art centre in the 1970s that was a kind of high church of the minimalist and conceptual art of the period. It exhibited artists like Carl Andre, Agnes Martin and Don Judd, but also Chuck Close, Per Kirkeby etc. It was my first contact with artists and to my surprise, I could talk to them. It was like being able to read and speak a language I had never learned. It was an exciting and very formative experience, but after a few years I found that the context was too intellectual and above all too dogmatic for me. I had always wanted to write film scripts; I admired people like Hitchcock and Lubitsch, who had made their films to entertain. Because they had a very high opinion of their public, those films are as much alive today as they were 50 or 70 years ago and can be viewed over and over again without fading. So I think I had the right frame of mind to work with commercial art. An acquaintance of mine, Andreas Bartsch had been working for a gallery that was closing. He had staged exhibitions with Ronald Searle and a few other cartoonists, and we decided to open a gallery together. Our second exhibition in 1980 was about the great cartoonists of the *New Yorker*: Peter Arno, Chas Addams, Steig and Steinberg;

the third was an exhibition with Sempé, with whom I have been working ever since. Fashion came two years later when I discovered René Gruau.

RS: How was this move from the field of avant-garde art to the more commercial sphere of graphic art perceived by your contemporaries and customers?

JC: Some of the artists and collectors I knew personally were perplexed but the public loved it and we were (modestly) successful from the start.

RS: Fashion, due to its physical superficiality, by which I mean its position on the surface of the body, and associations with commerciality and femininity, has long been met with a mixture of fascination and ridicule. To what extent would you say that the marginalisation of fashion drawings is linked to the ambiguous attitude to fashion itself?

JC: I'm not sure that is the reason. If the superficiality of fashion were one of the reasons, how could one explain that fashion has become such a cultural force today? Besides, attitudes have changed over the years: at the beginning of the twentieth century, fashion artists all had a classical background. They had galleries representing their work and the Musée des Arts Décoratifs in Paris held an exhibition dedicated to their work every year parallel to the "Salons". This changed around 1927, when they were still very well paid for their work but there didn't seem to be any interest in the originals. When I went to see Gruau for the first time in 1982, he couldn't understand why I was interested in his fashion drawings and why I thought other people might be. He had been a star much like the star photographers of today, but in his own eyes he was somebody who executed commands.

RS: How would you personally describe the position fashion drawings occupy between art and commerce, between fine art and commercial art?

JC: The radius of fashion drawing being quite small nowadays, the artists who engage in this profession cannot be overtly commercially minded. They still work on assignment, so this genre therefore belongs to the field of commercial art. On the other hand, interesting works are always more than they pretend to be, and so the dividing line must be a fluid one.

RS: Fashion drawings and fashion photography are often – reductively – described as representations of dress and fashion. How would you define a fashion drawing?

JC: A fashion drawing is the staging of bodies and attitudes. It is defined, above all, by the quality of the drawing and the creativity of the artist, but it also requires a perfect understanding of the essence of the garment and the ability to translate it into an image of desire.

RS: Apart from photographic reproducibility, what, in your view, makes a fashion drawing different from a fashion photograph?

JC: It is definitely the power of abstraction of the drawing that imprints itself in the memory of the viewer more effectively than a more realistic photograph can do. Gruau's answer, when asked the same question, was that a good photograph worked better than a good drawing, but that a very good drawing was superior to a very good photograph. When I went to see him for the first time, almost 30 years ago, and we started looking into his cabinet drawers, I was surprised to find out how many drawings I knew already. I had never been interested in fashion before but as a child had spent many rainy days looking at my mother's fashion magazines which had been relegated to the attic of our house.

RS: Within fashion photography many a photographer rejects the label of "fashion photographer". How do the artists you represent feel about the

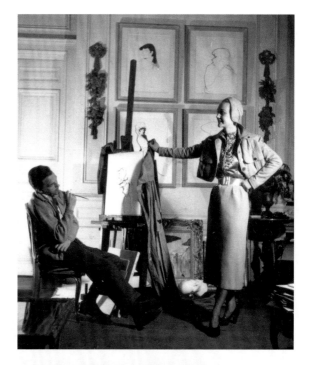

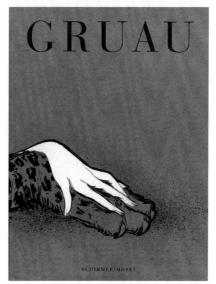

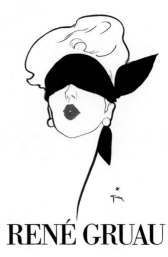

(*top*) René Gruau with a model in his studio in the Rue Galilée, 1940s. Photograph by Seeberger;
(*bottom left*) Cover: *Gruau*, edited by Joëlle Chariau, Schirmer/Mosel, 1999. This cover with the leopard paw was inspired by Mitza Bricard, the muse of Christian Dior who consulted her on everything. When once asked who was the most elegant woman he had ever met, René Gruau answered without hesitating: "Mitza Bricard";
(*bottom right*) Cover: *René Gruau*, edited by Joëlle Chariau, Schirmer/Mosel, 1984. The cover with the blindfold reproduces an advertisement for "Rouge Baiser" lipstick. It is probably the most famous advertisement of the 1950s and has virtually become a symbol of the age.

association with fashion and the term "fashion illustrator"?

JC: I'm quite certain that none of them has a problem with being labelled a "fashion artist" – after all, it is the profession they have chosen. But, on the other hand, they would certainly think that the term illustration does not apply to their work, an illustrator being somebody, let's say like Du Maurier in Victorian England, who renders with great fidelity what he has been given to reproduce.

RS: Mats Gustafson has apparently left the subject of fashion behind and Aurore de La Morinerie works in different genres – is there a move away from the illustrator or artist specialising in fashion, such as Lopez or François Berthoud?

JC: Fashion artists have seldom limited themselves to fashion. Some of them, like Marty and Iribe, also worked as designers, and many created costumes and sets for the theatre. Bérard's reputation, for instance, is founded above all on his work for Cocteau, Kochno, Balanchine, Louis Jouvet and on his paintings. Most of them, but particularly René Bouché and Gruau, were very much in demand as society painters. When *La Gazette du Bon Ton* was created in 1912, its art director Jean de Brunhoff made the round of the painters' studios in Paris to persuade them to work for him. *La Gazette du Bon Ton* played the same role for fashion drawing that *The New Yorker* played a little later for cartoons: it elevated the genre from a popular information and amusement commodity to an artistic and culturally relevant profession. Mats Gustafson pursues a career as a fine artist with galleries in Stockholm and New York parallel to his fashion work. Aurore also works as a fine artist. Antonio's incredible input and creativity and the continual renewal of his style probably prevented him doing much beside his drawings. François Berthoud's graphic approach to images has found a fecund environment in fashion, but his research evolves in more directions.

RS: The common denominator between all of the artists presented here – apart from the subject of fashion, obviously – is France. Even those few who are not French, like Gustafson or Antonio, have spent formative years in France, where fashion is a legitimate, even celebrated part of the national discourse. What importance would you attribute to this cultural context – indeed your own cultural background in this respect?

JC: Being French and having spent so much of my life in Germany has made me very aware of the cultural differences. Germany, with its love of abstract philosophy, of music, the most abstract of all arts, offers the best example of a culture of content. France on the other hand, like most Latin countries, definitely belongs to a culture of surfaces. Of course, it loves ideas too, but these are mostly concerned with life. In France, what we call "les arts de vivre" have always been part of our cultural life. After all, France is the country where Voltaire once wrote: "Le superflu, toujours chose très nécessaire." [The superfluous, always a very necessary thing.] This cultural consensus is probably the reason why France still offers the best background for fashion at a time when Paris designers get hired internationally like football players.

RS: To what extent has this cultural background of yours and your gender determined your eye for fashion drawings?

JC: I was interested in quality, so I never had the feeling I was working in a minor genre. The fact that it had not been explored before, at least not in the way I wanted to, was also a major factor in its attraction. In an era where almost everything suffers from over-exposure, to find something that one loves and that is so little known is exhilarating. My business partner and I didn't open a gallery in order to exhibit fashion: it was a chance encounter with Gruau in the pages of a '50s magazine for graphic design that made me look for him and this then led to all the other artists. I do not

think that my gender had anything to do with it as I was more interested in drawing than in fashion.

RS: Facilitator, cultural intermediary, patron, art broker – how do you view your role as a gallery owner?

JC: My role is to find good artists, to create a worthy platform for them and a market for their work.

RS: What was the first fashion drawing you acquired?

JC: It was a pencil drawing by Gruau in 1982. Although the originals were not expensive at the time, I could not afford to buy the published works. Besides, I sometimes prefer the preliminary drawing, which is closer to the hand of the artist.

RS: And how did your collection develop after that?

JC: An art dealer will always try to keep his favourite works for himself. Necessity very often compels him to sell, and then forces him to find another work he likes at least as much as the one he just has just parted with. After Gruau, I began exploring the whole field. Together with my partner, who has now retired, we mounted exhibitions by the artists of Art-Deco: Erté; but also Antonio in 1987, Mats whom we first exhibited in '89 and François Berthoud in '92. I started working with Aurore de La Morinerie only four years ago. In the early '90s we got the chance to buy most of what had been the content of Poiret's studio, including his archives. The gallery represents the estate of Gruau and of Antonio, so that gave me the opportunity to make a selection from a vast body of works. As this domain is hardly known by the public I decided quite early to form a collection that would ideally be acquired by a museum where it would remain on view.

RS: René Gruau has been a great influence both on the history of fashion drawings and directly on your own career, yet there is uncertainty over his inclusion in this exhibition. How can you explain this?

JC: Gruau has certainly been a decisive influence on my career and I was the first gallery to exhibit his fashion drawings and publish books about his work (see illus. p. 21 below). However, the permission to reproduce the 27 Gruau drawings that are part of the collection has been refused. The rights to his work are overseen by the SARL René Gruau whose role it is to look after the legacy and the reputation of the artist. It is owned by two partners, one of whom is the executive director. This person would like to prevent the works of René Gruau from appearing in both the exhibition (she cannot prevent that) and this accompanying catalogue. Gruau's son and heir, Aldo Zavagli, who is the other partner in the company, is convinced that this decision is contrary to the mission of the SARL. It is truly unforgivable that this book, which is dedicated to the masters of fashion drawing, has to be published without René Gruau – one of the greatest of them all.

RS: While it might have been more obvious to collect the early stars of fashion drawing, such as Lepape, Erté, Gruau – what influenced your decision to collect lesser-known artists?

JC: It is not difficult to learn very quickly which artists have been important in a certain field, at a given time, but it is even more interesting to guess which ones will follow them, so it is part of the profession to scout new talents.

RS: At the same time, Aurore de La Morinerie is the only representative of today's younger generation of fashion artists, and indeed the only female artist to be included in the show. Can you explain this focus of your collection?

JC: I represent the classics. There have been thousands and thousands of fashion artists – both men and women. This exhibition shows the work of 18 of them and covers a whole century. It is essentially very selective and subjective. I have worked closely with the oeuvre of Lepape, with Gruau, Blossac, Antonio, Mats, François Berthoud and now Aurore.

RS: How did you discover her work?

JC: Another chance encounter: she had written to the gallery. But nowadays, galleries receive so many e-mails from artists all over the world that it isn't even possible to read all of them. I mistook her name for de La Morinière, which was familiar to me, so I opened her e-mail. She had enclosed two drawings, which I found interesting. The next time I went to Paris, I visited her studio and we have been working together since.

RS: Although they all take as their subject the transient field of fashion, the artists presented here seem to be united by a timeless elegance and an evocative, sensual aesthetic rather than engaging in an overtly fashionable language.

JC: It is true that fashion drawing never participated in the hype of the '80s. It also never gave up the idea of taste, which was almost considered politically incorrect in the '90s. But each artist in this collection represents a completely different talent for me: Lepape is the best incarnation of the spirit of what has probably been the most creative period of the whole twentieth century. Gruau, between Toulouse-Lautrec and pop art, is a graphic genius. His drawings are pure surface, which makes him perfect for fashion. Then there is Mats Gustafson, whose works, minimalist and sensuous at the same time, also have a meditative quality that draws you in. François Berthoud, intellectual and experimental, is obsessed with the fantastic surfaces he arrives at through a complicated and time-consuming technique.

Aurore is equally interested in surfaces but more impulsive and intuitive.

RS: You once said: "I think I always had the best artists." And your collection is a manifesto of this vision of yours. Why do you think there is a contemporary recognition of the validity and greatness of these artists and their fashion works?

JC: Is there? I really think that all the artists in this collection deserve to be much better known than they are.

RS: Nonetheless, after the pre-eminence of photography in the context of fashion between the 1950s and 1990s, fashion drawing has regained strength in the past decade. How do you perceive this recent revival of fashion illustration?

JC: It probably goes together with a revaluation of drawing, more generally of everything hand-made. This is logical since it has almost disappeared in modern life.

RS: This exhibition constitutes, among other things, a walk through twentieth-century Western European aesthetics and ideas, through the history of fashion, beauty and body ideals. However, it is also a life story. How does it feel finally to view these works together in the context of one narrative?

JC: Yes, it presents a sum of my work in this field and I'm very grateful to the Design Museum in London and to Prestel who gave me this opportunity.

Munich, August 2010

PLATES

ARTISTS OF ART DECO

I DISCOVERED POIRET AND PARIS FASHION BEFORE 1914 BY SEEING LEPAPE'S
DRAWINGS WHEN I WAS STILL A SCHOOLBOY. THE FIRST THING I EVER BOUGHT
WAS A PAGE OF THE GAZETTE DU BON TON, FROM 1912, CALLED 'SERAIS-JE
EN AVANCE?': A WOMAN IN A YELLOW COAT BY POIRET ENTERING A BOX IN
A THEATER. LATER I FOUND THE FIRST SKETCH OF THAT PAGE AND ITS FINAL
ORIGINAL PAINTING. I THINK I HAVE THE BIGGEST COLLECTION OF LEPAPE IN
THE WORLD.

I ADORE LEPAPE!!!!! MY FAVOURITES ARE FROM 1910 TO 1923. THE SKETCHES
OF THIS PERIOD ARE THE MOST MAGICAL. HE INVENTED MODERN FASHION
ILLUSTRATION AND IN DOING SO CREATED THE FINAL IMAGE OF A GREAT ERA.
— *Karl Lagerfeld*

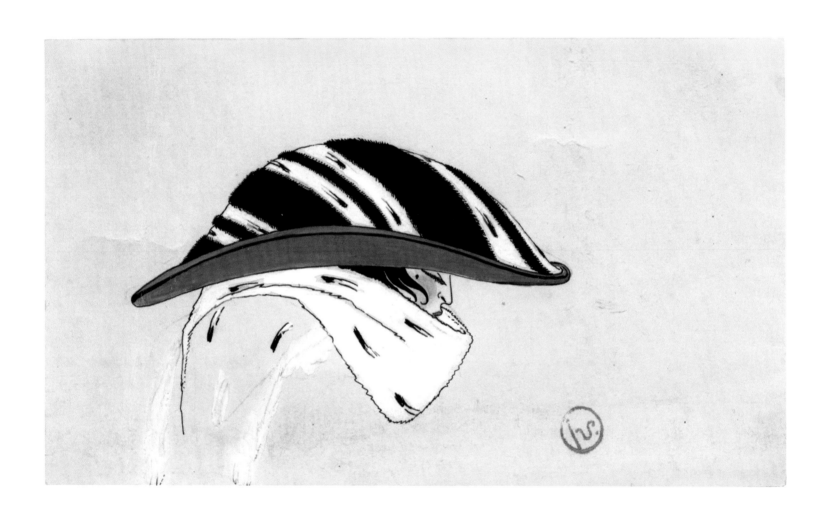

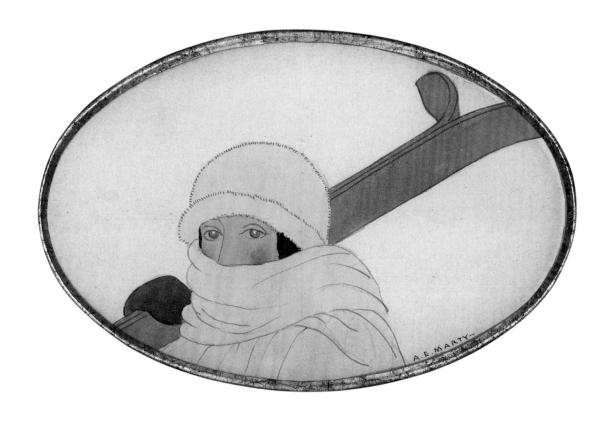

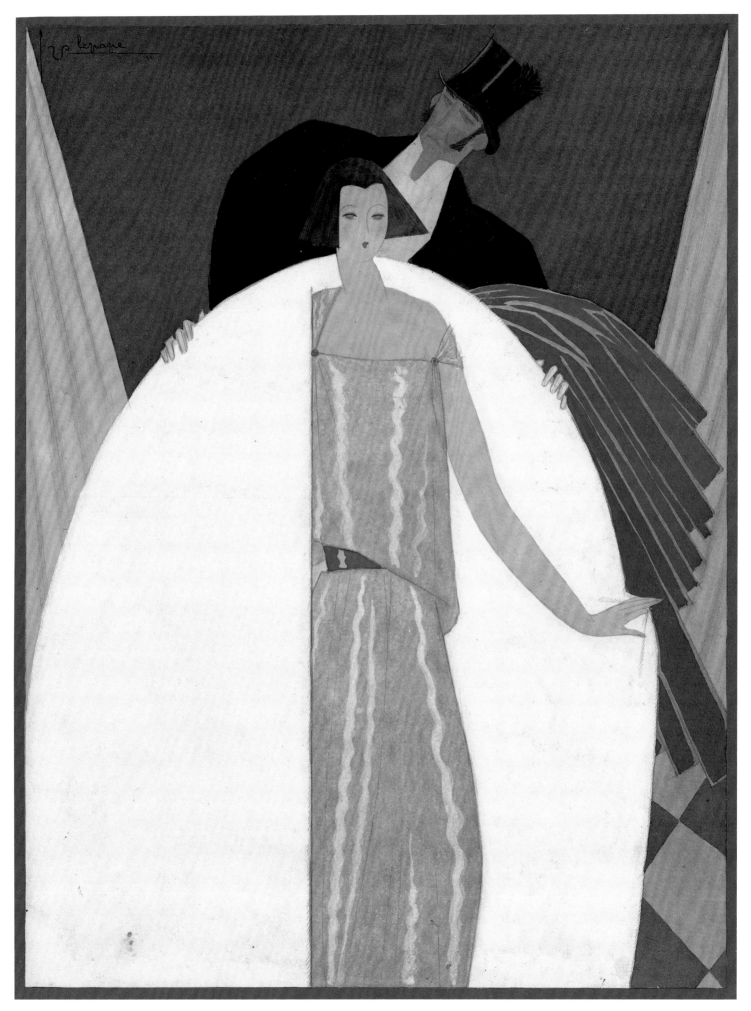

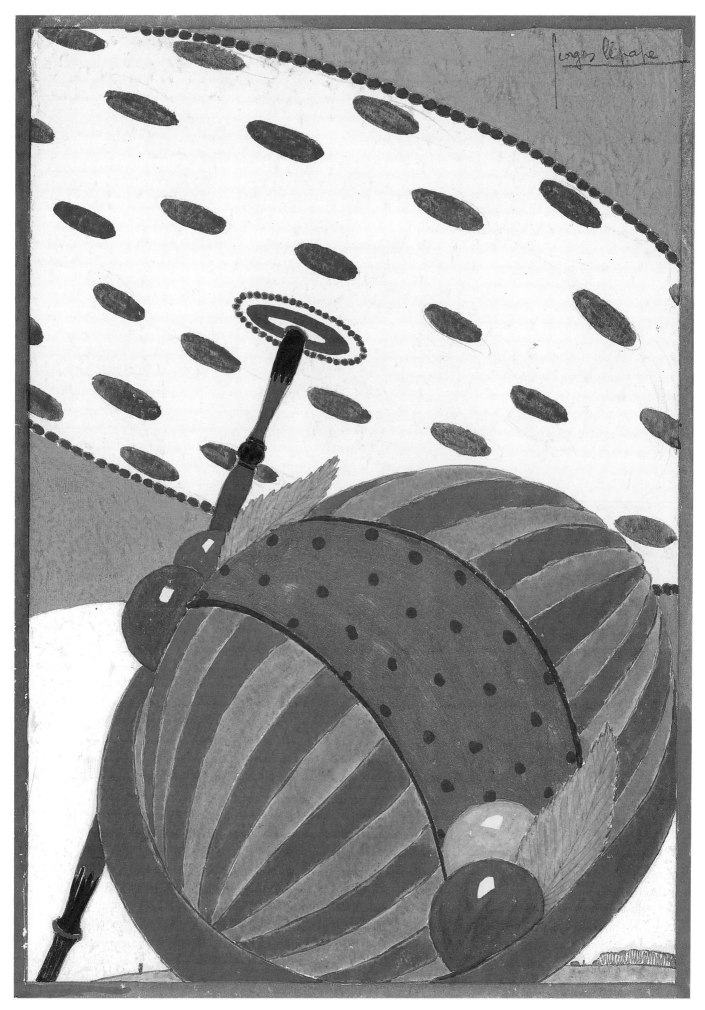

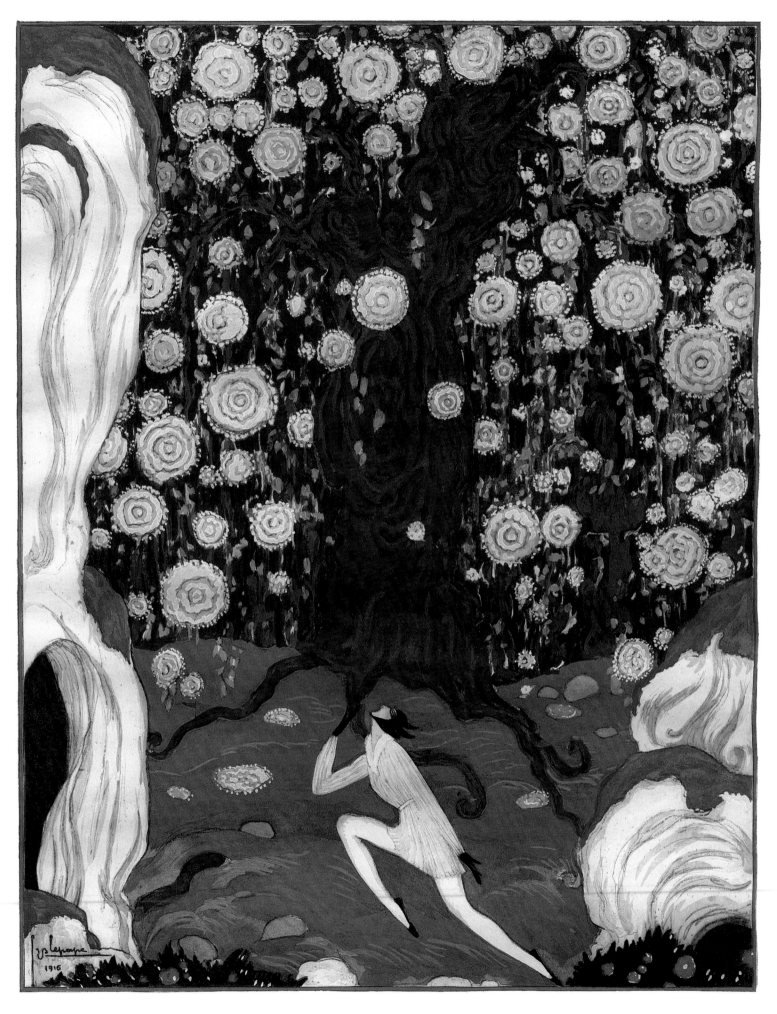

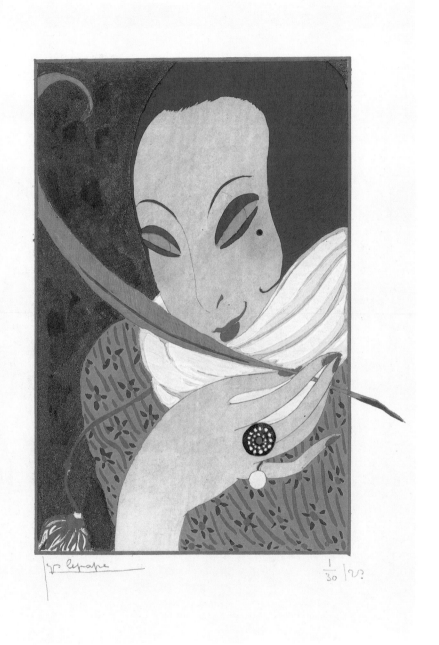

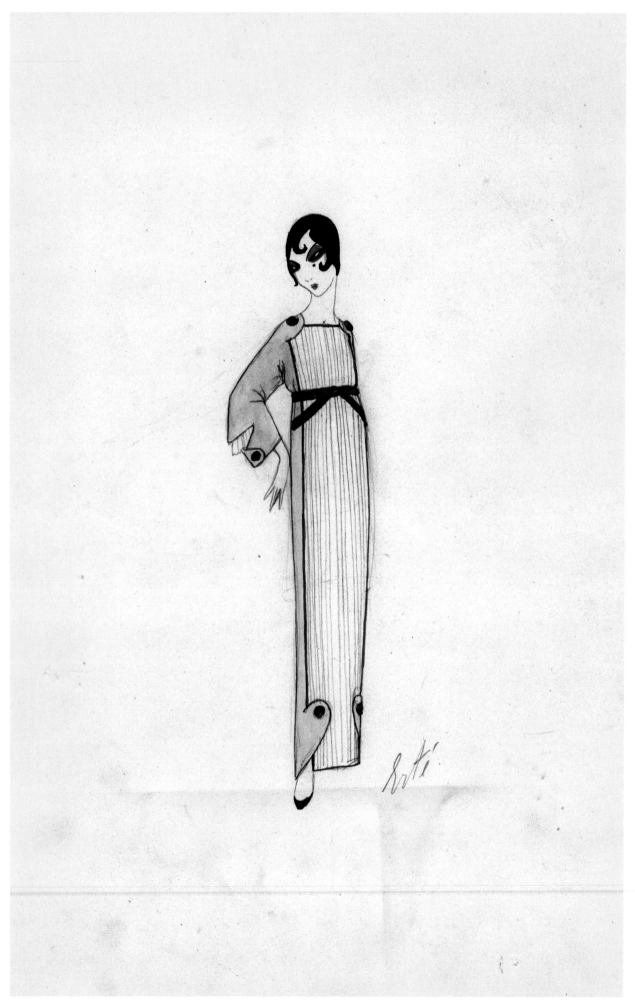

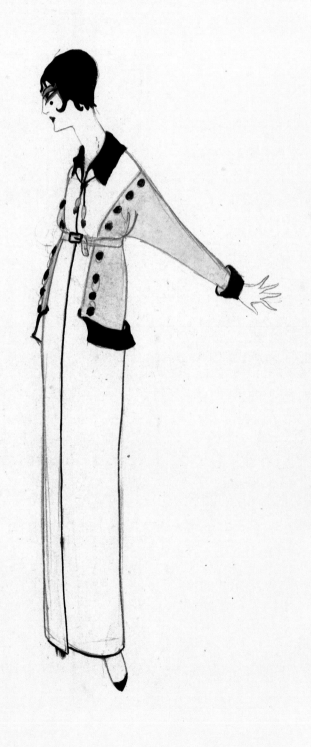

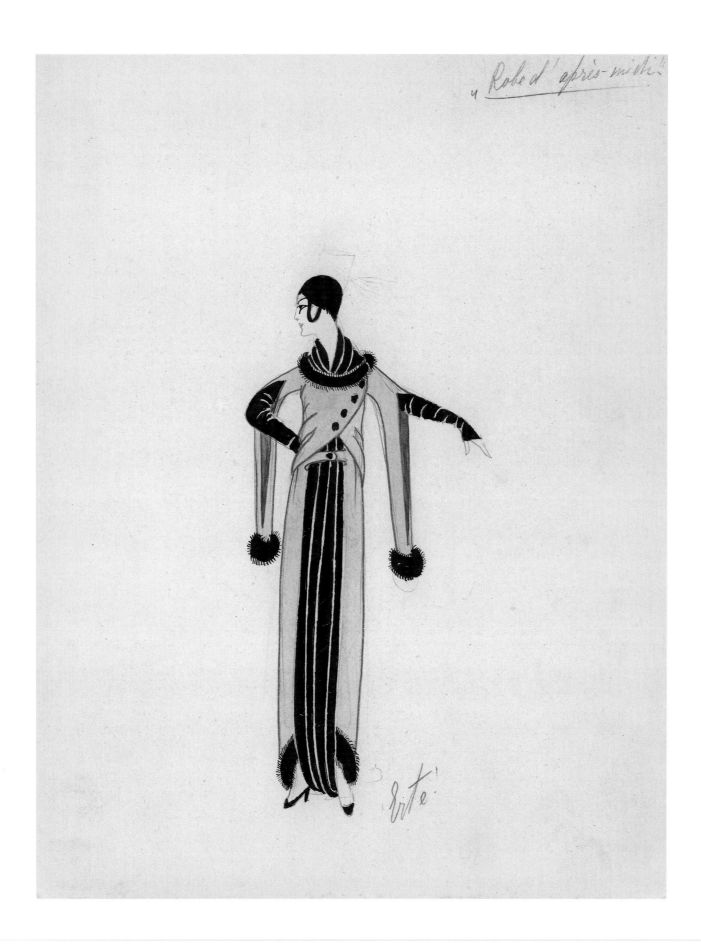

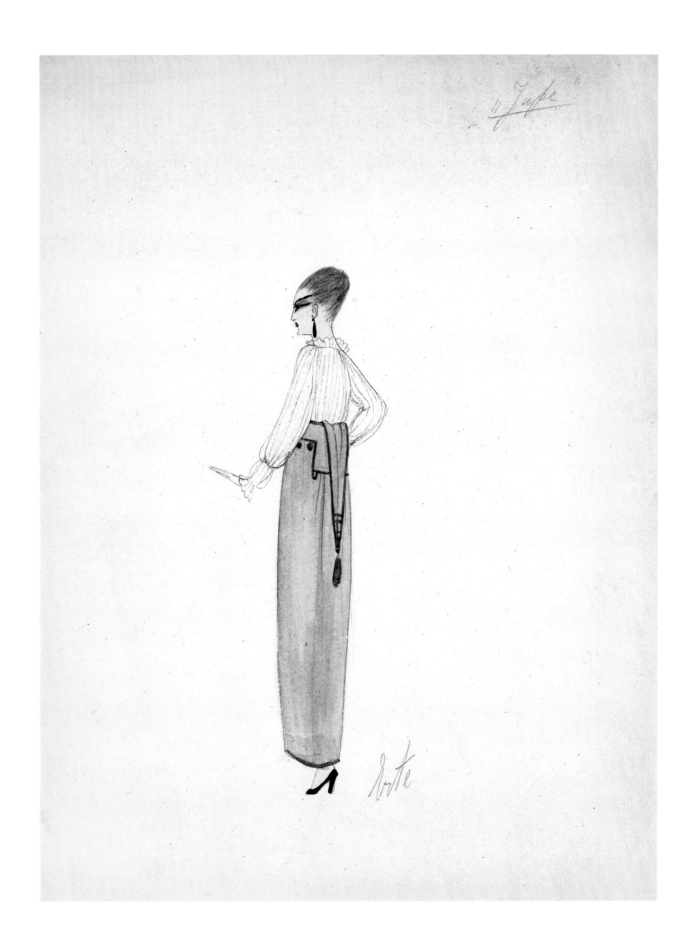

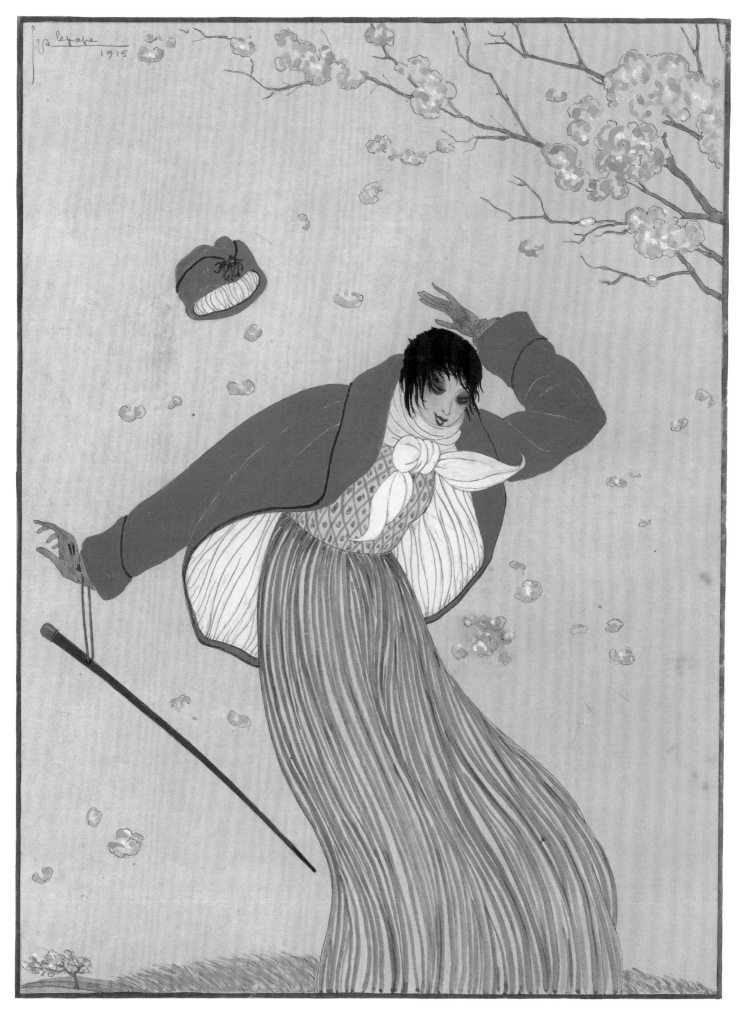

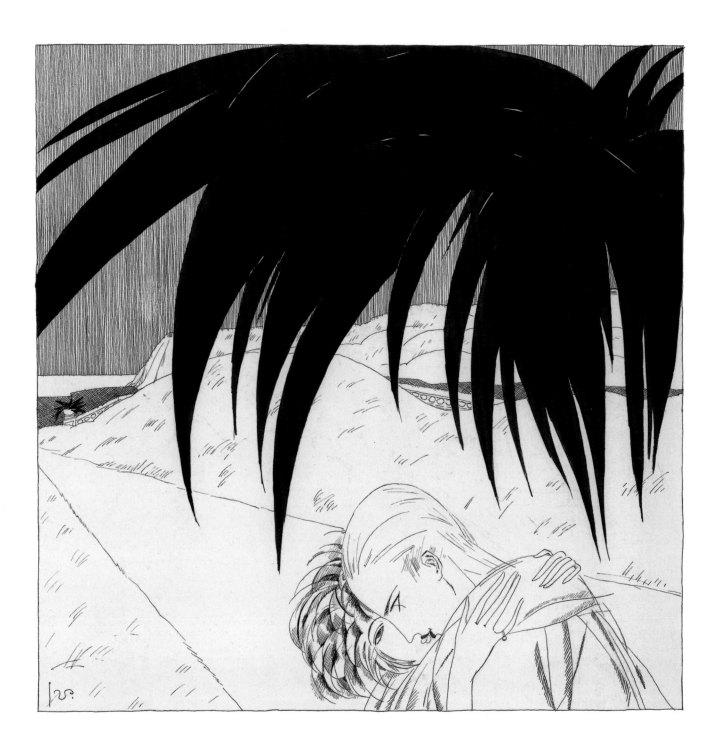

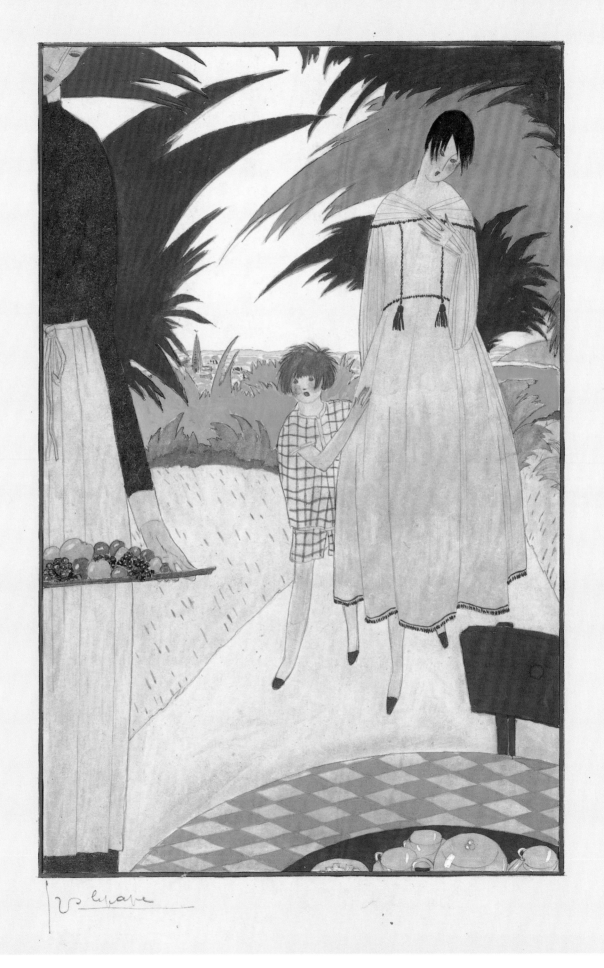

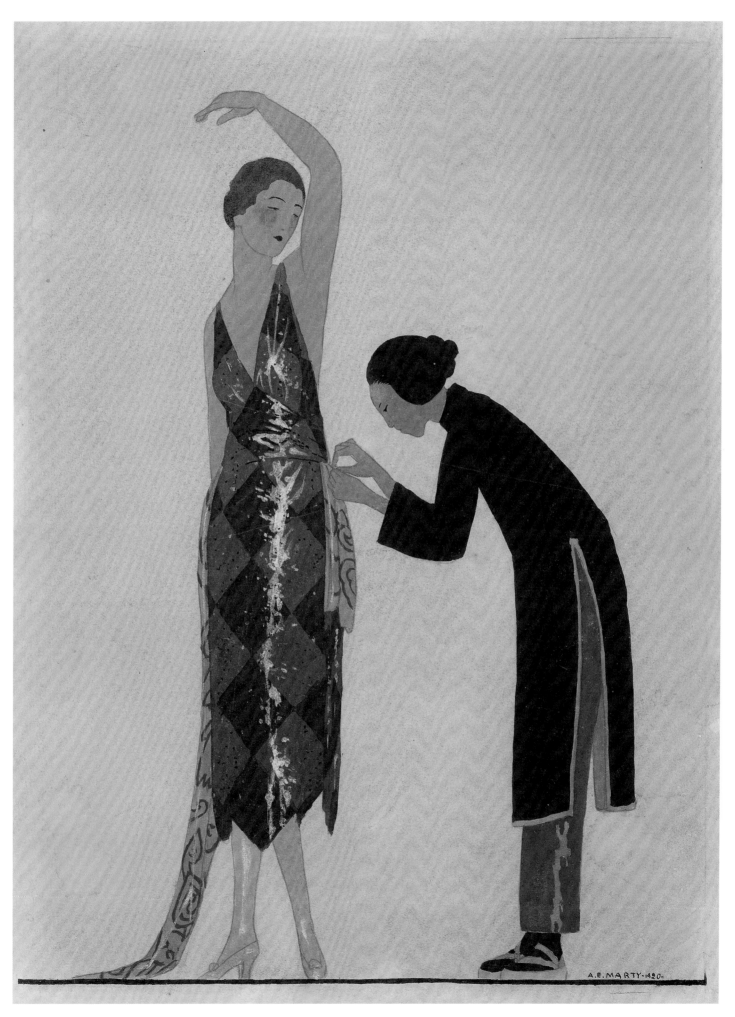

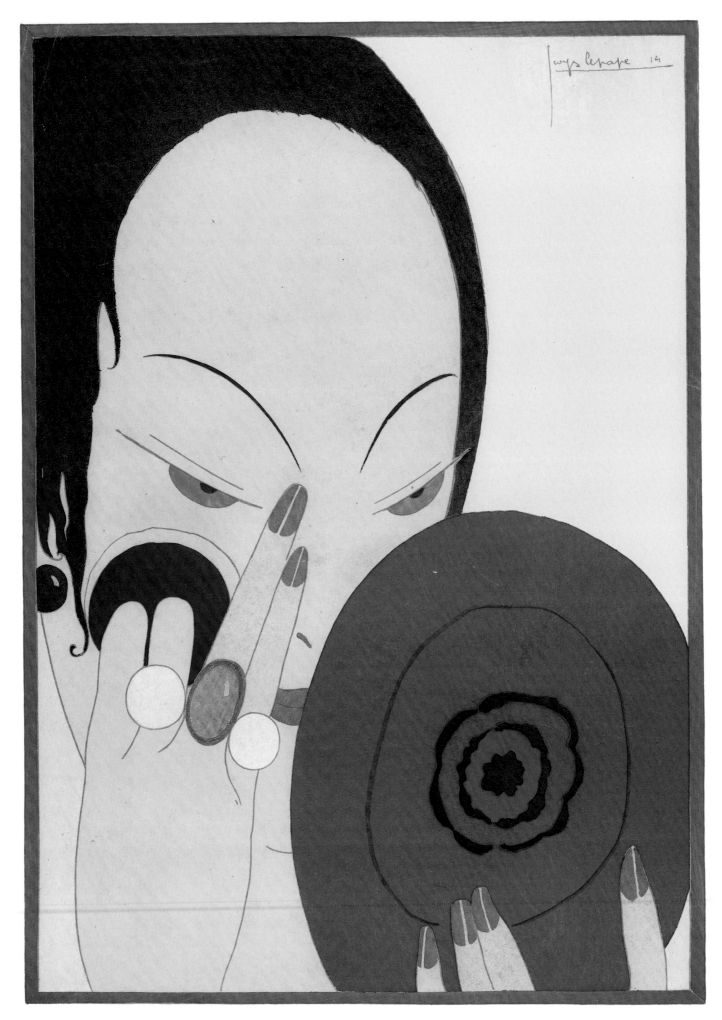

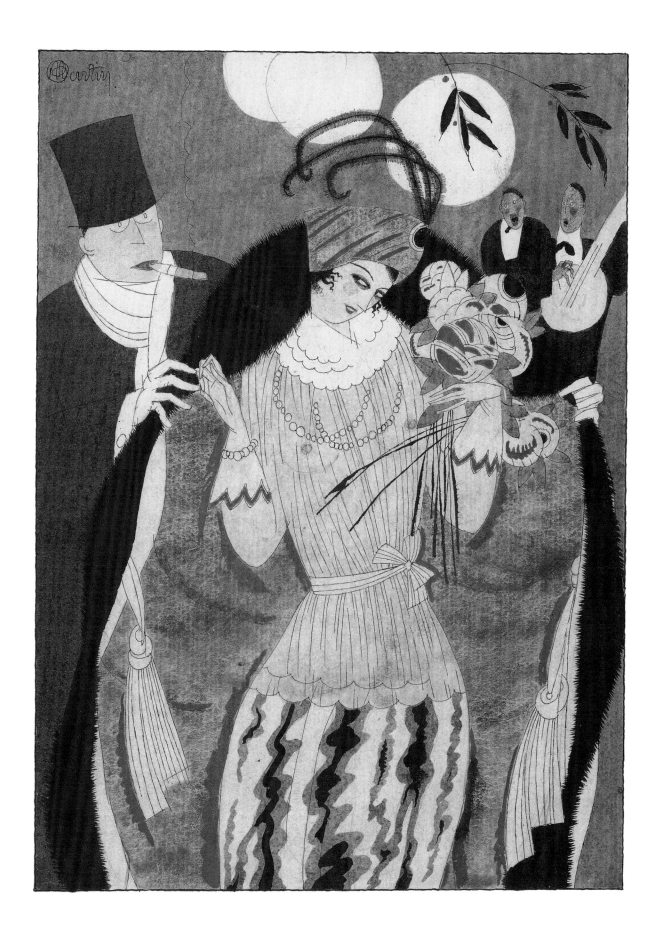

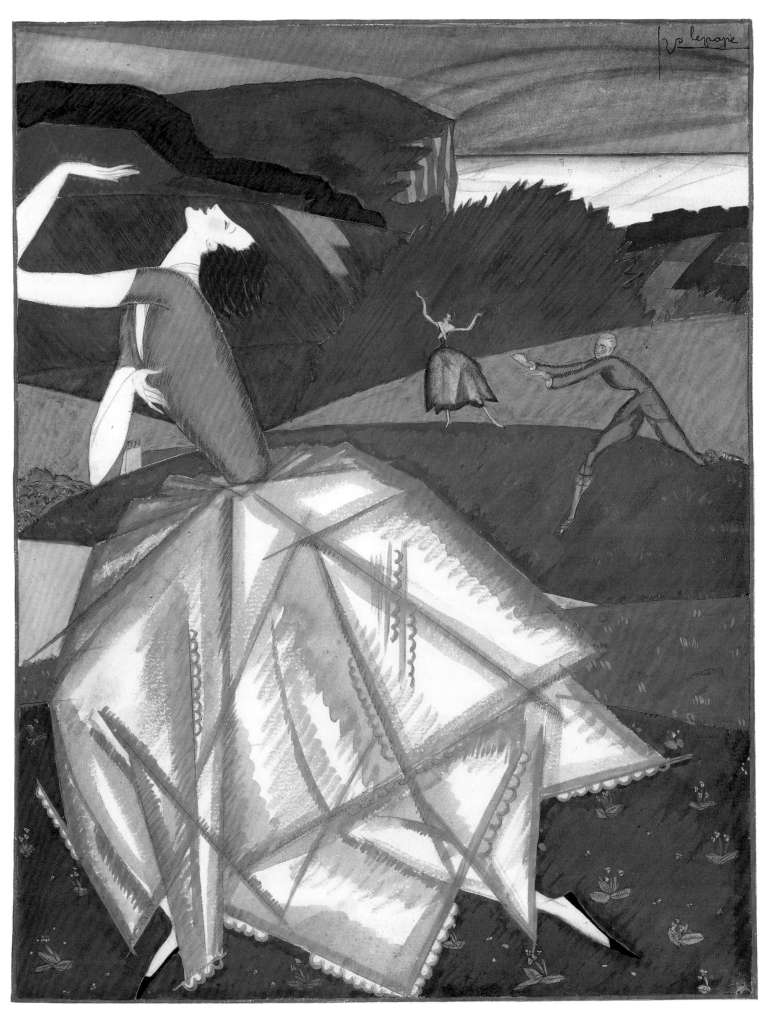

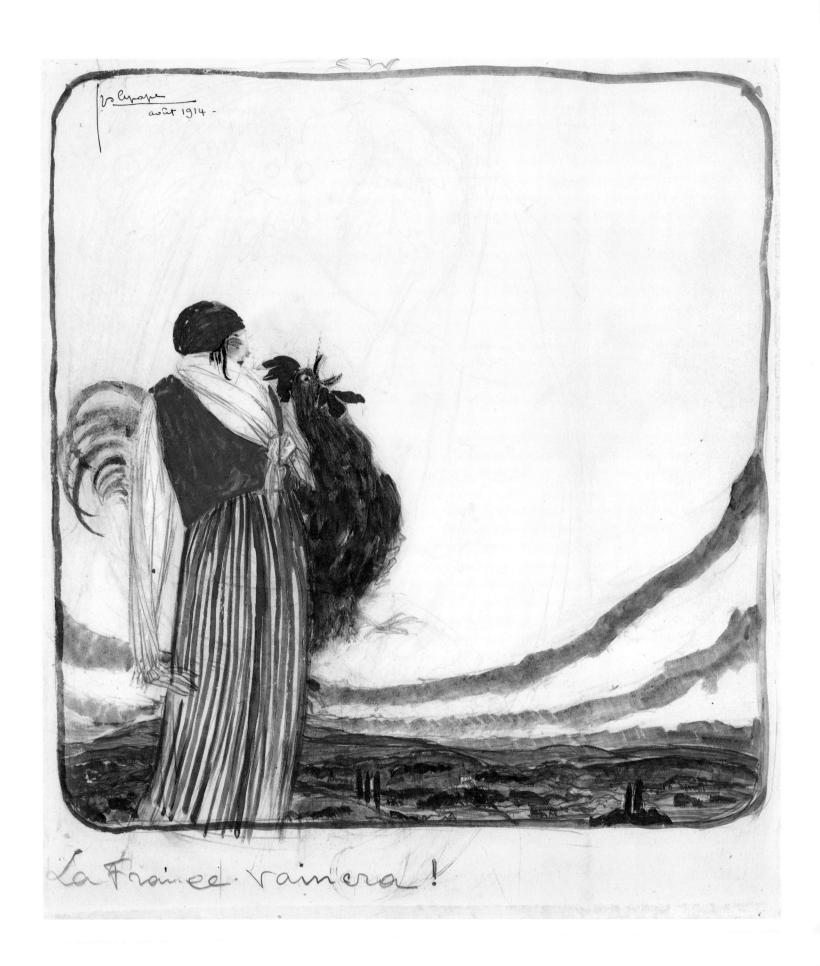

La France vaincra !

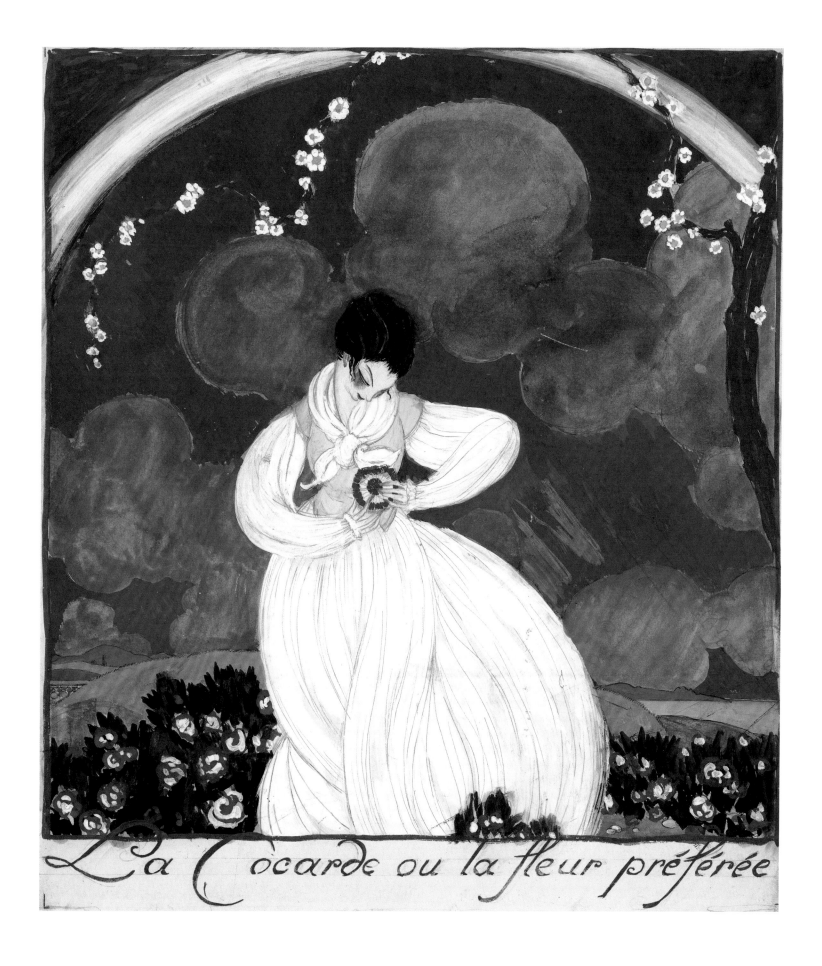

La Cocarde ou la fleur préférée

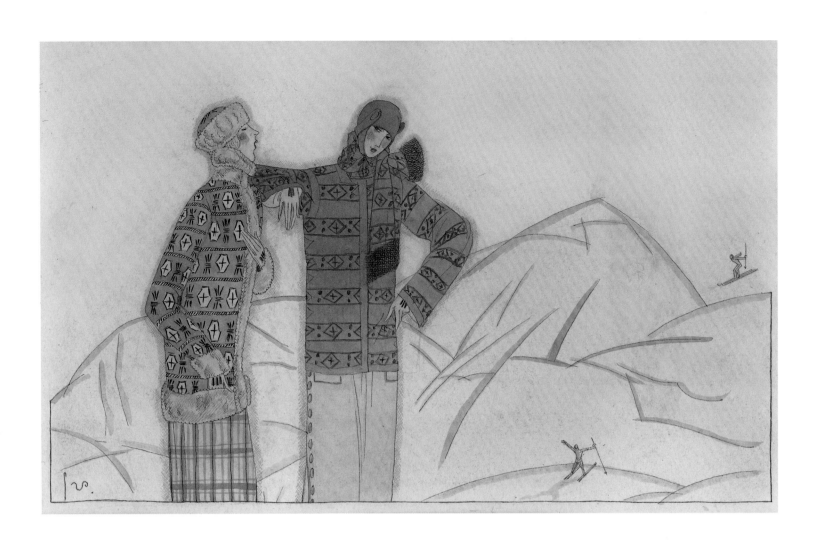

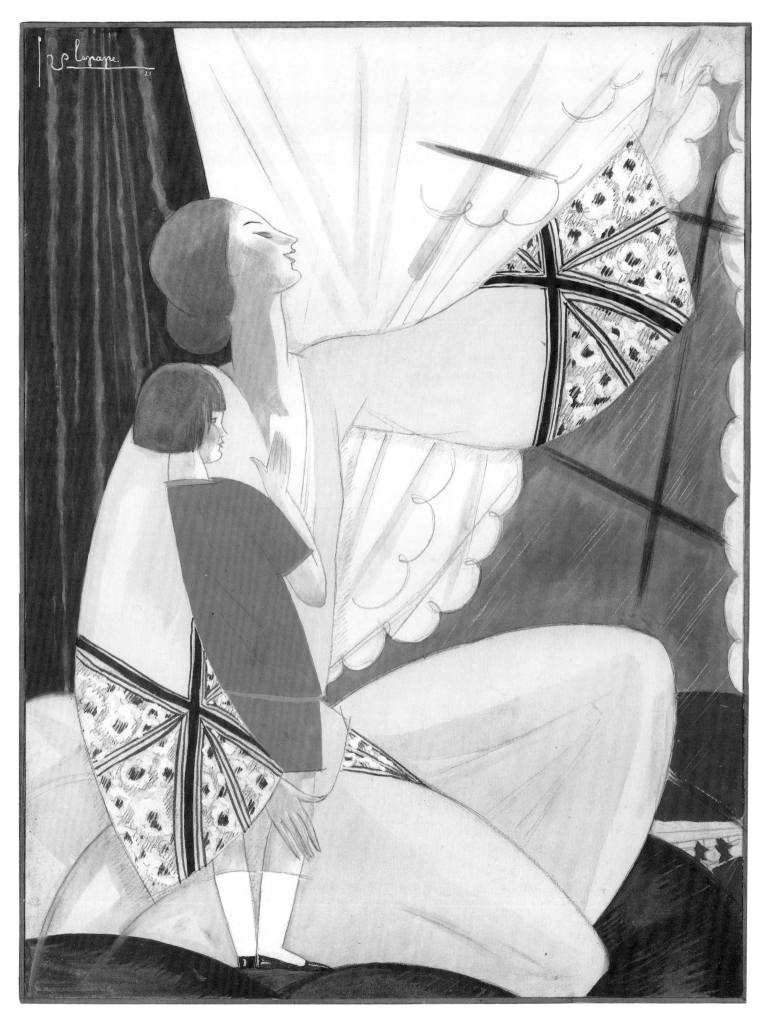

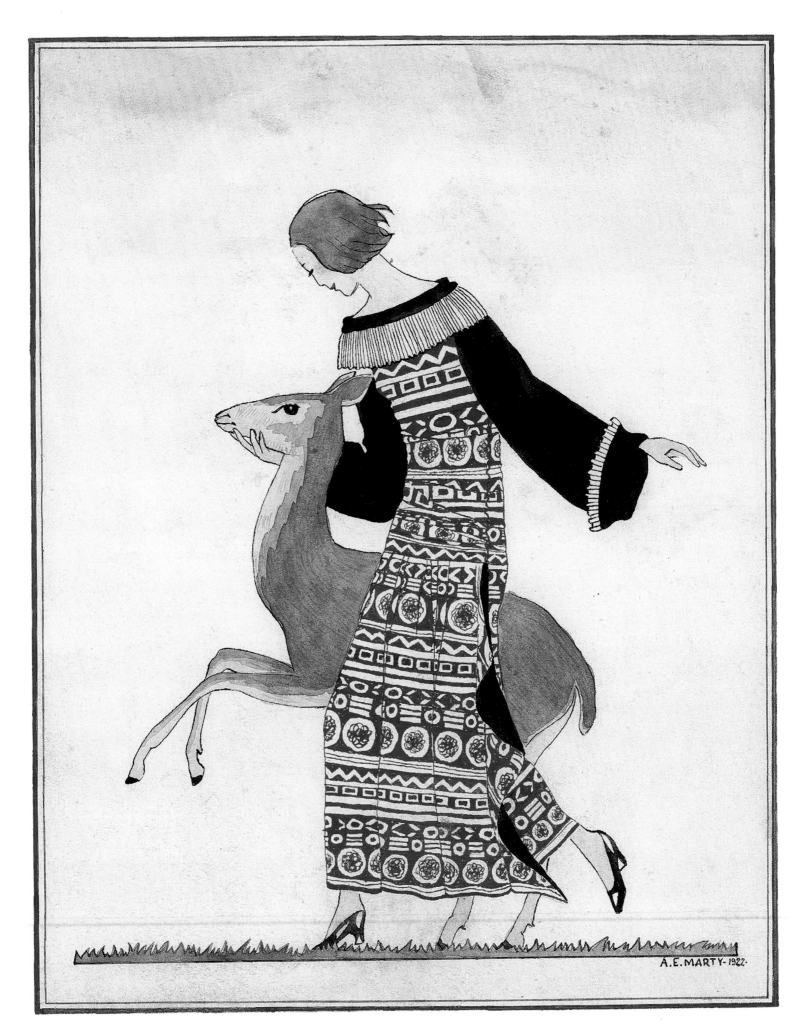

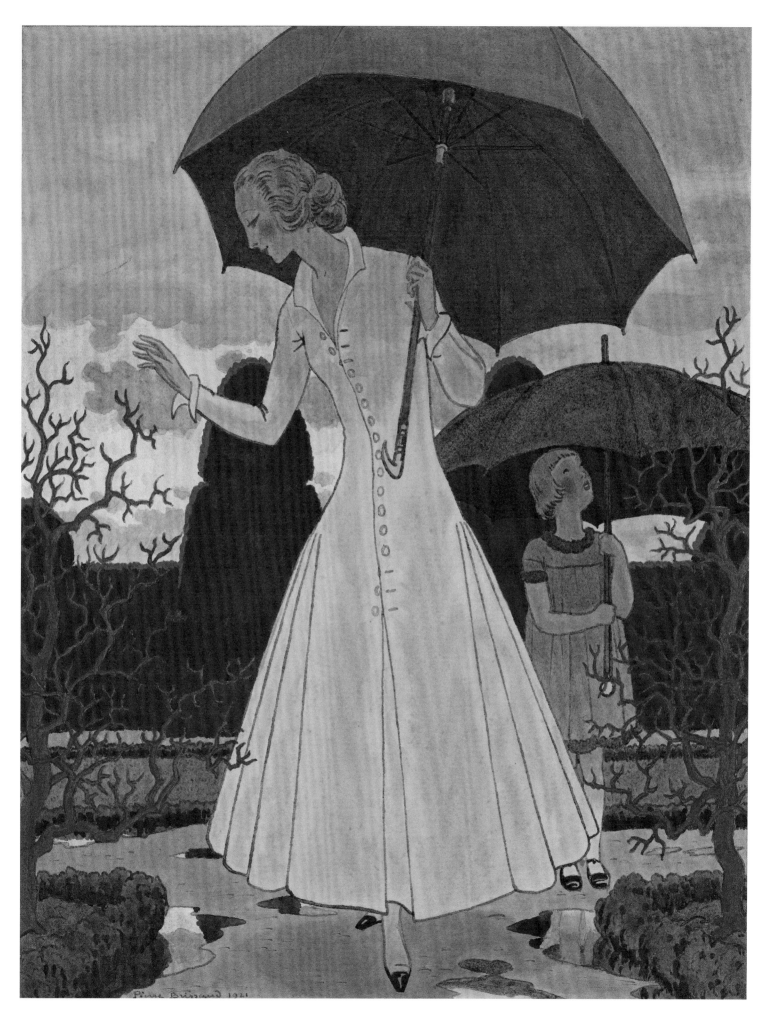

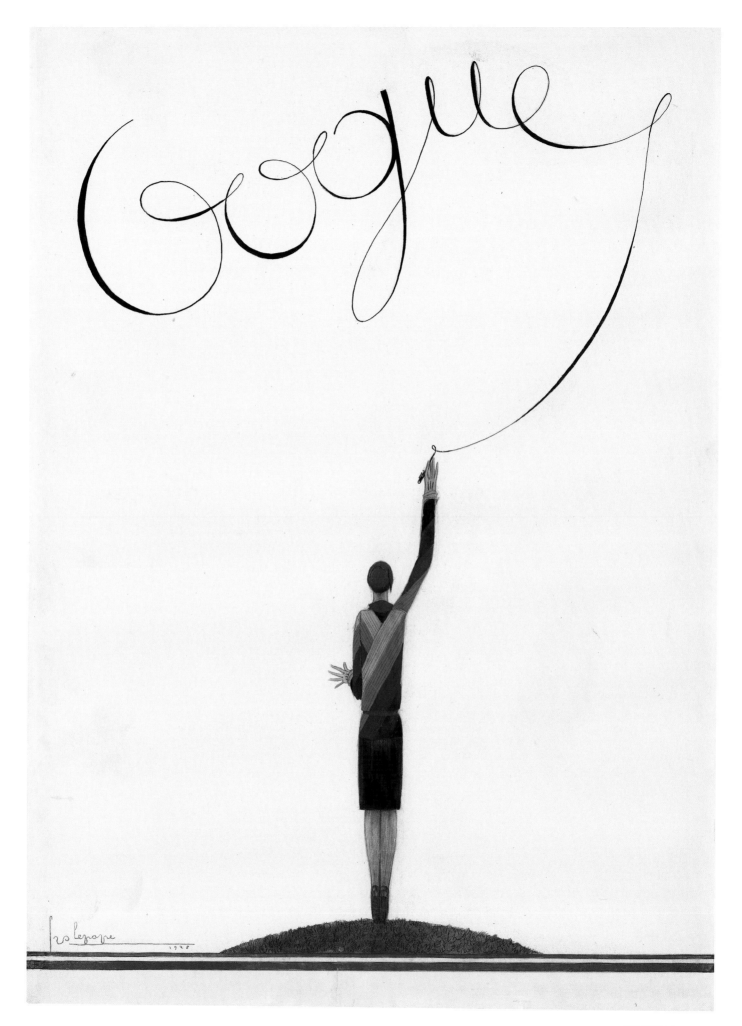

THE THIRTIES & FORTIES

CHRISTIAN BÉRARD REMAINS THE GREAT MAN WHO AFFIRMED SO STRONGLY
THAT EACH ART FORM HAD AS MUCH VALUE AS ANY OTHER. HIS VERSATILE
GENIUS ENABLED HIM ... TO SKETCH CLOTHES THAT CONVEYED THE ATTITUDES
OF CONTEMPORARY WOMEN, REVEALING BY SUCCESSIVE STROKES SOME
HIDDEN ASPECTS OF THEIR DAILY LIVES; OR, ON THE CONTRARY, TO SUGGEST
BY SUBTLETY THAT THE STYLES OF TODAY OWE SOMETHING TO HISTORY;
TO CREATE THUS A DOCUMENT OF FASHION SURPASSING ANYTHING WHICH
HAD EXISTED PREVIOUSLY; TO MAKE THIS RECORD RECOGNISABLE AT FIRST
GLANCE, CHARACTERISED – IN THE WORDS OF JEAN COCTEAU – BY AN
"ABSOLUTE ABSENCE OF VULGARITY "; TO KNOW HOW TO EVINCE THE SPIRIT
OF FORMS AND THEIR LOGIC.
— *Edmonde Charles-Roux*

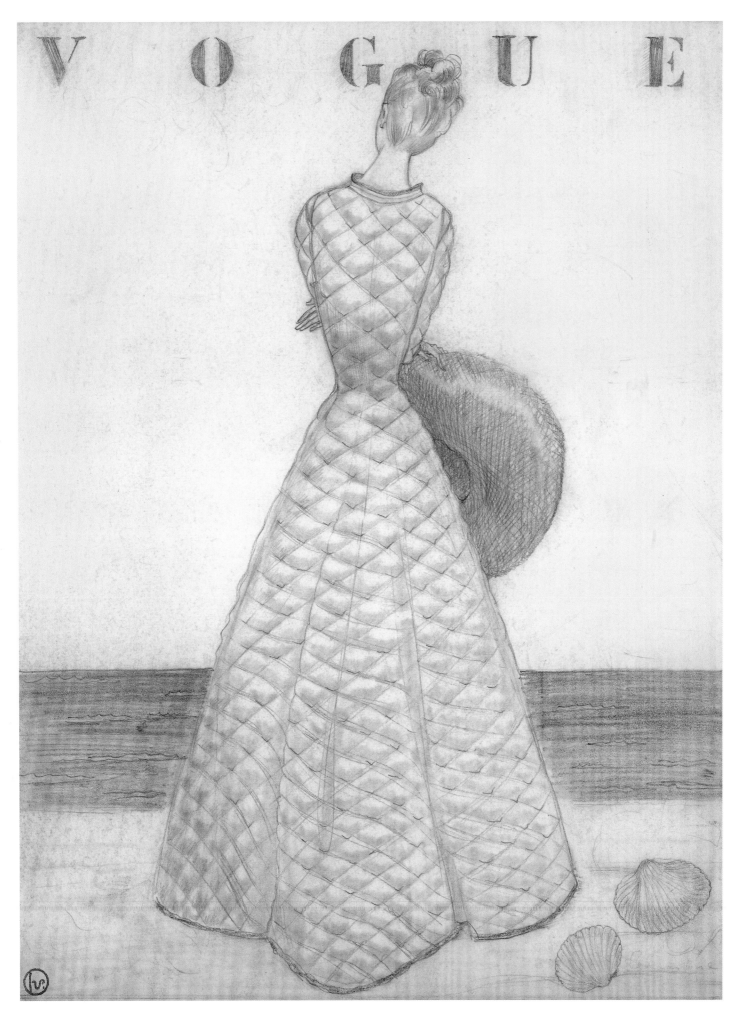

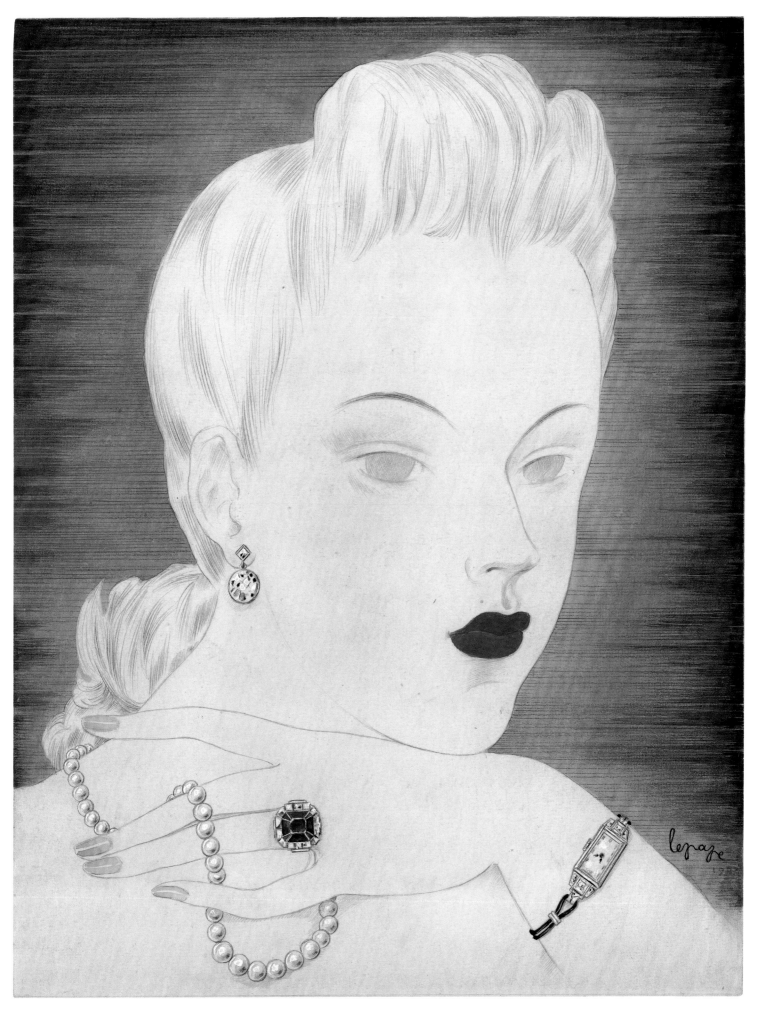

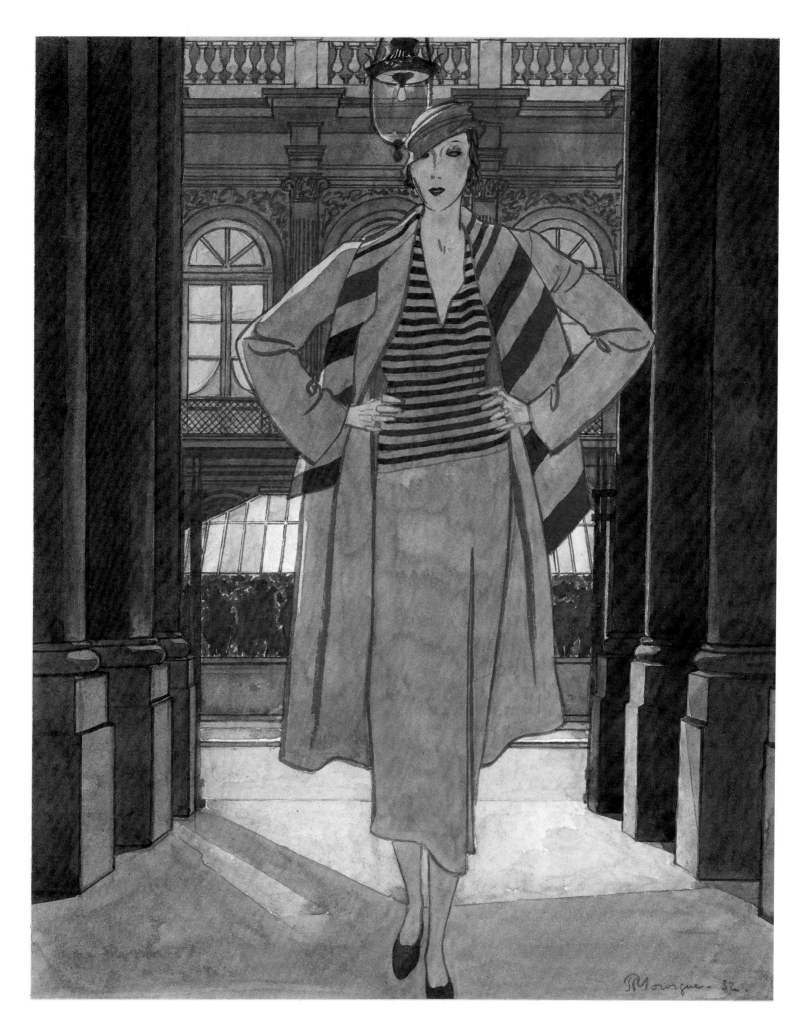

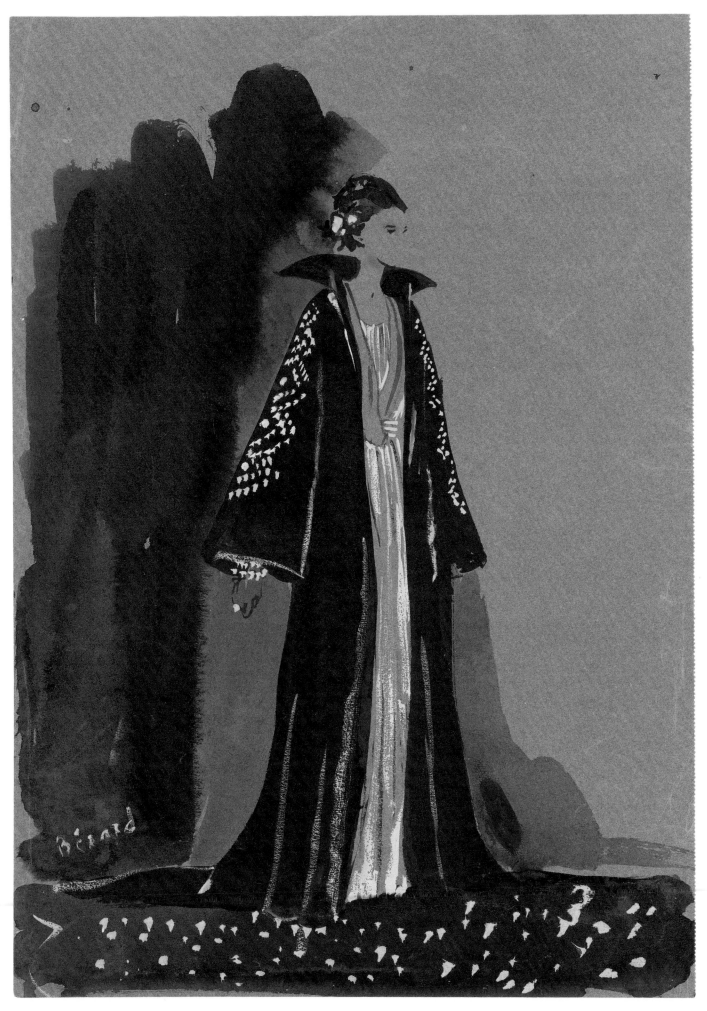

64 (*left and right*) CHRISTIAN BÉRARD

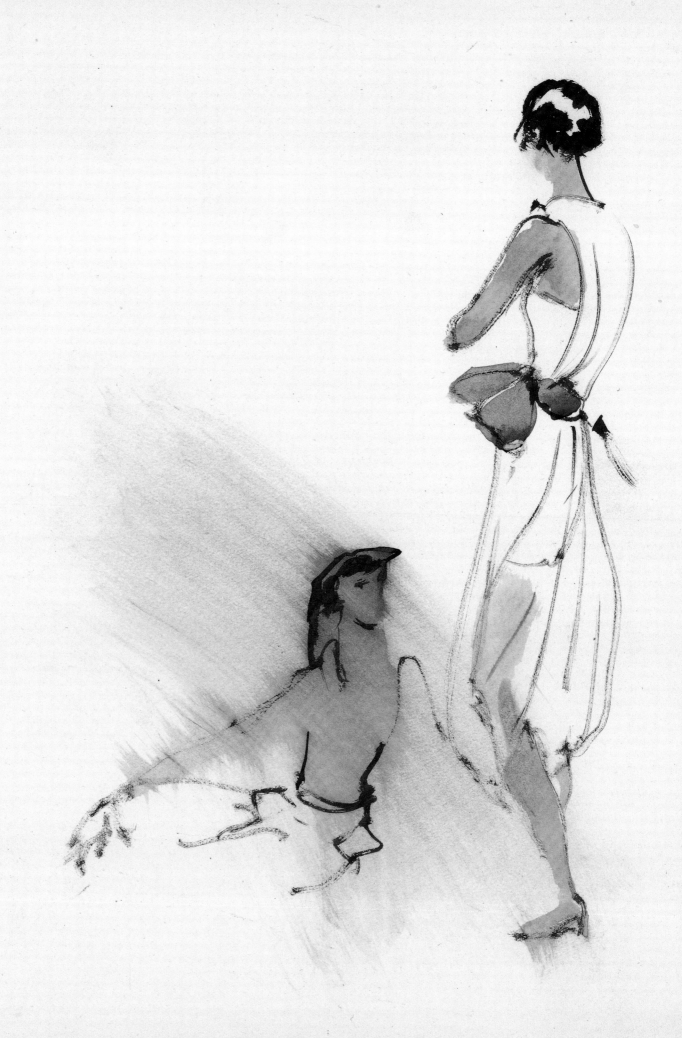

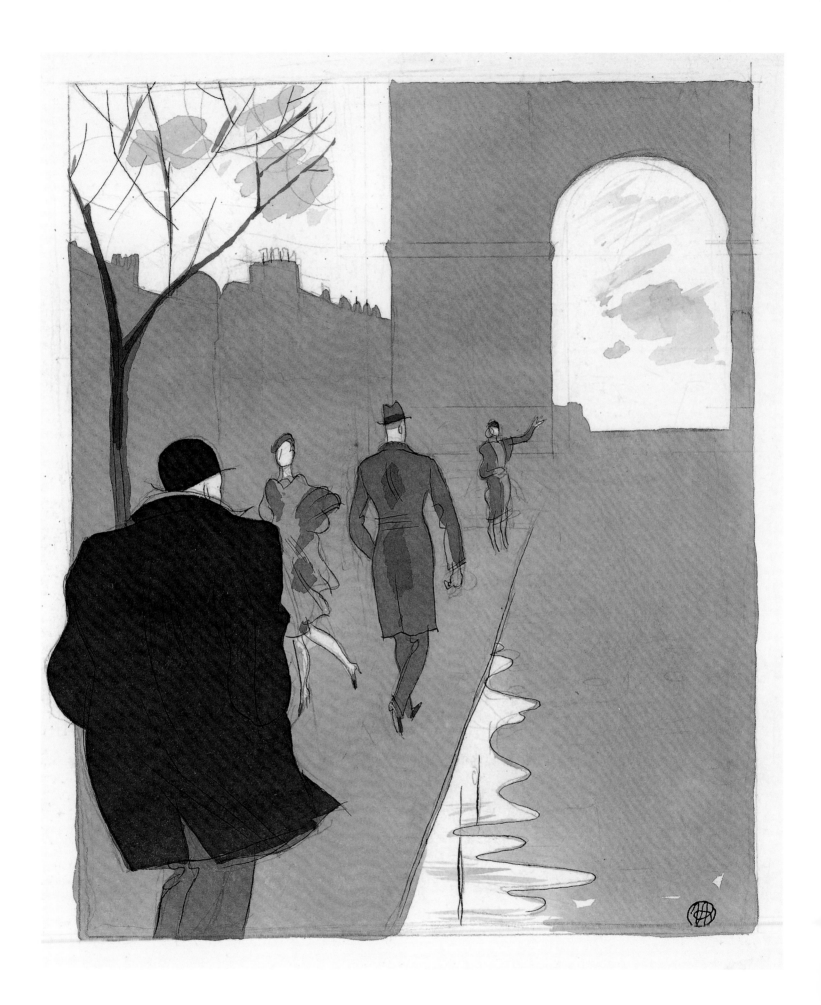

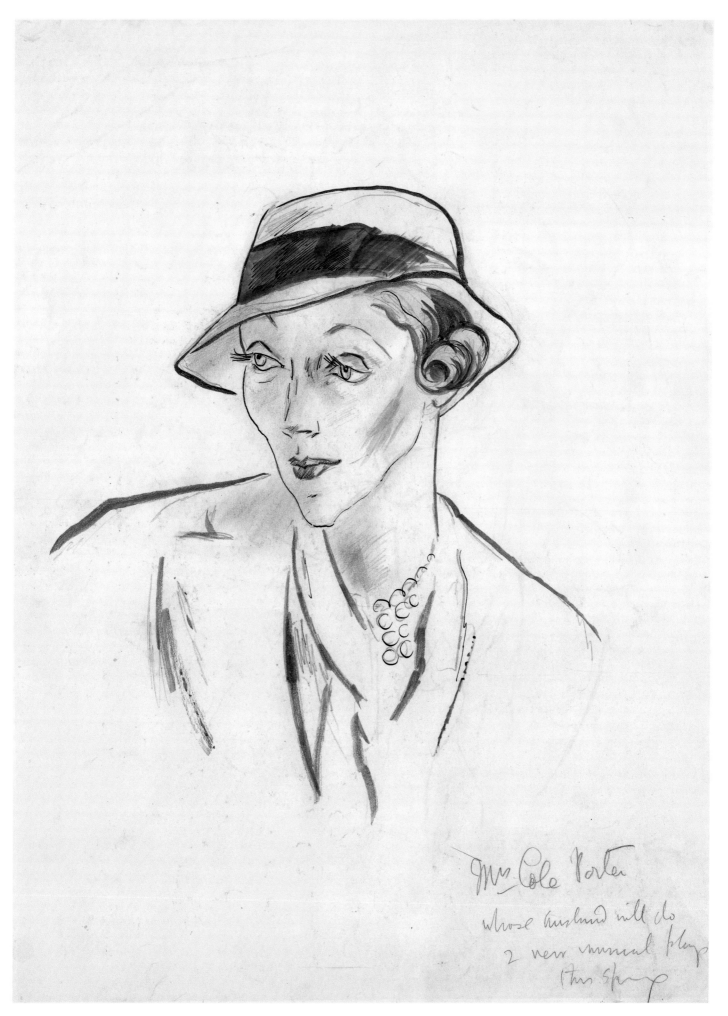

Mrs Cole Porter
whose husband will do
2 new musical plays
this Spring

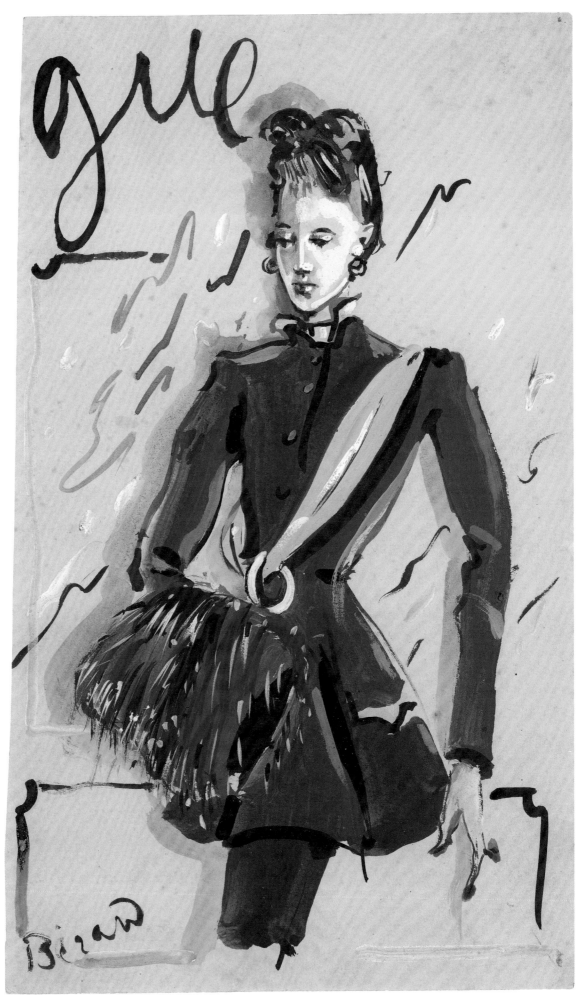

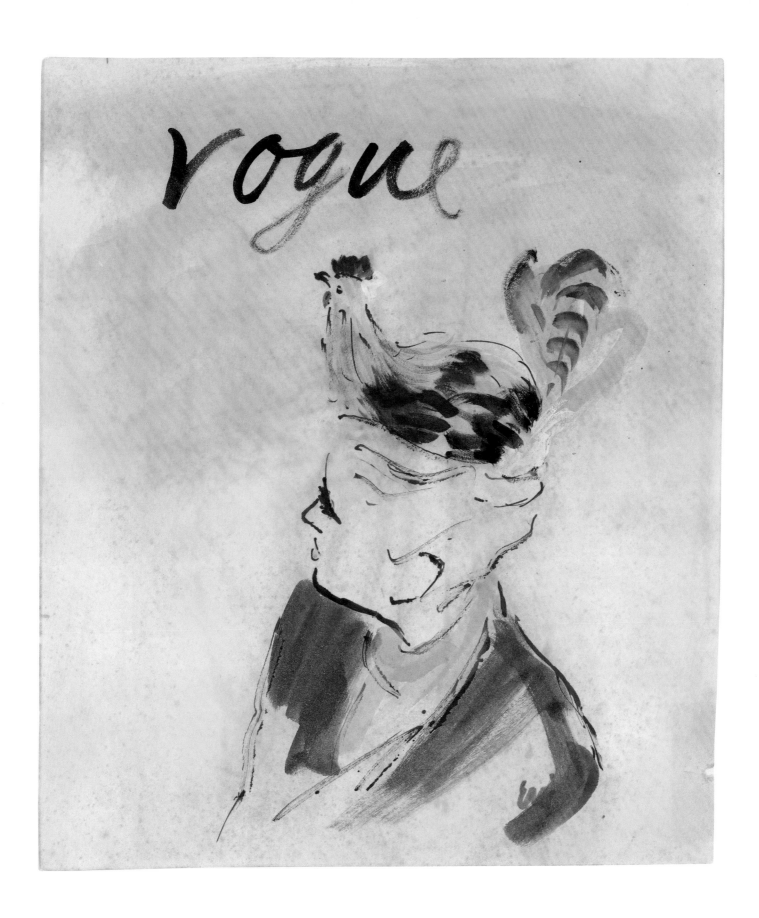

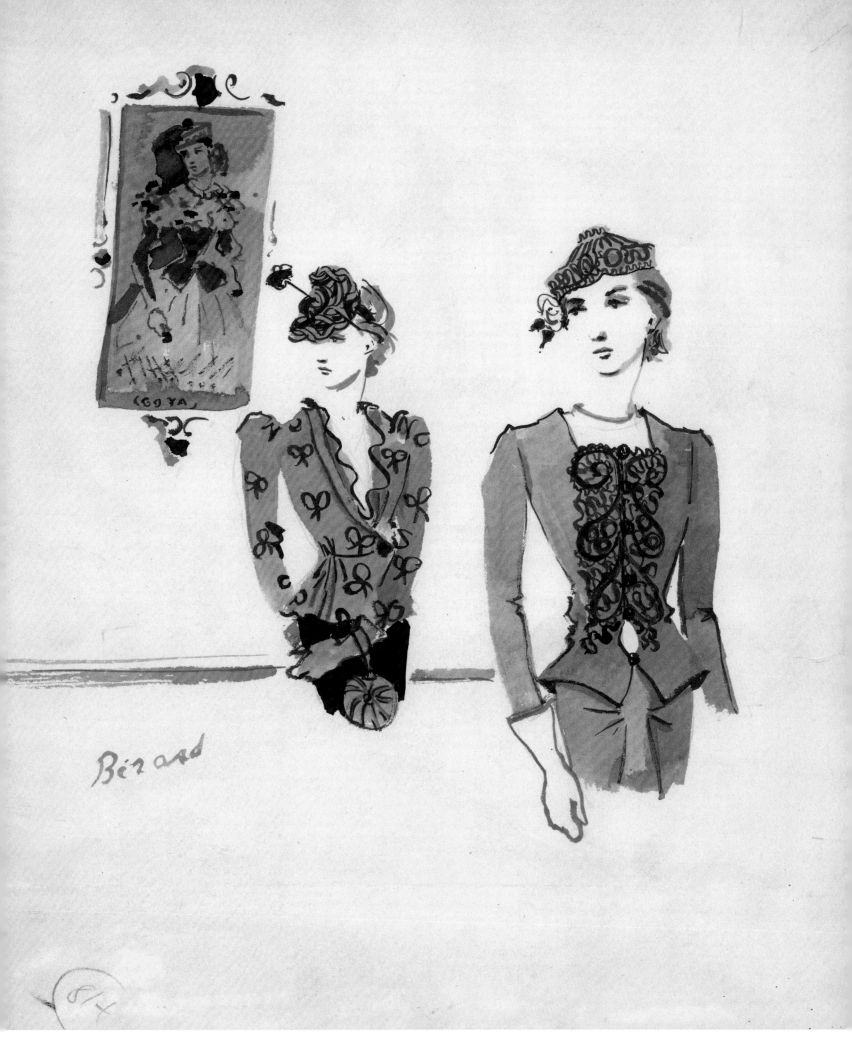

Bérard

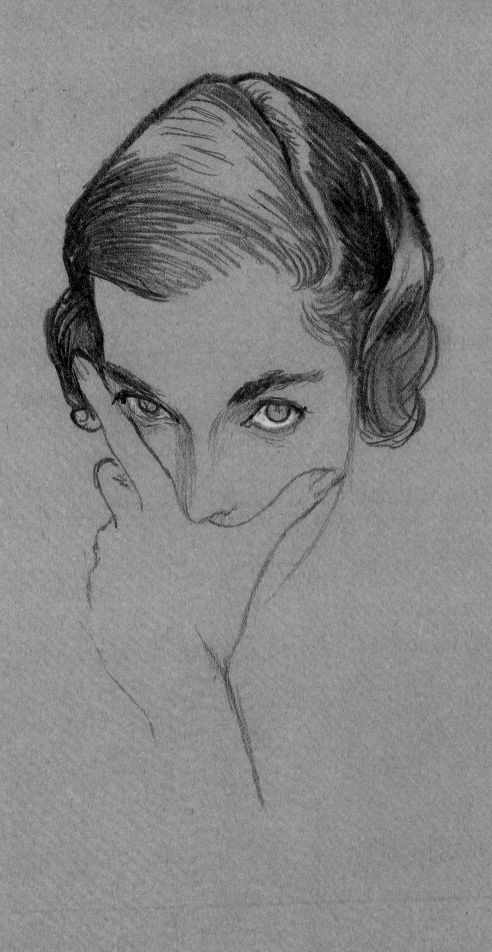

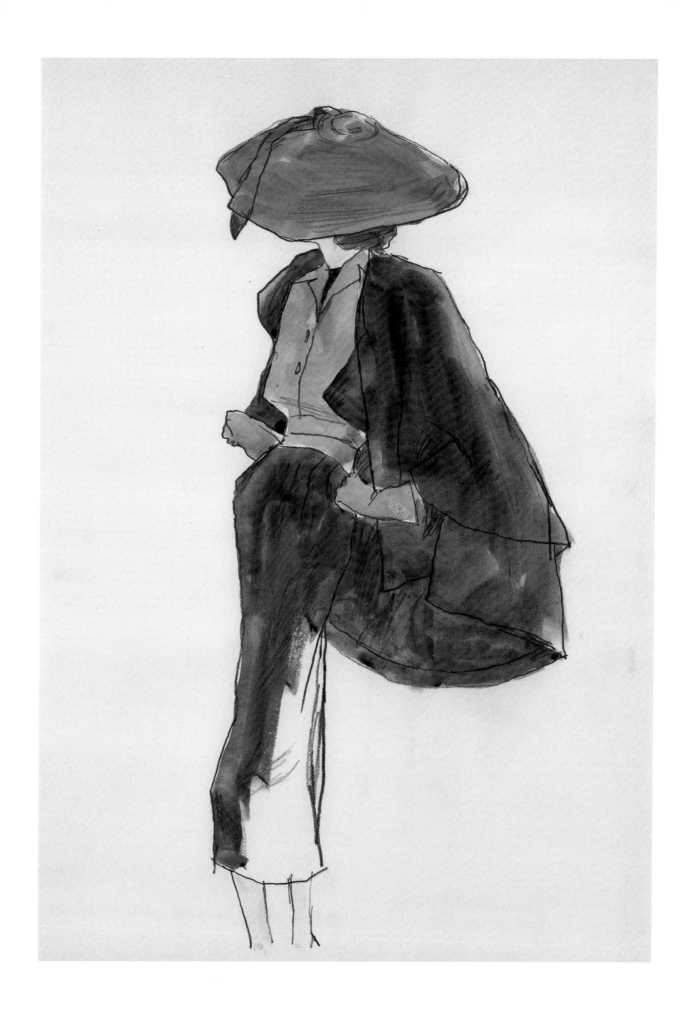

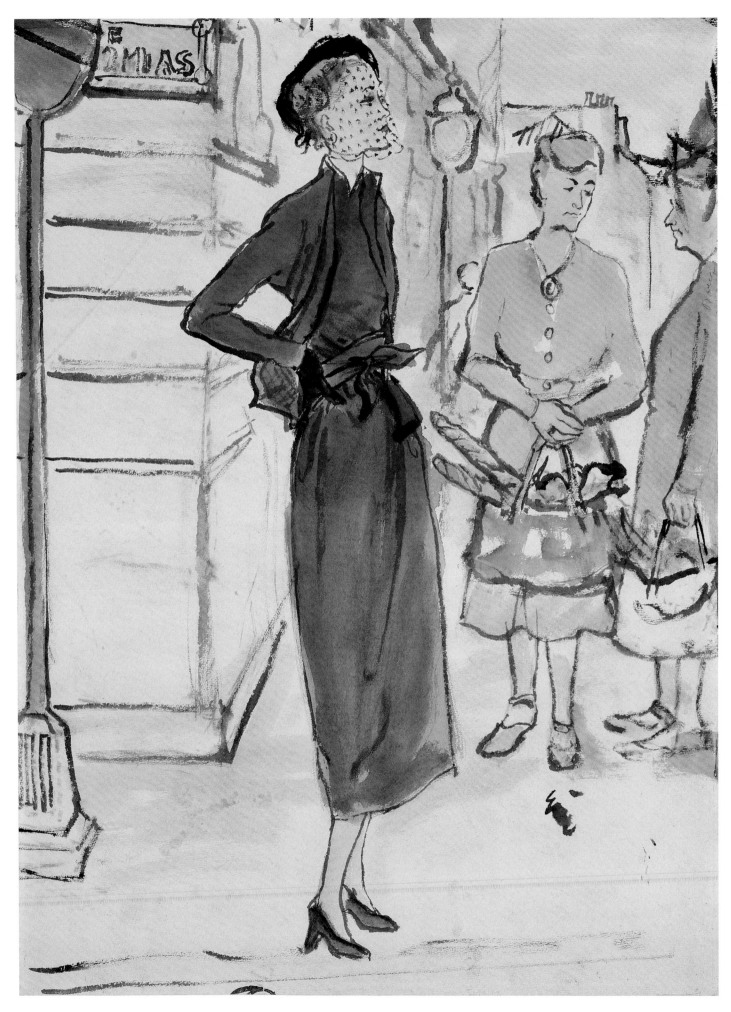

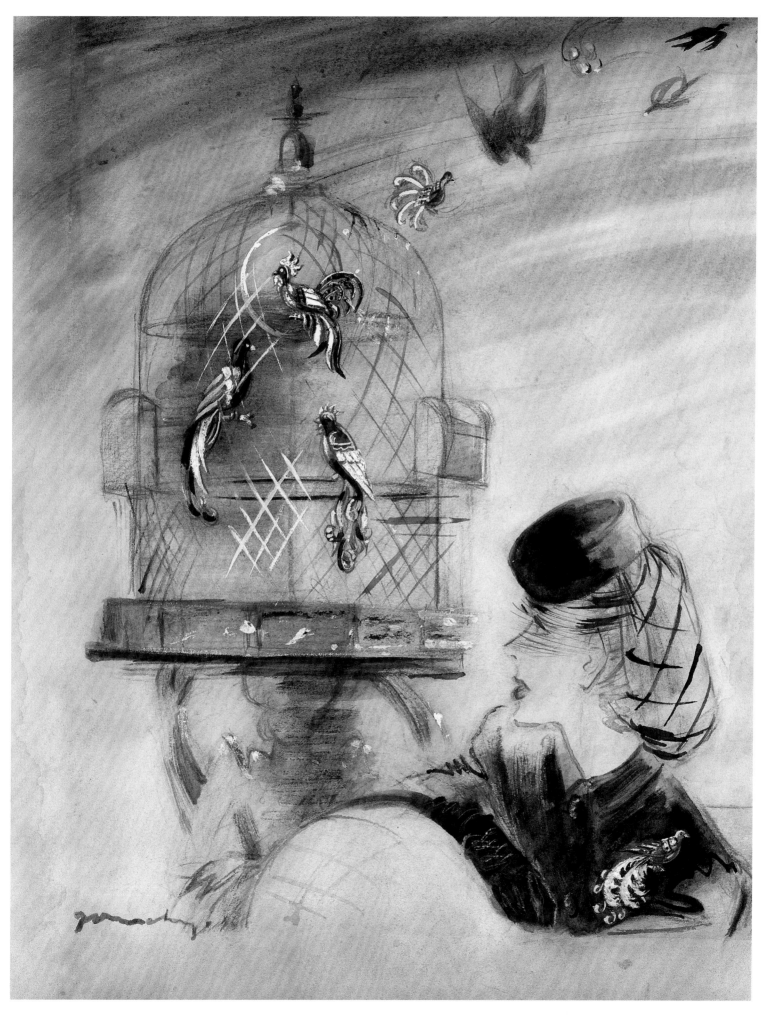

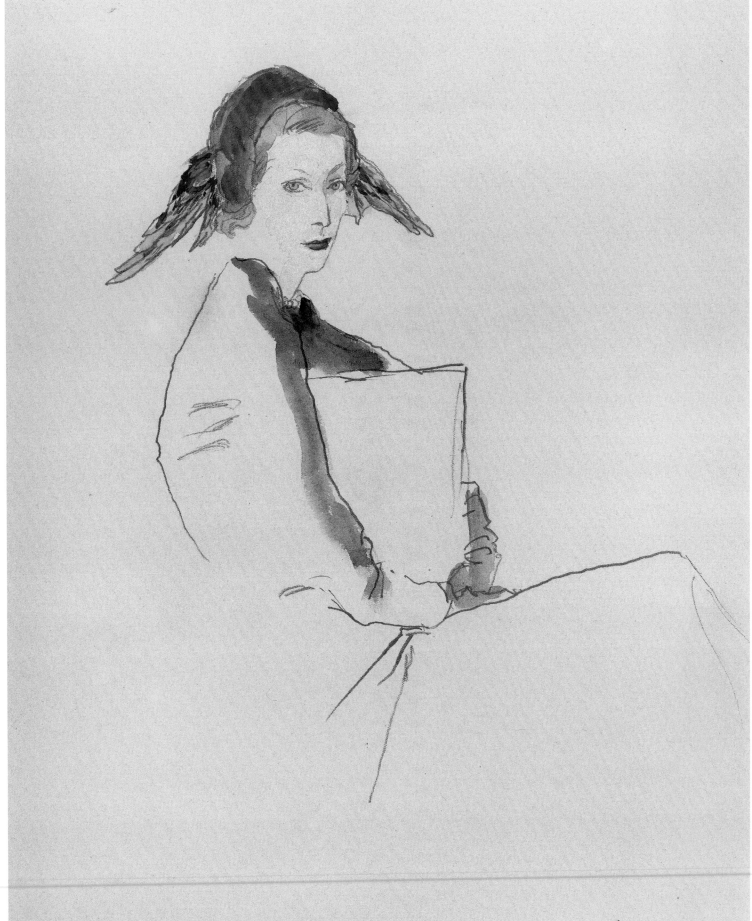

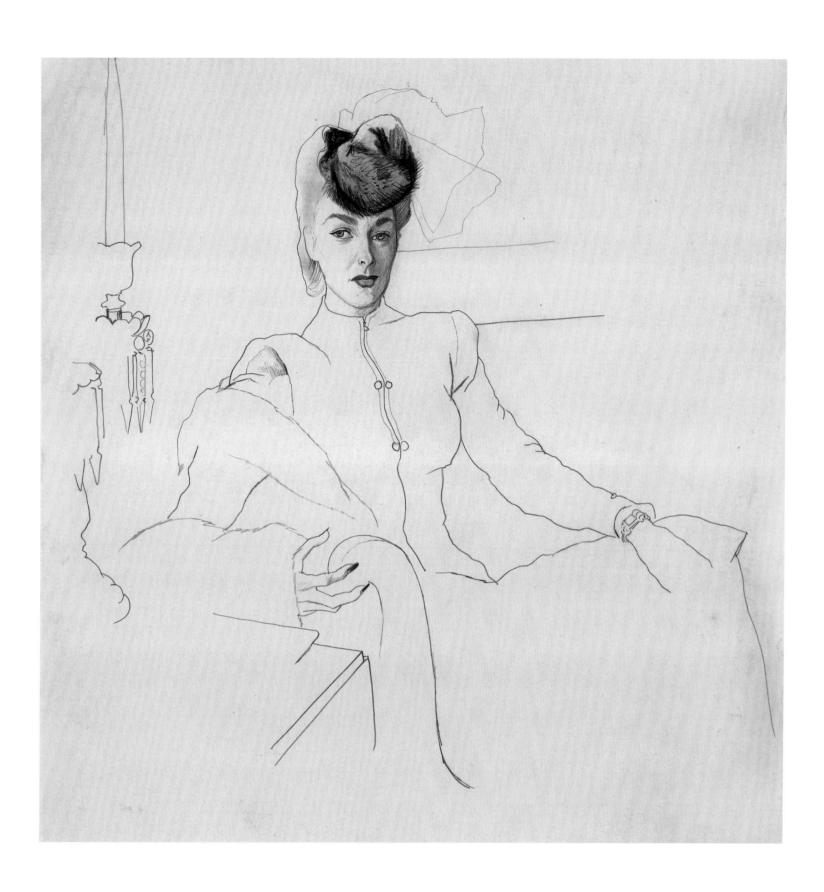

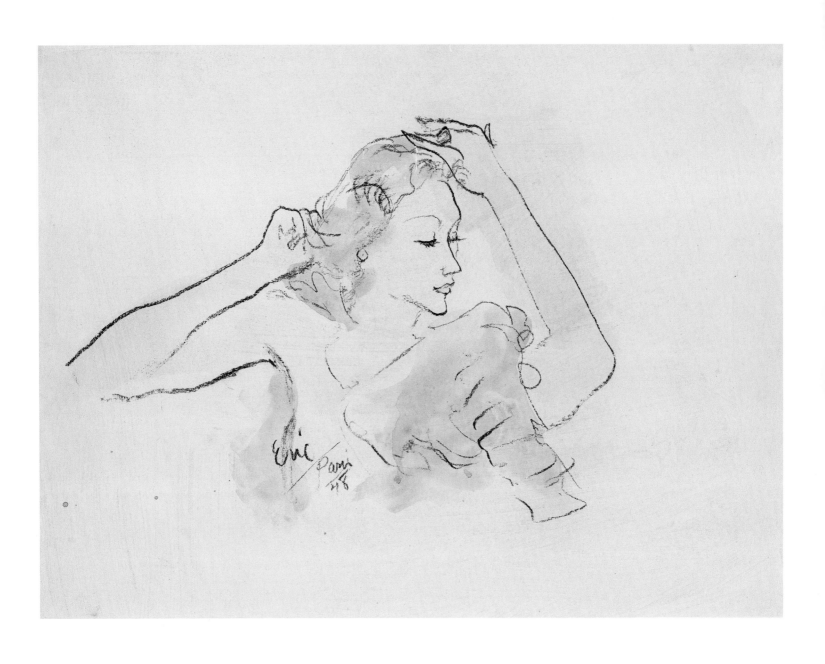

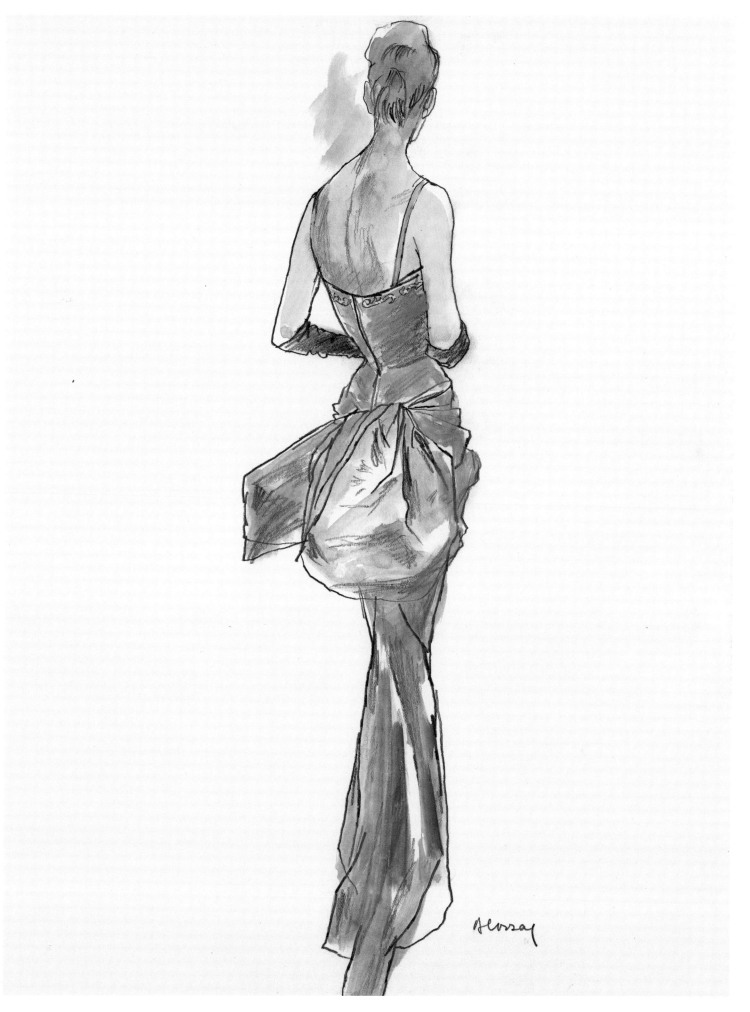

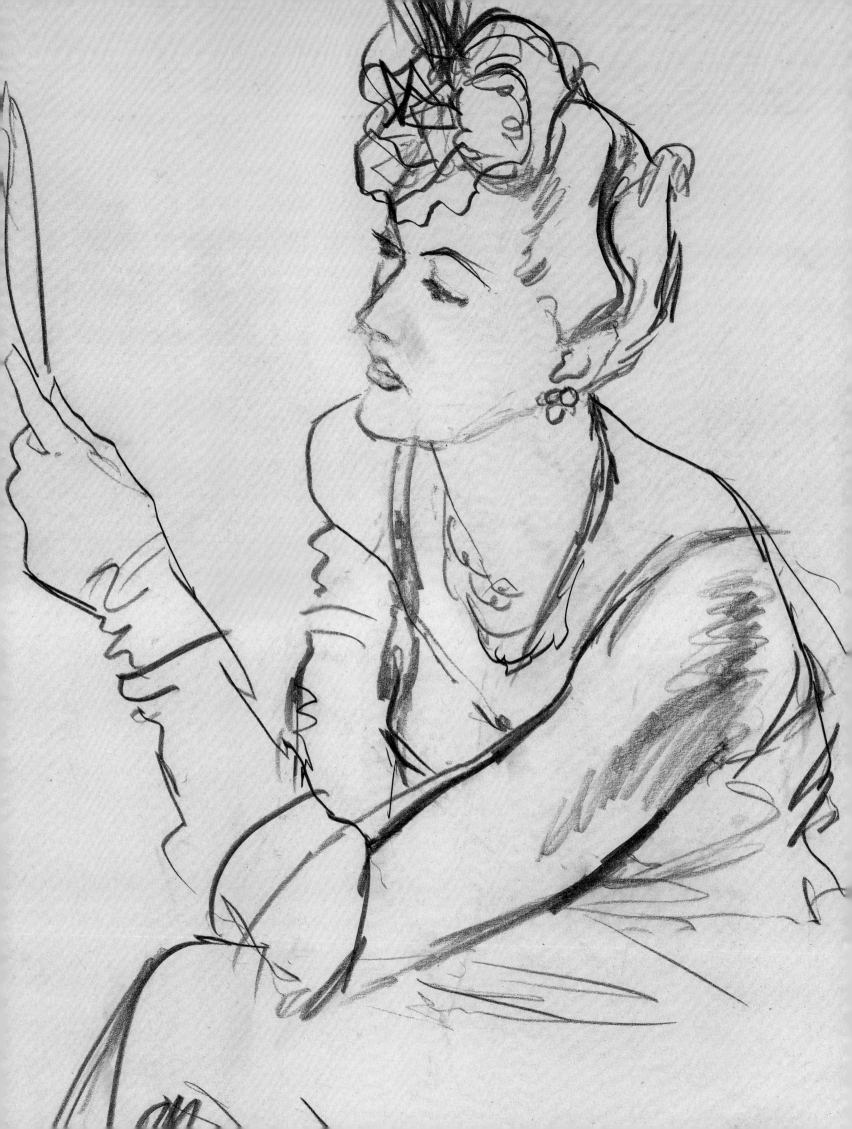

THE FORTIES
& FIFTIES

BALMAIN AND I COULD NOT FORGET THAT LELONG TAUGHT US OUR TRADE IN
THE MIDST OF THE GREATEST RESTRICTIONS. THE LIBERATION OCCURRED WHILE
WE WERE PREPARING OUR WINTER COLLECTION AGAINST ALL ODDS. A FEW WEEKS
LATER, LUCIEN LELONG'S CLEVERNESS AND HARD WORK MADE IT POSSIBLE TO
SHOW THE STUPEFIED ALLIES THAT PARISIAN FASHION WAS STILL QUITE ALIVE ...
FASHION IN THOSE DAYS WAS AS IT WAS ... SUBJECTED TO THE RULES OF
TRAVELLING IN THE METRO OR BY BICYCLE AND WALKING IN WOODEN-SOLED
SHOES ... HOW MUCH AVENGING GLEE DID I FEEL WHEN I WAS LATER ABLE TO
TAKE THE OPPOSITE COURSE!
— *Christian Dior, 1956*

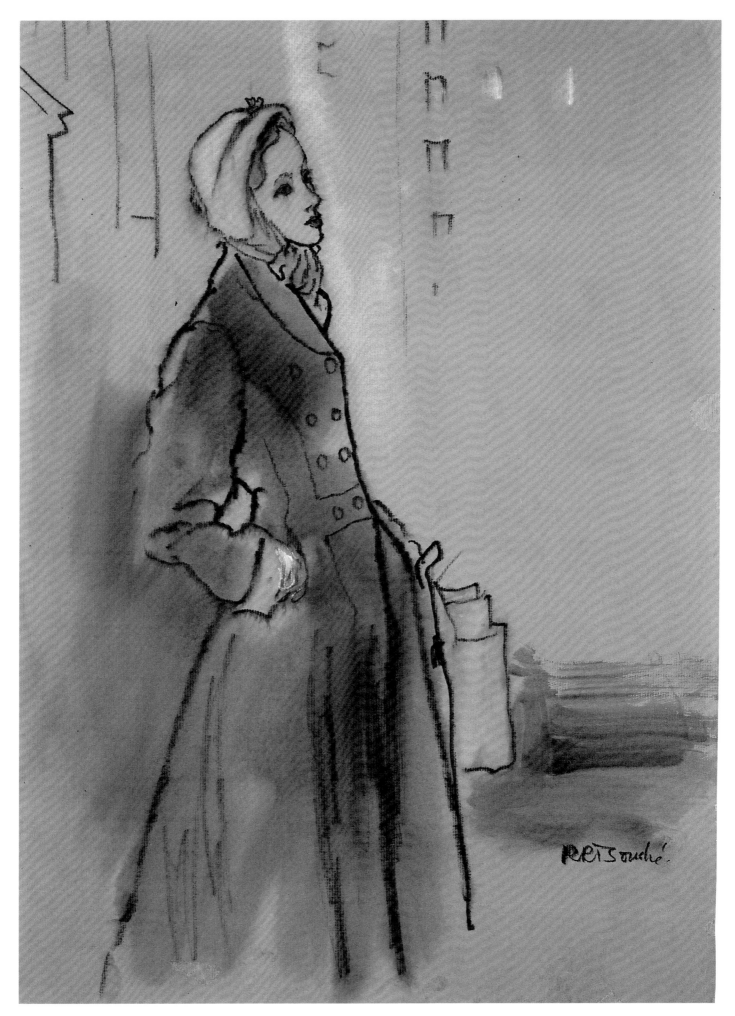

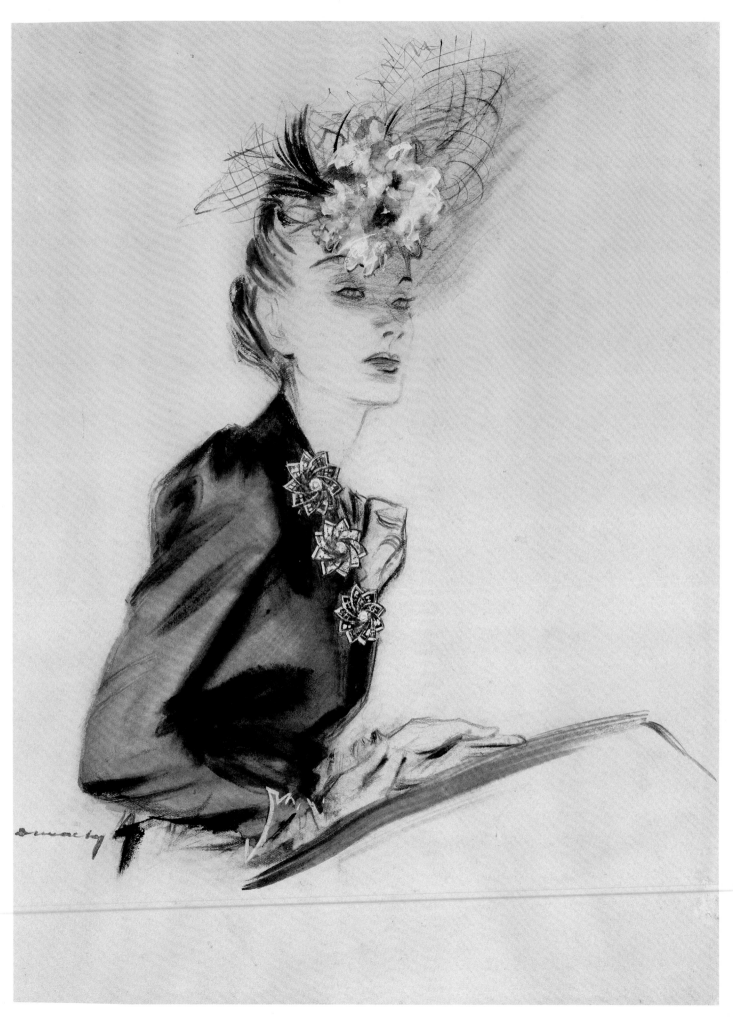

86 (*left*) JACQUES DEMACHY, (*right*) ERIC

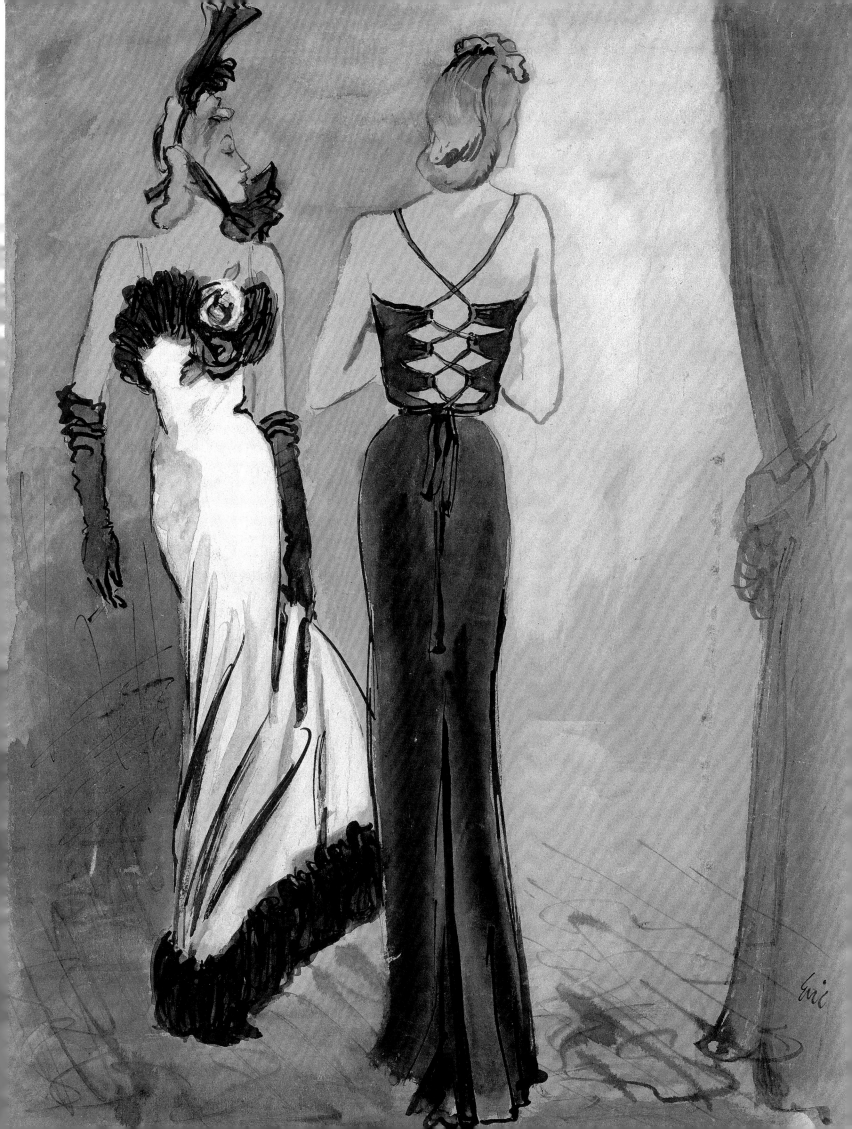

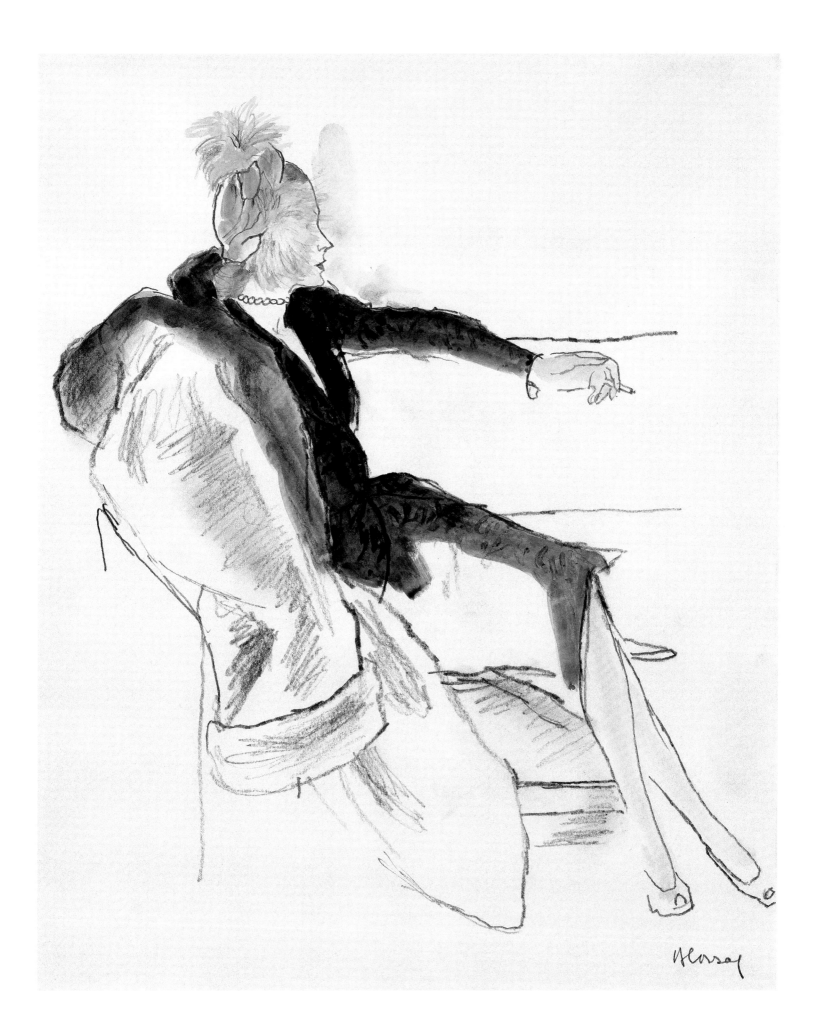

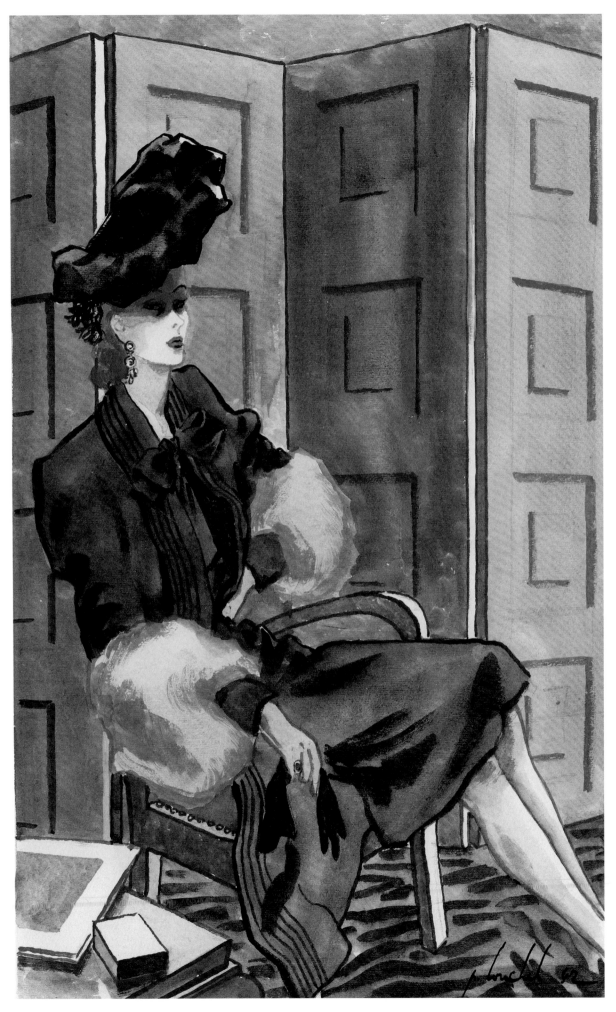

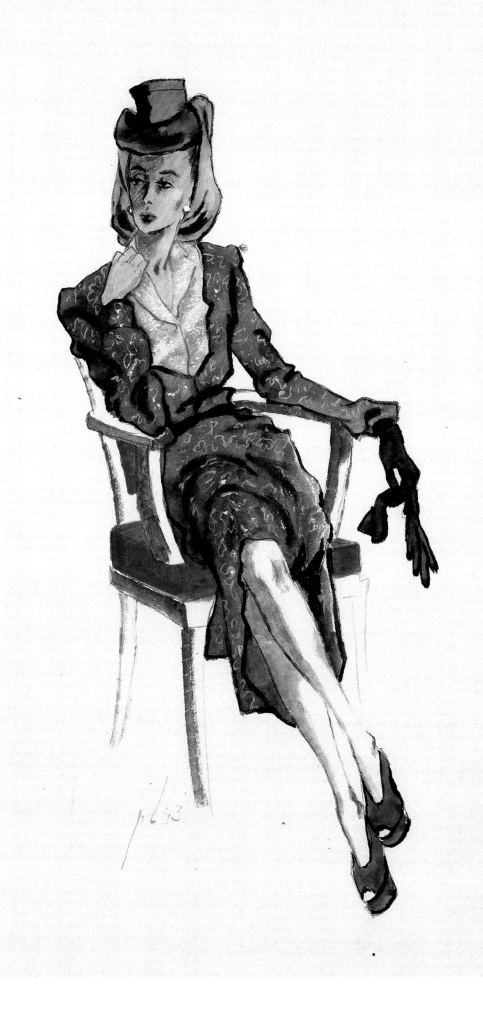

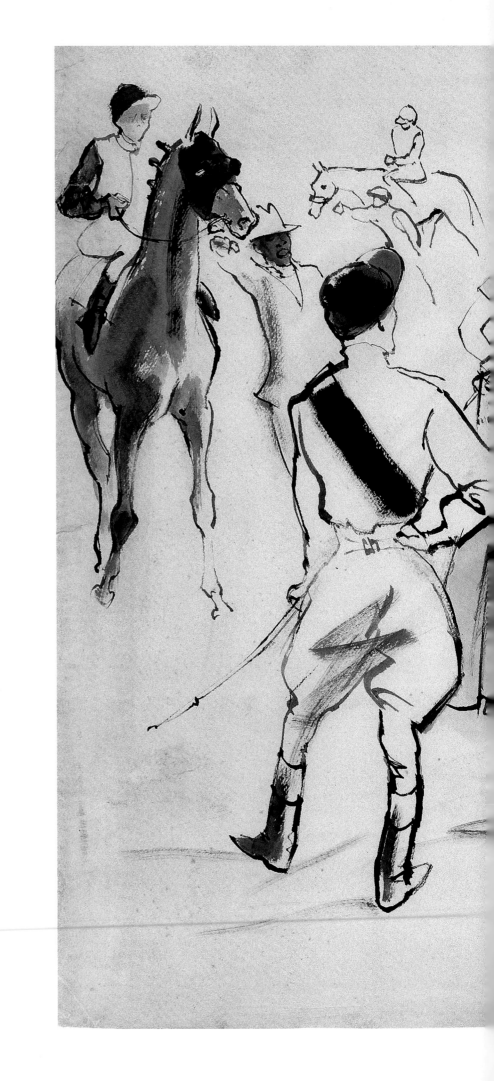

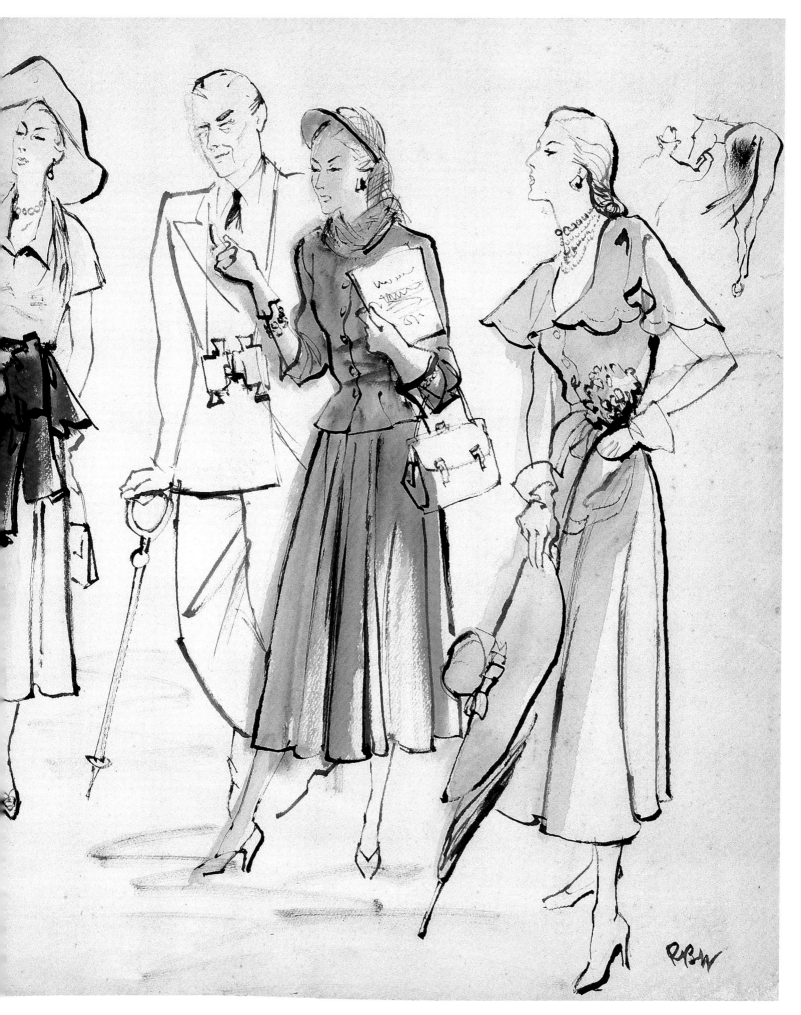

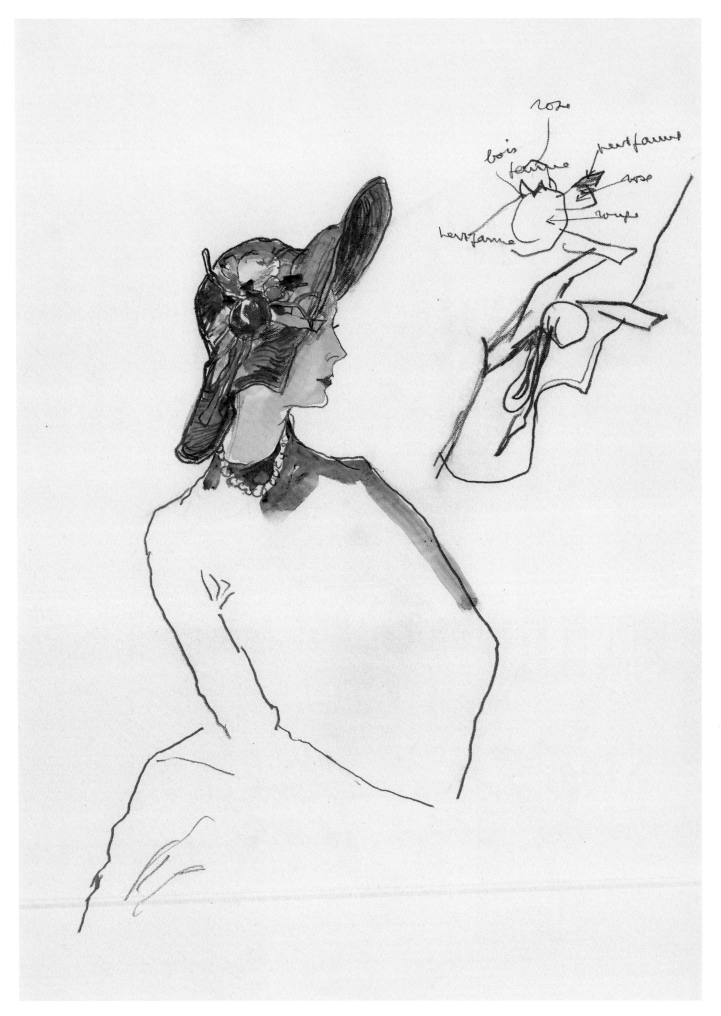

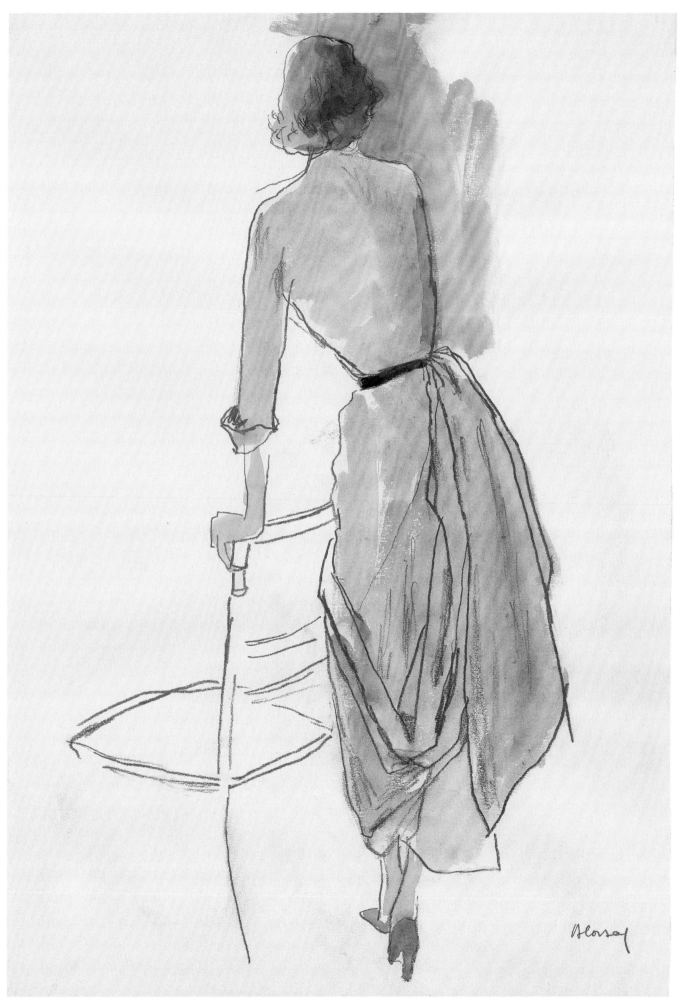

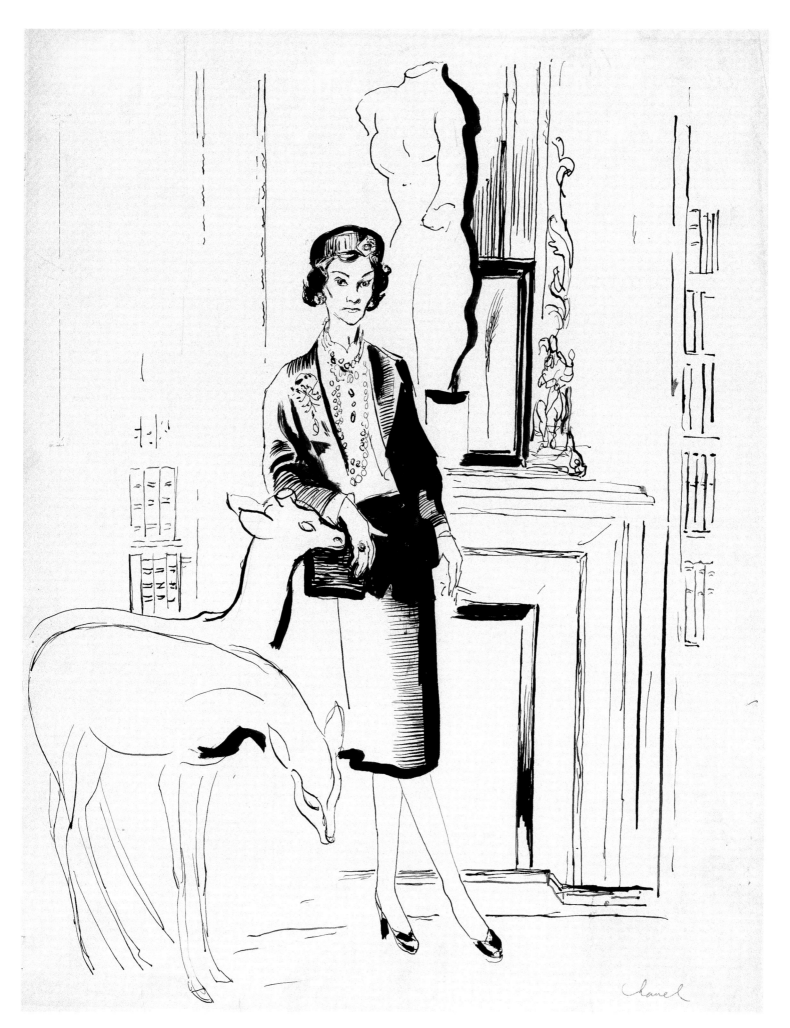

Chanel

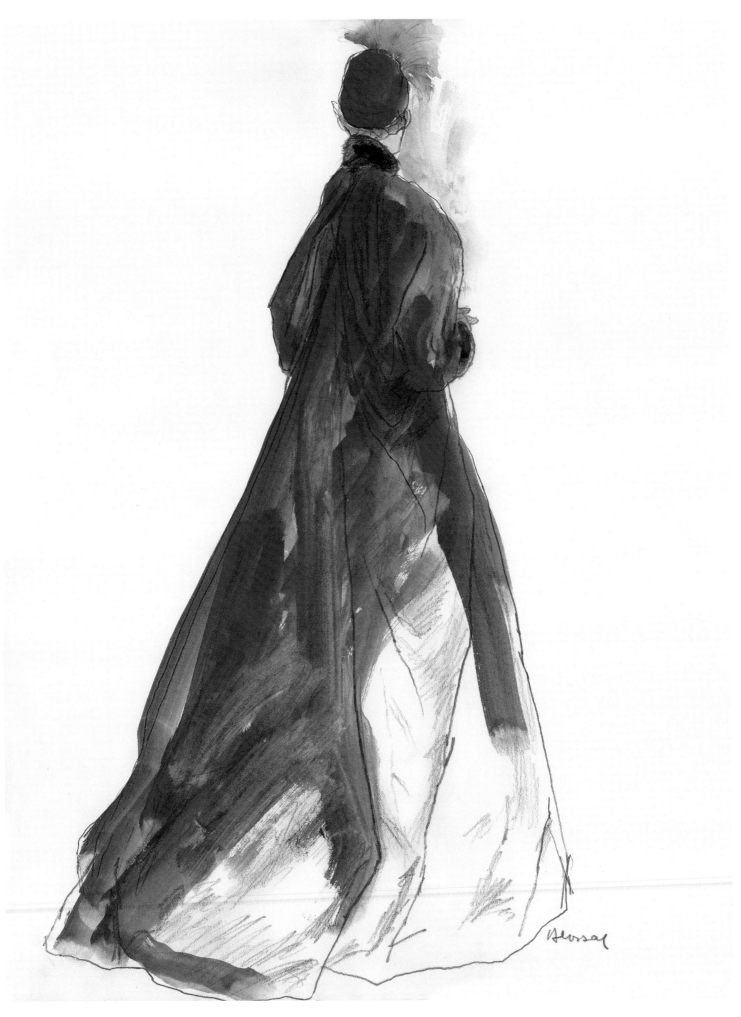

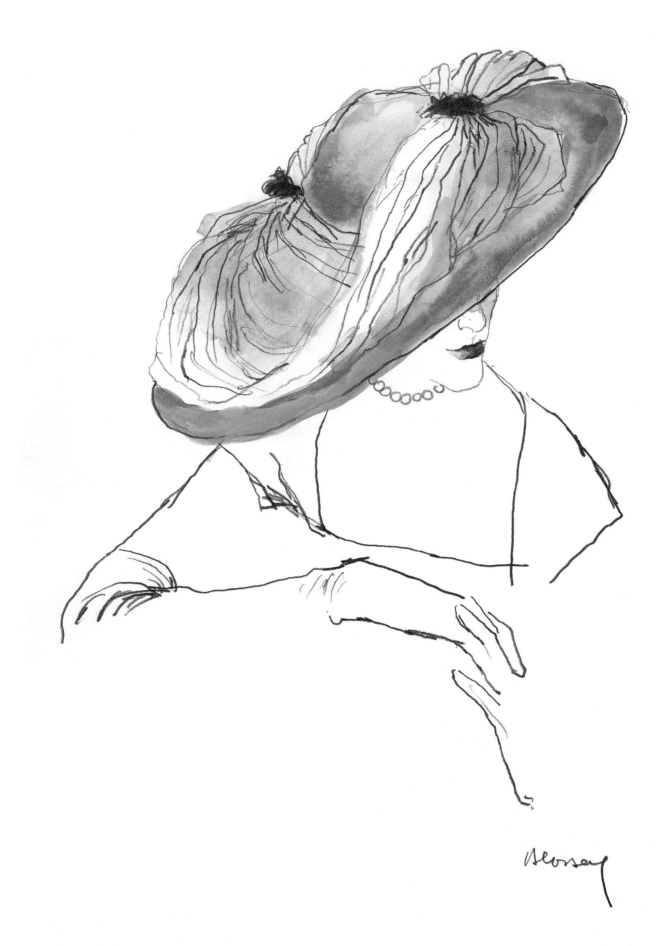

ANTONIO

A SAVAGE SENSUALITY, ASIAN GRACE, BLACK STYLE AND
FLUIDITY ARE ALL PART OF THE ANTONIO IDEAL, YET THE
FIGURES THEMSELVES MELD THE ATTRIBUTES OF ALL TIMES
AND ALL CULTURES. ANTONIO IS NOW AND FOREVER ONE OF
THE GREAT ARTISTS OF OUR TIME.
— *Richard Martin*

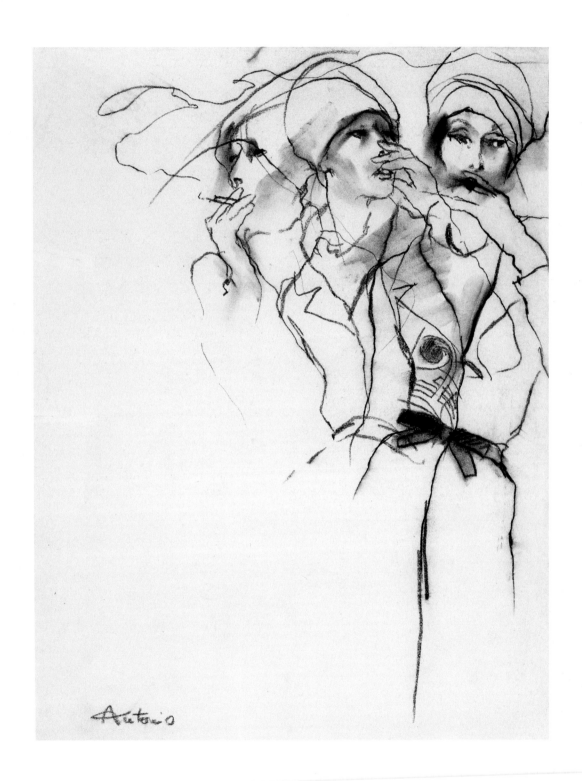

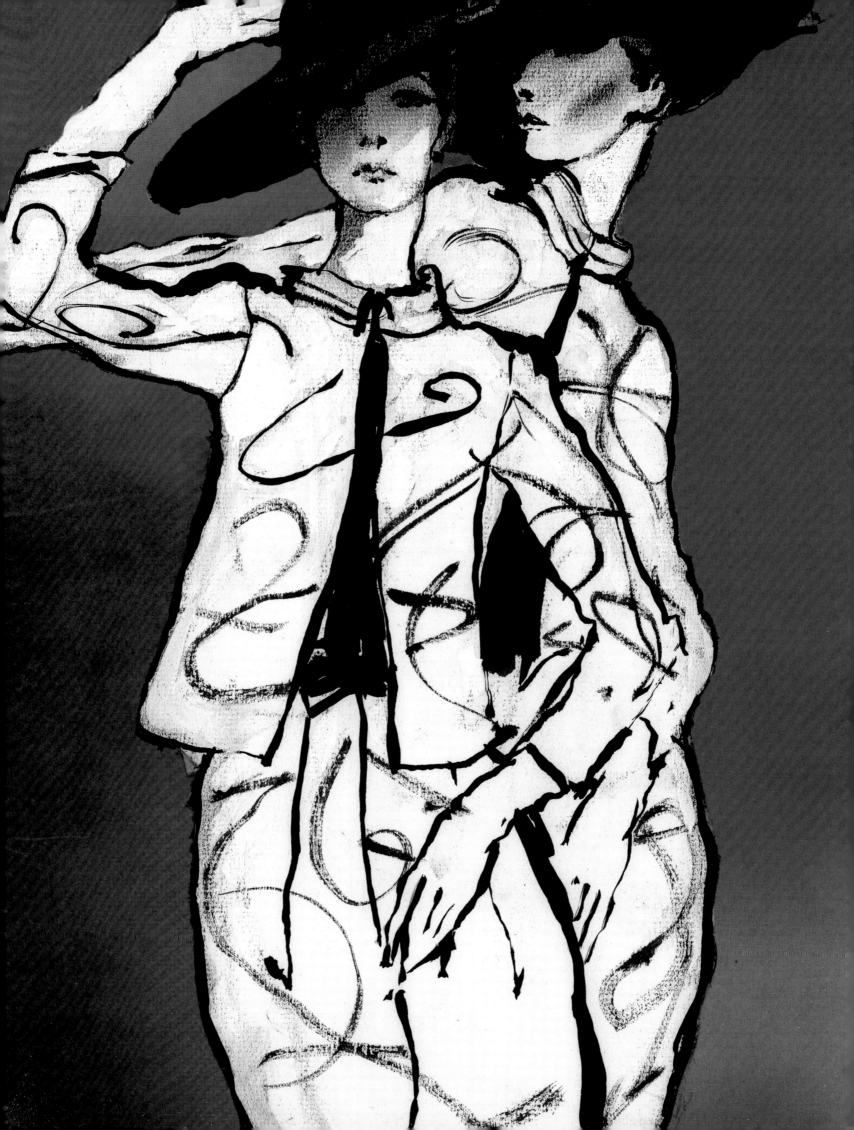

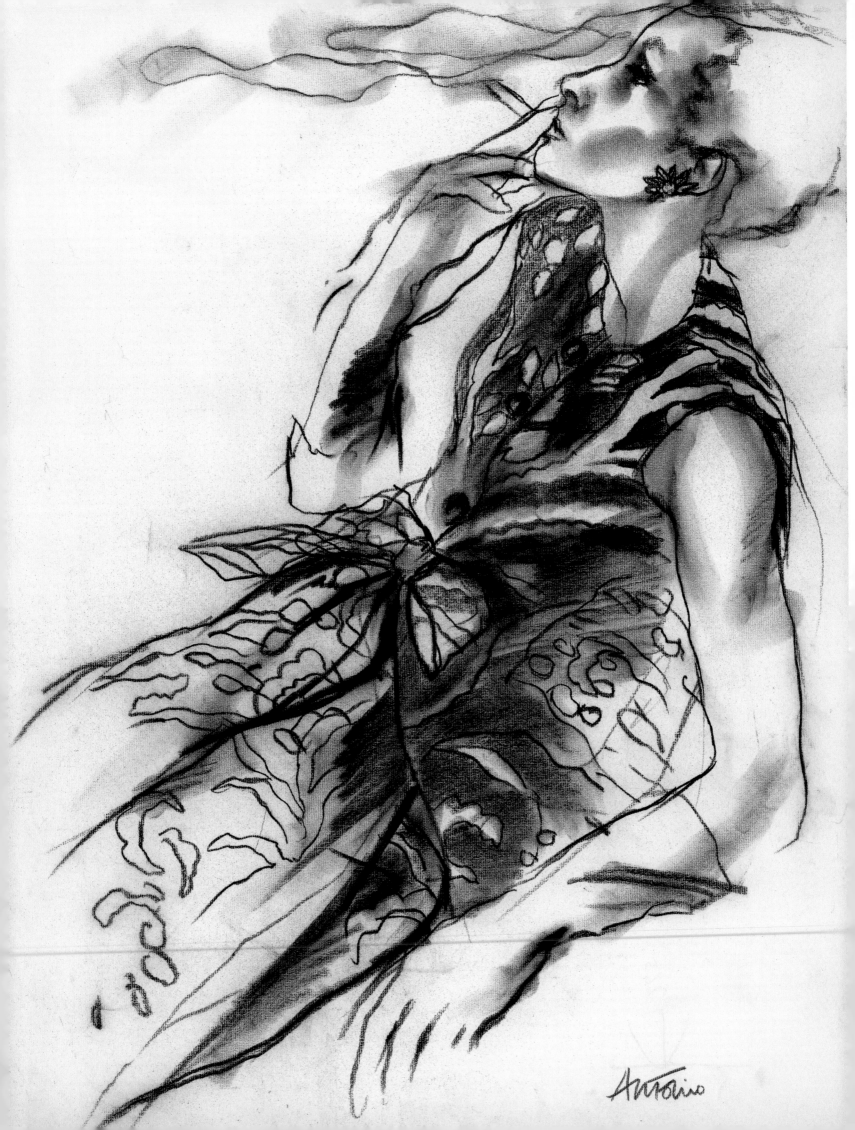

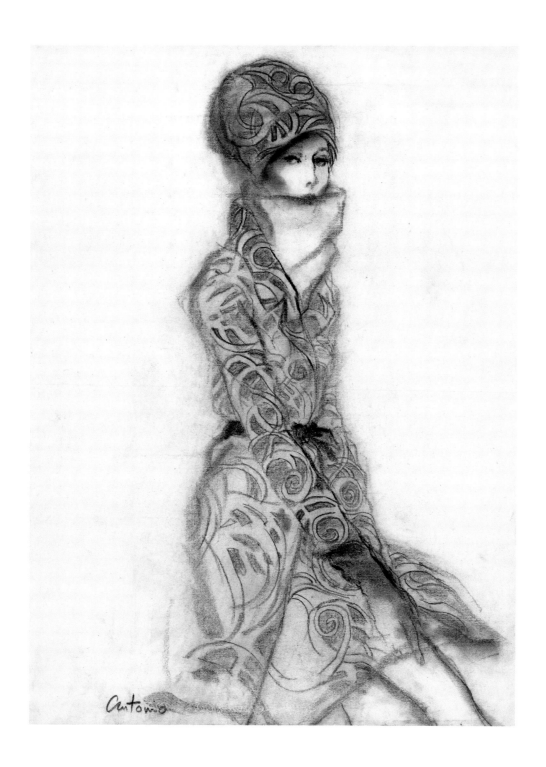

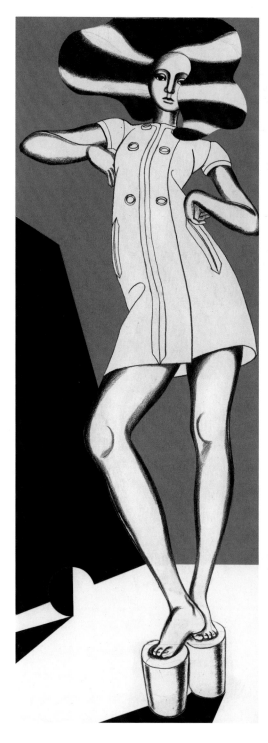
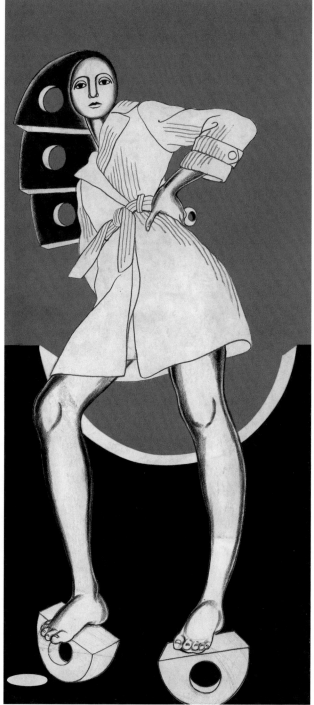

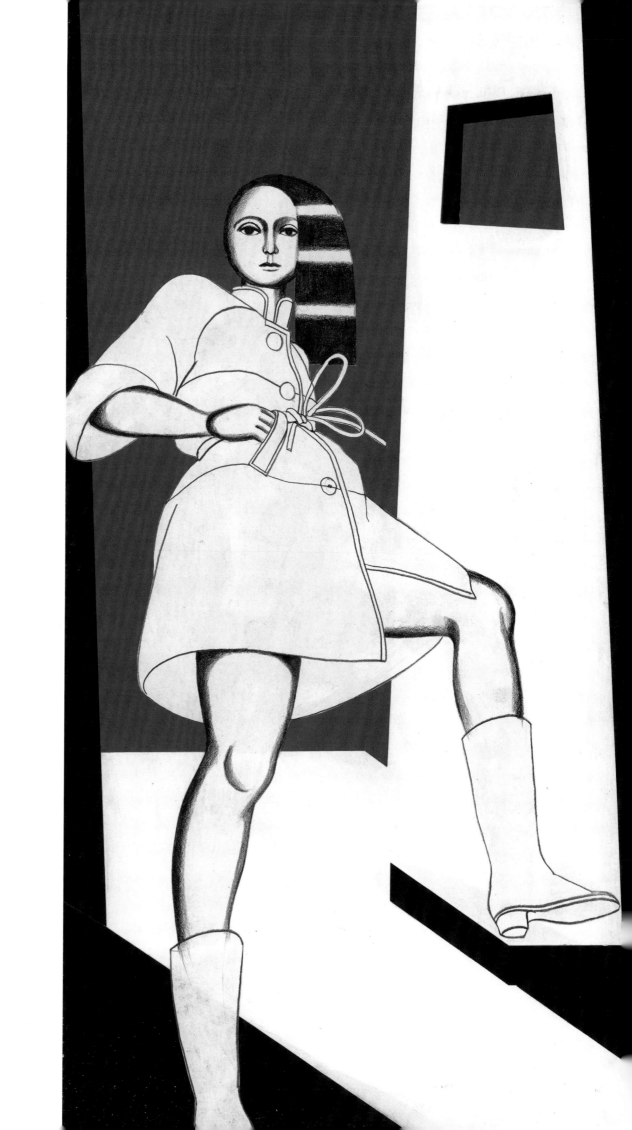

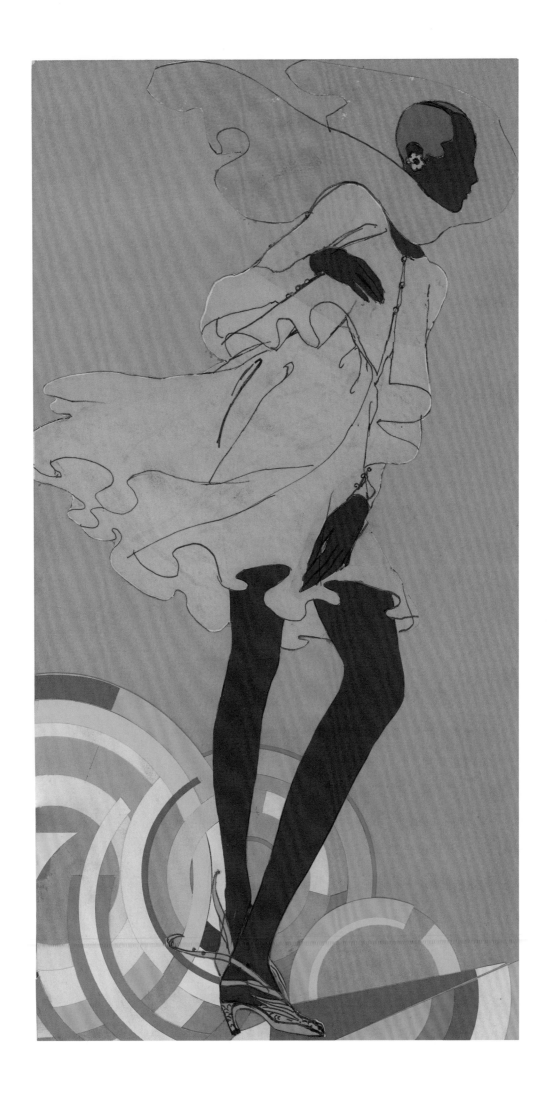

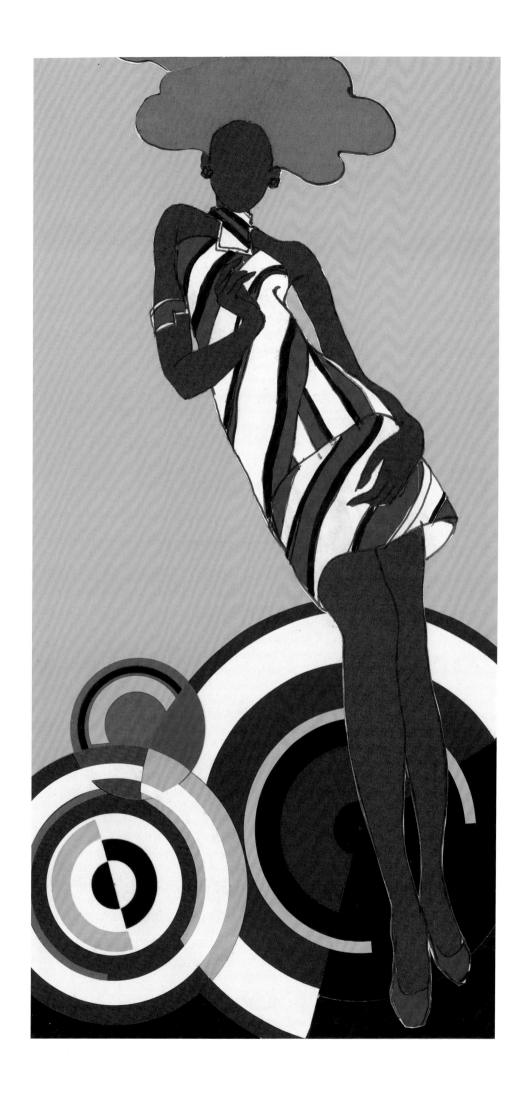

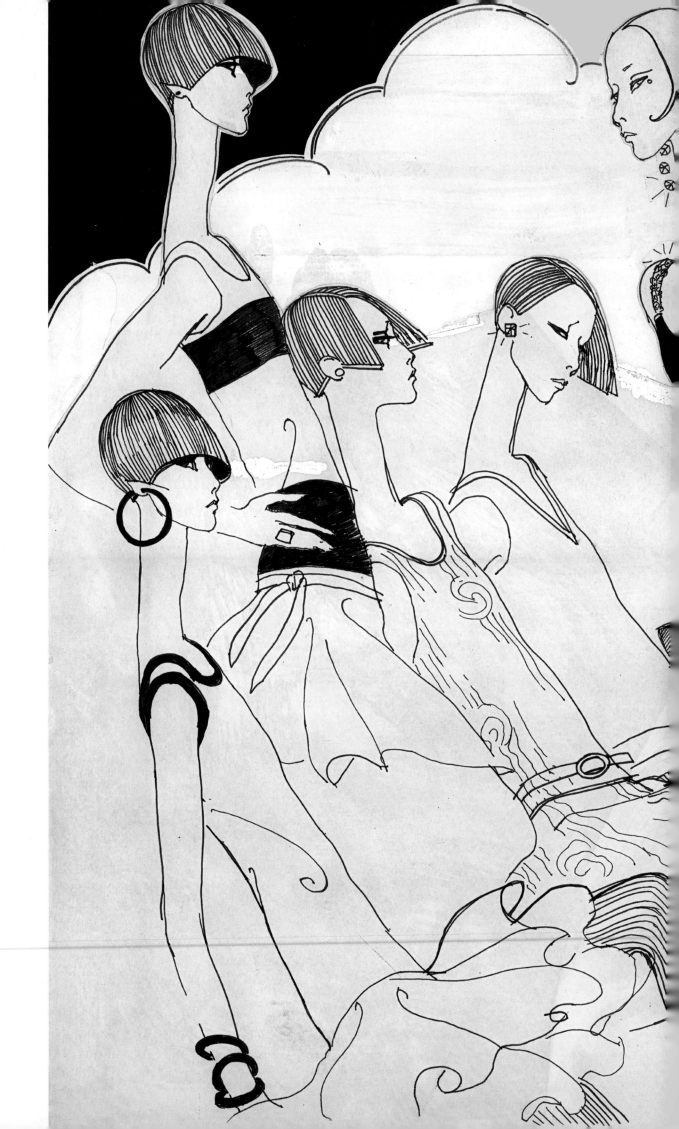

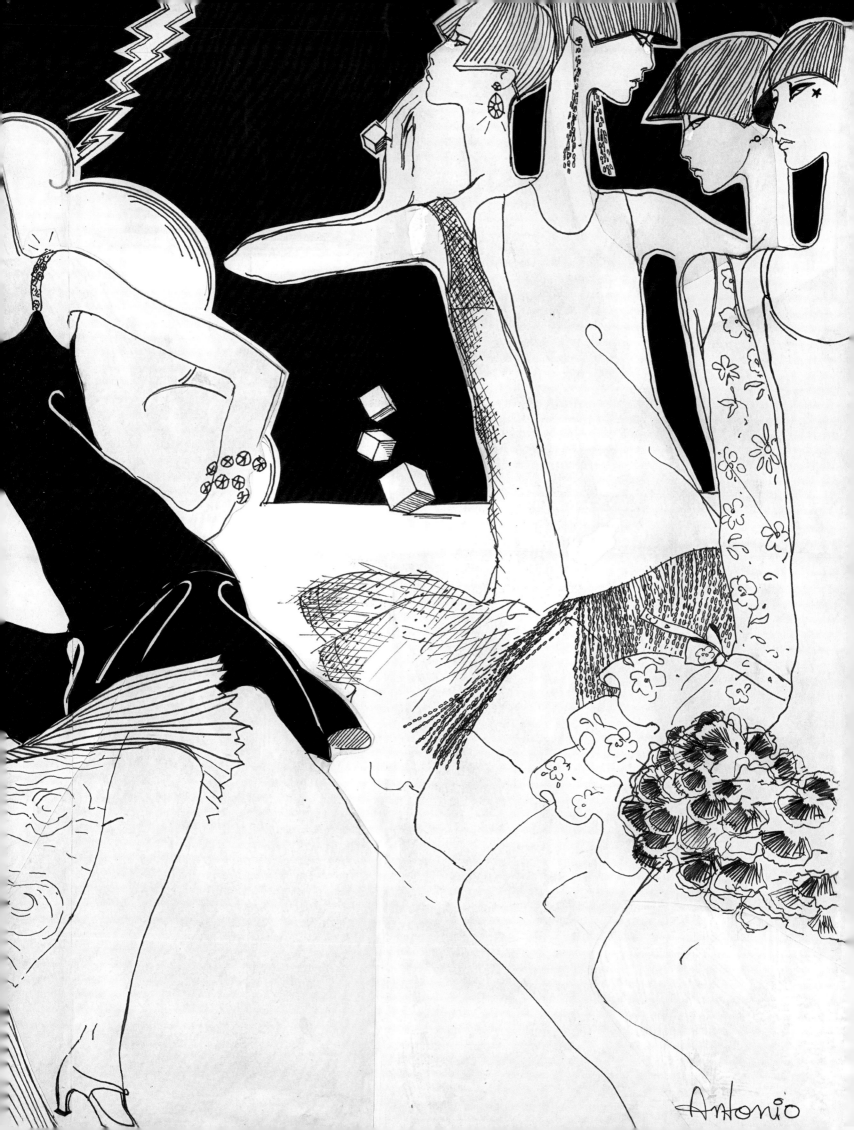

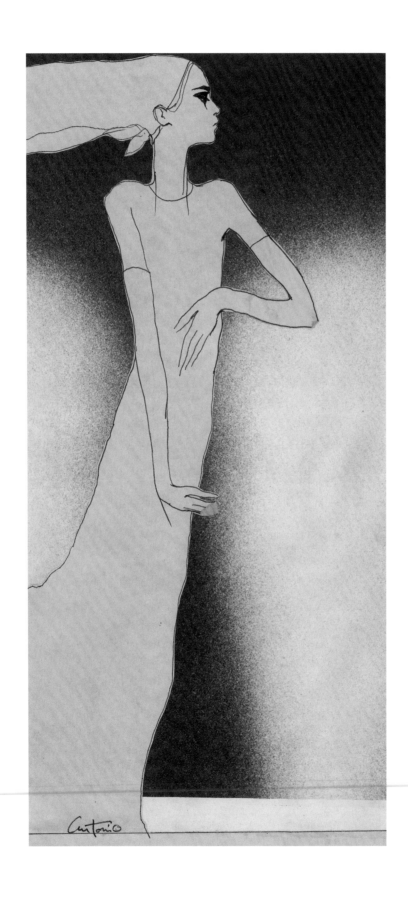

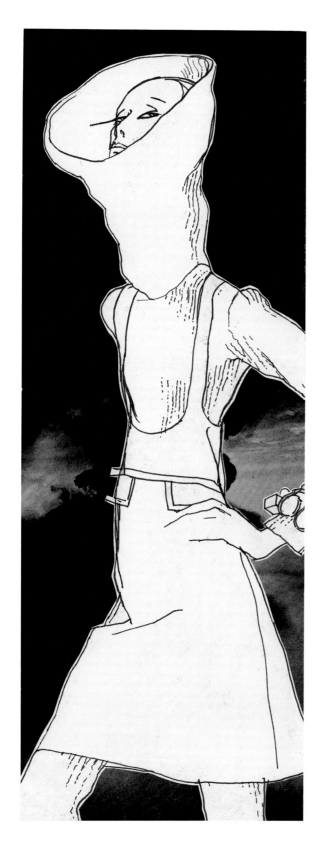
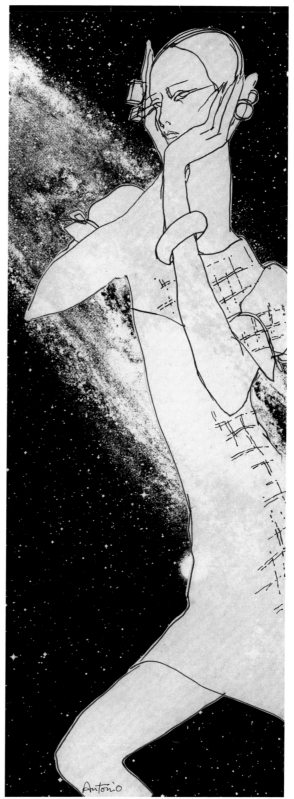

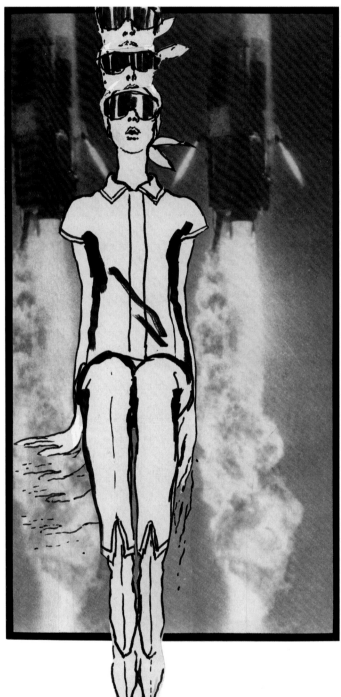

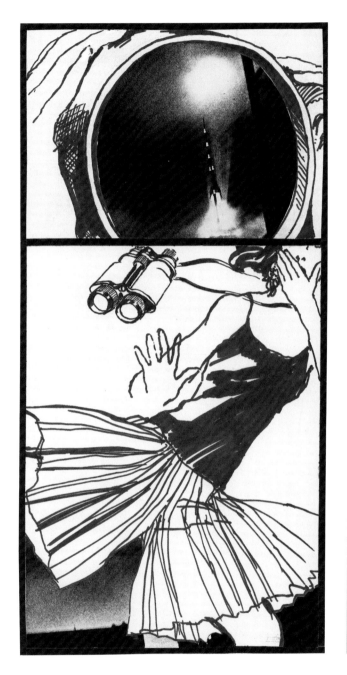
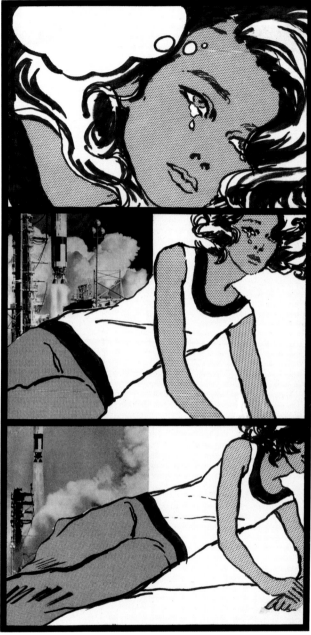

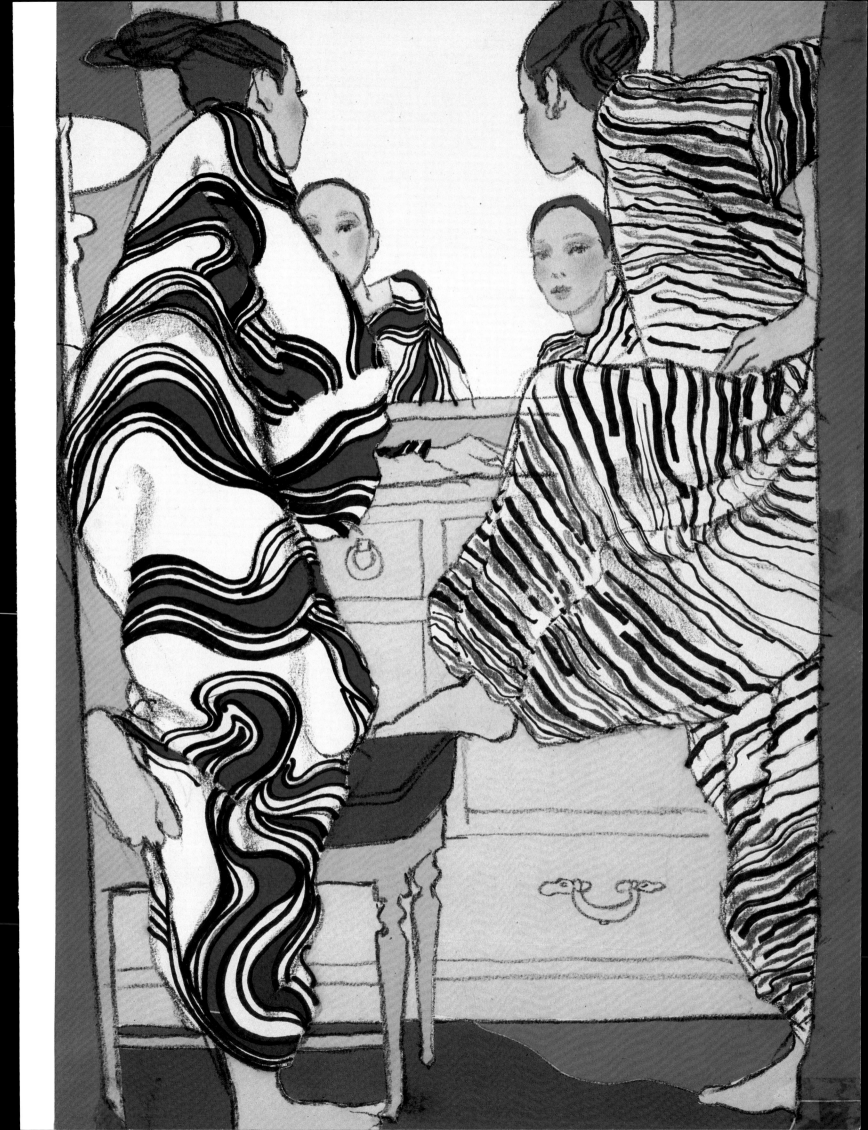

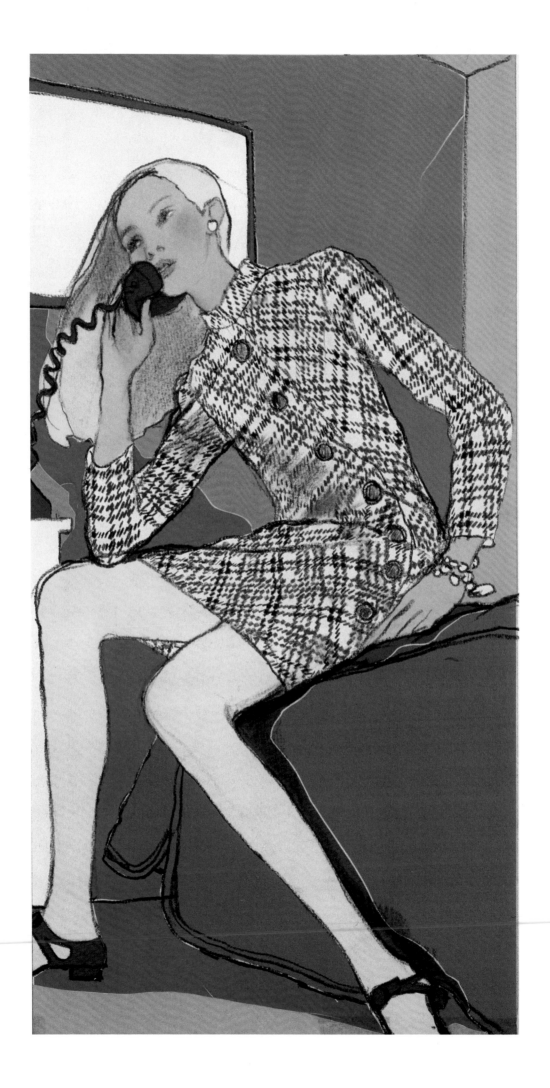

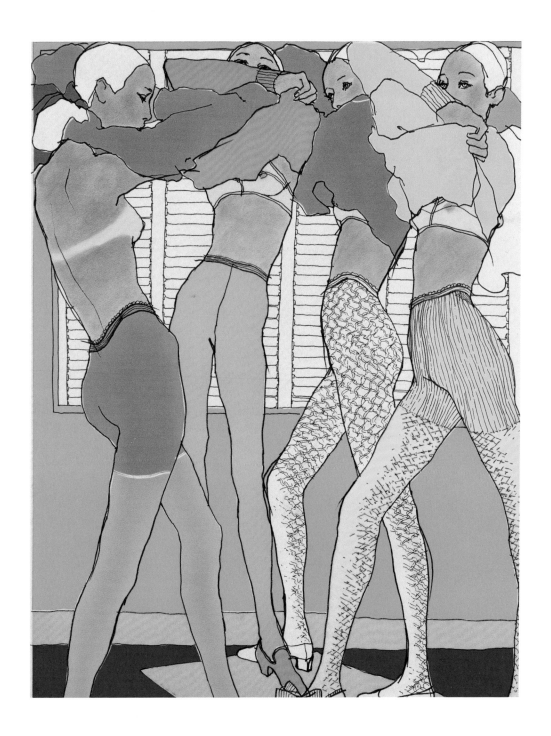

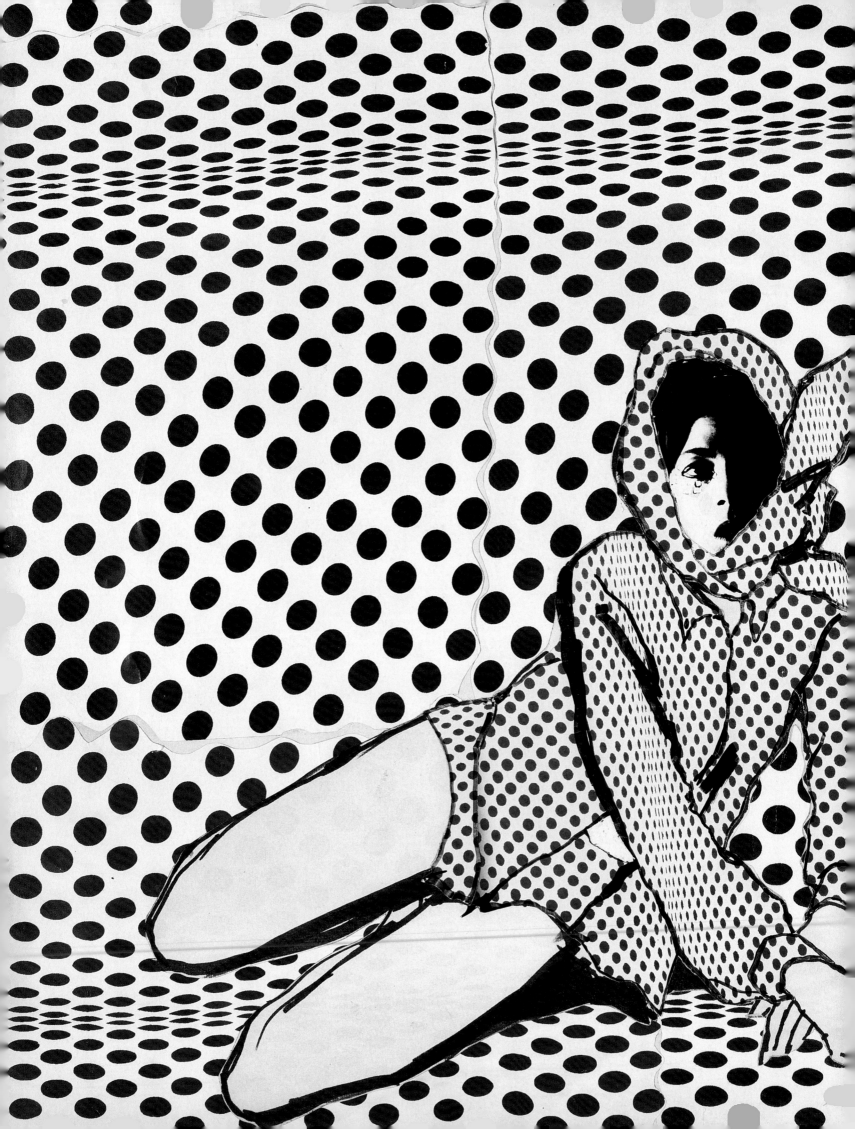

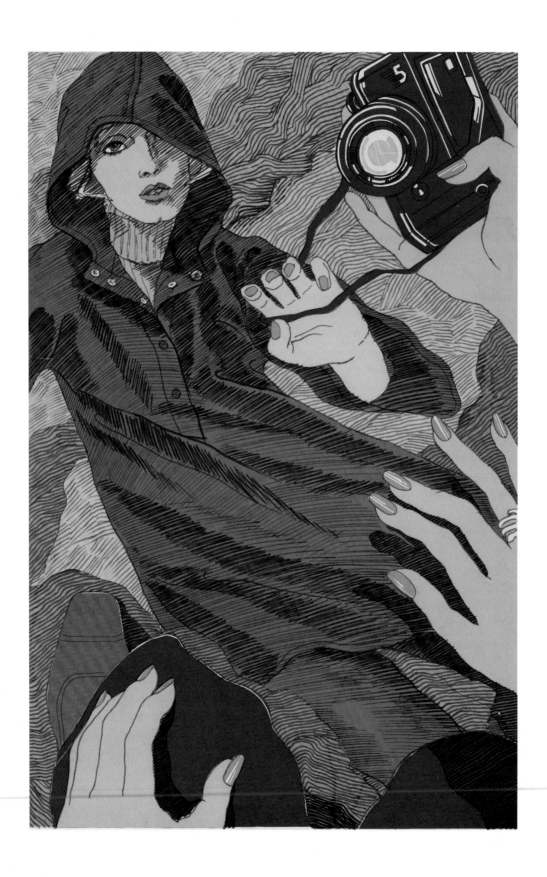

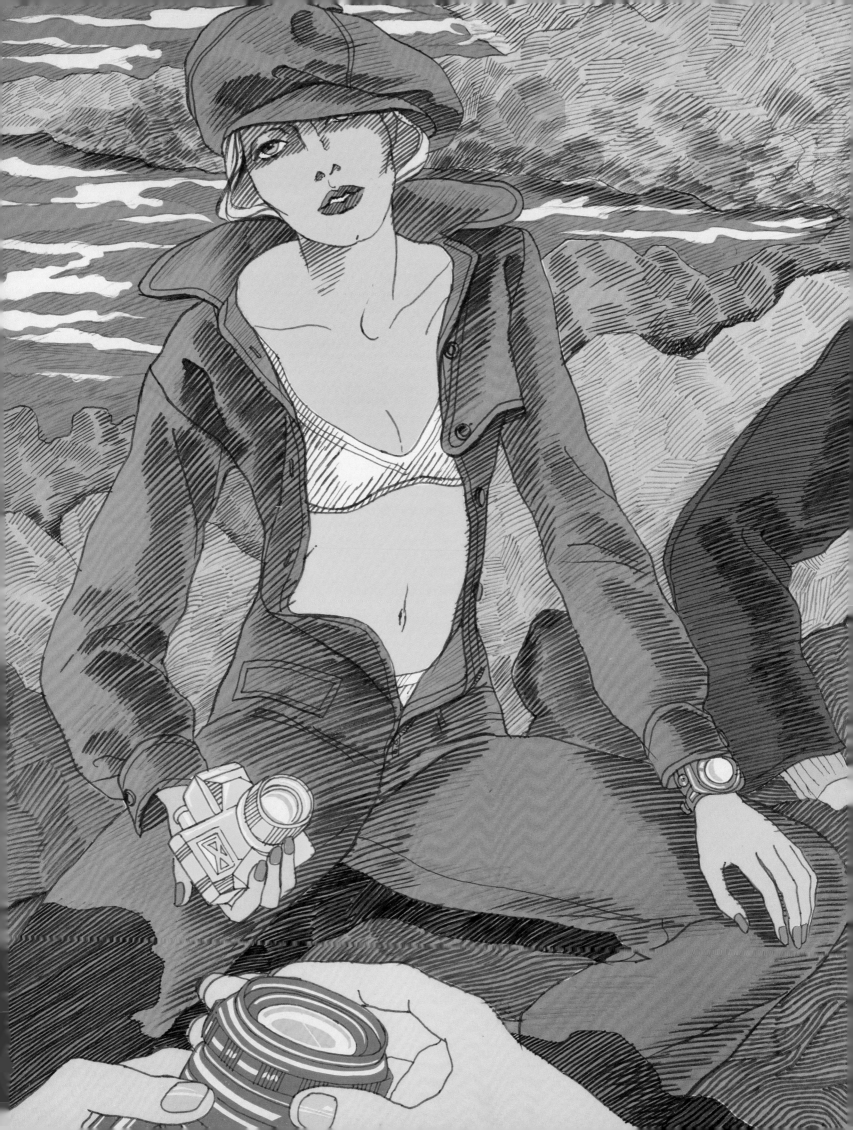

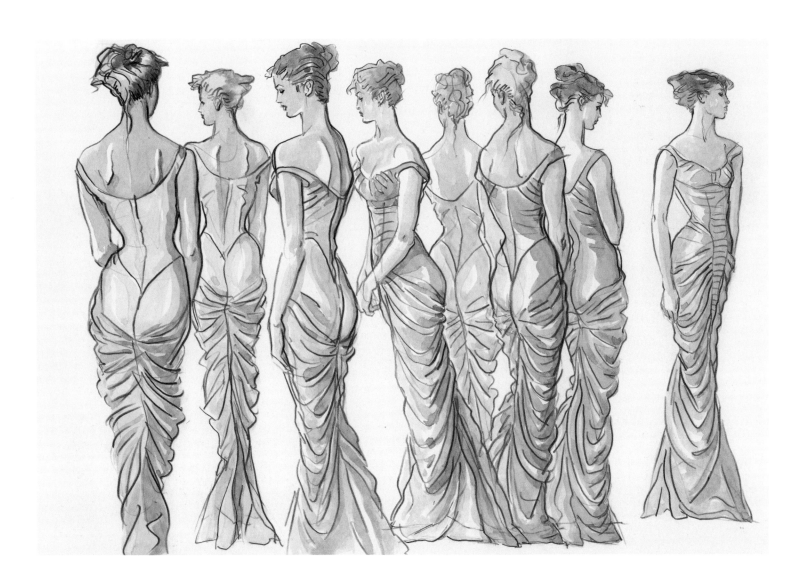

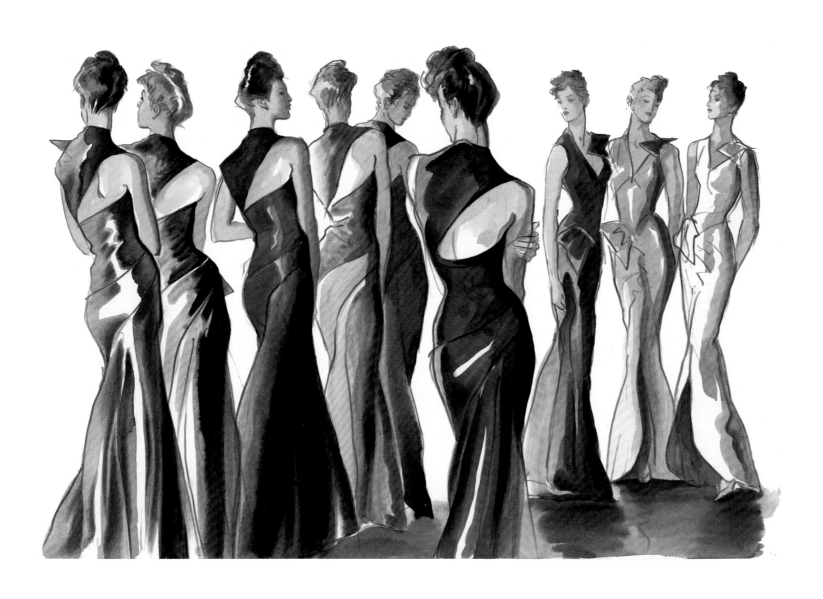

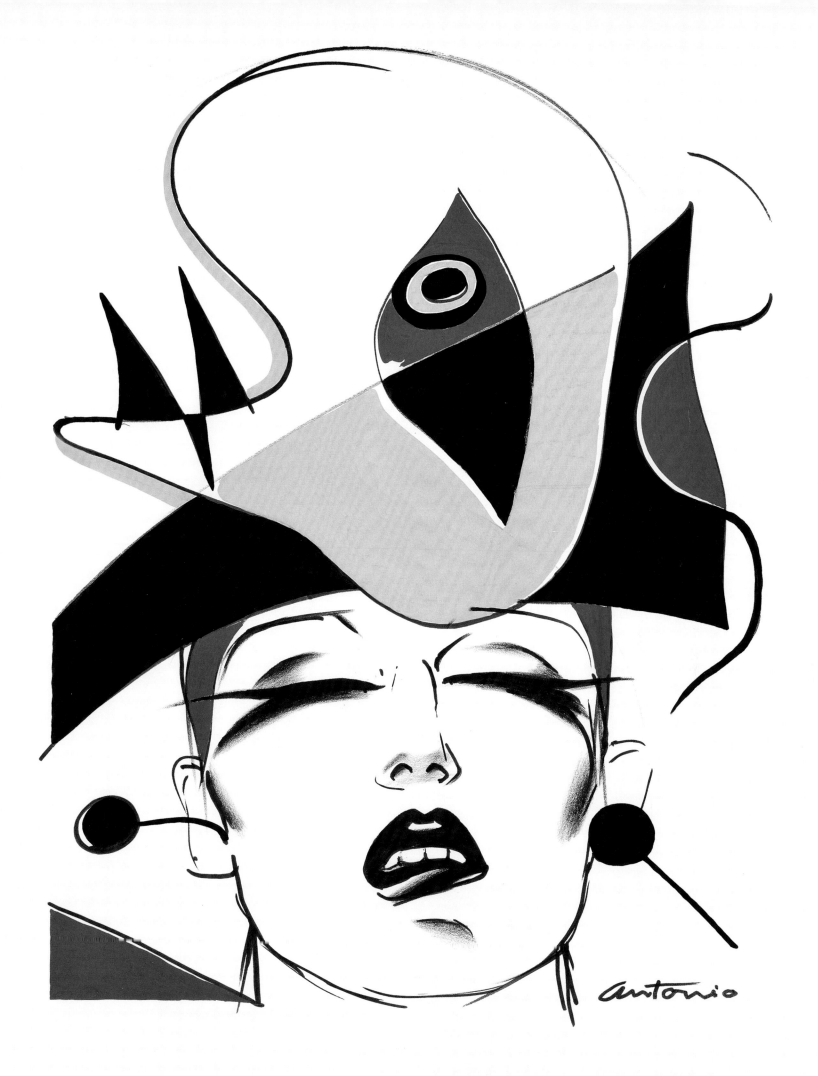

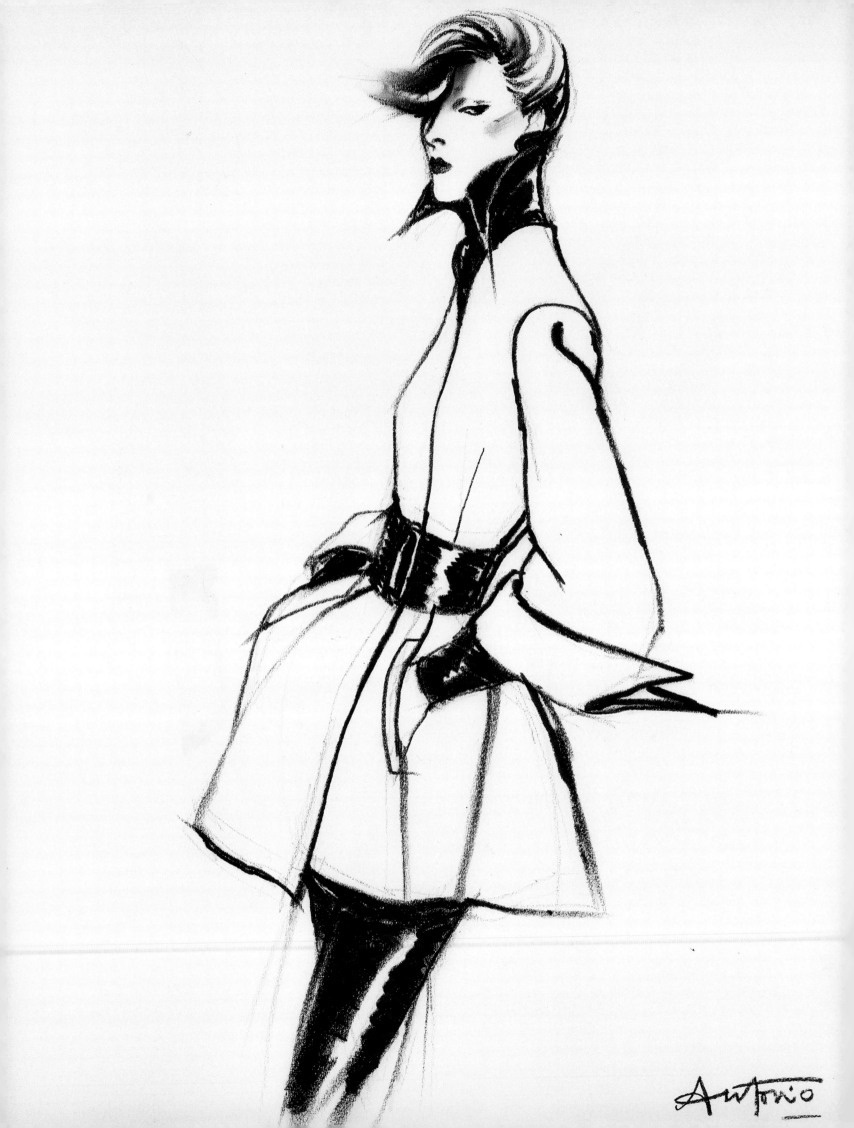

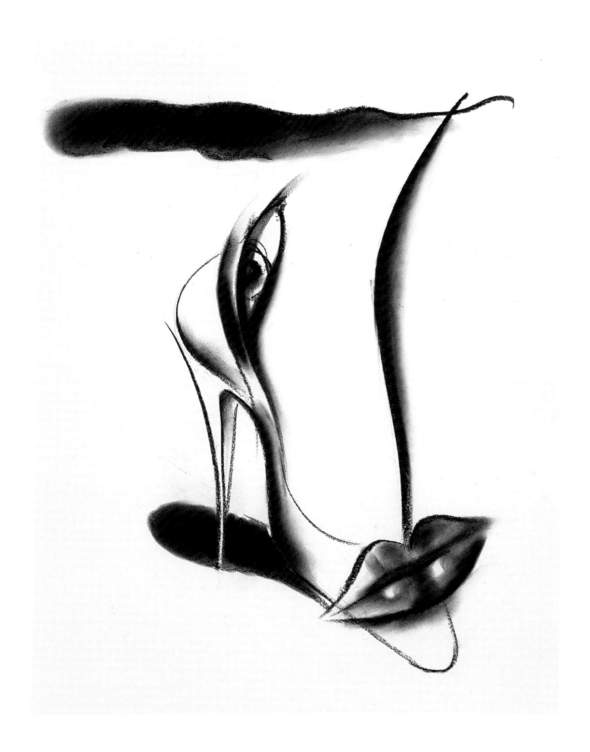

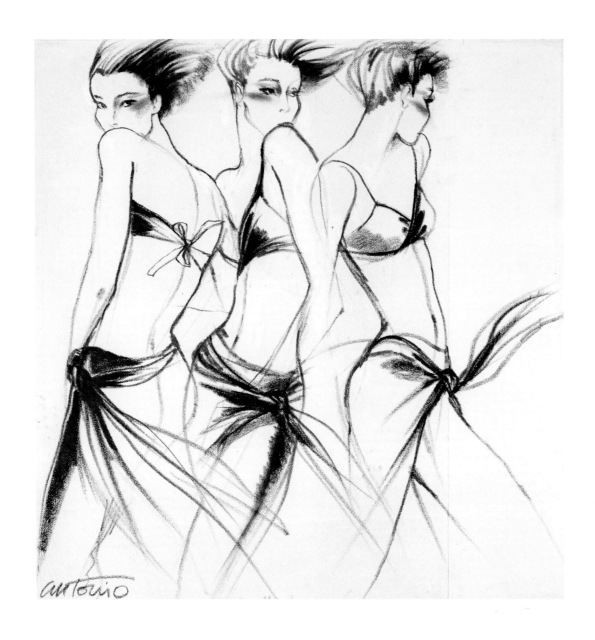

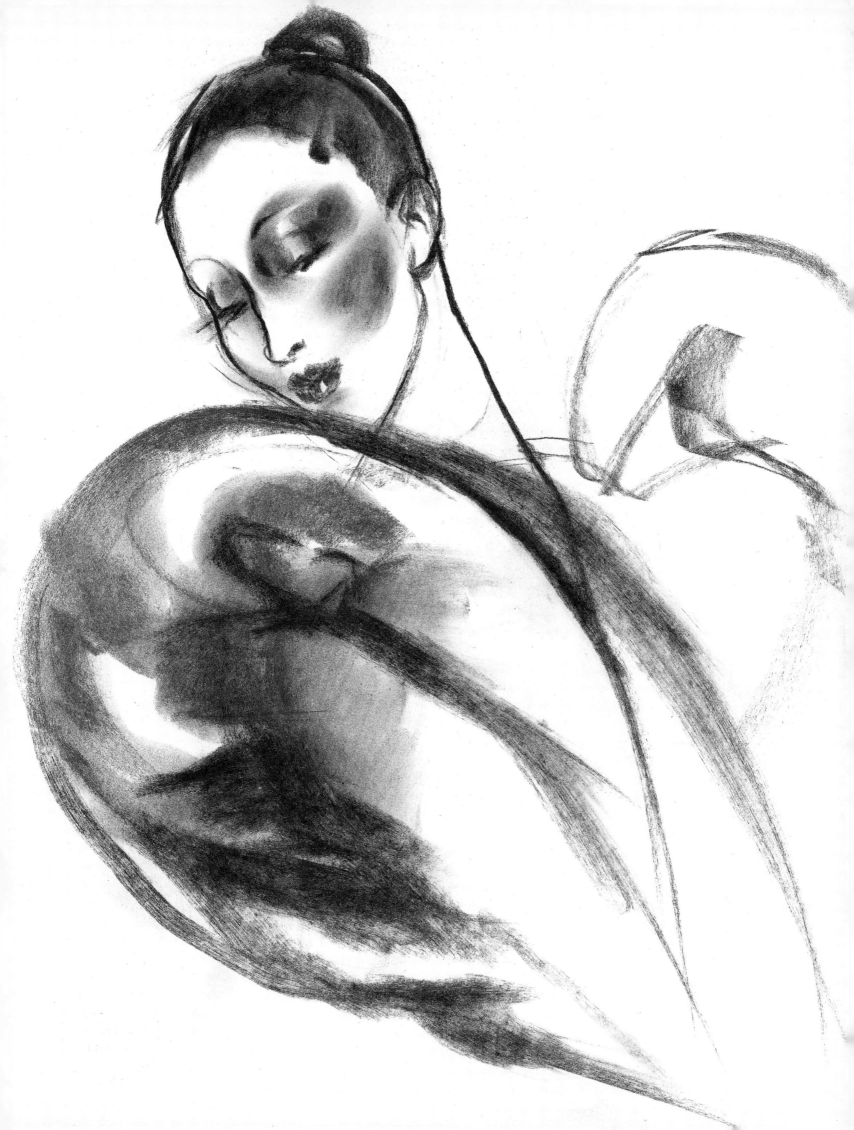

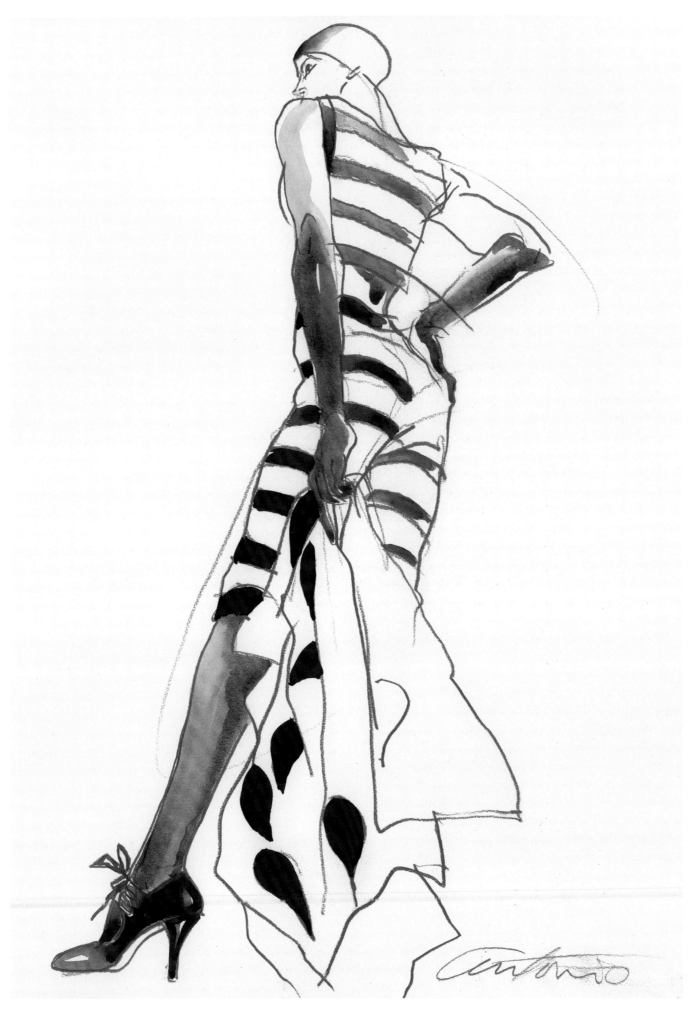

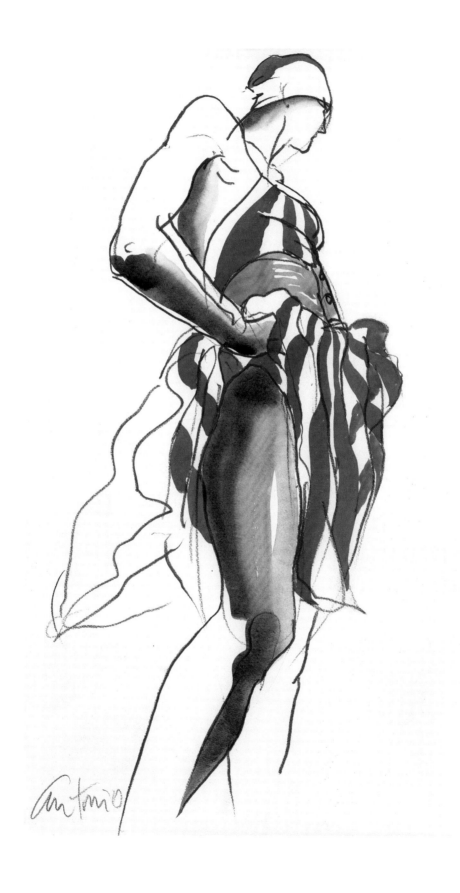

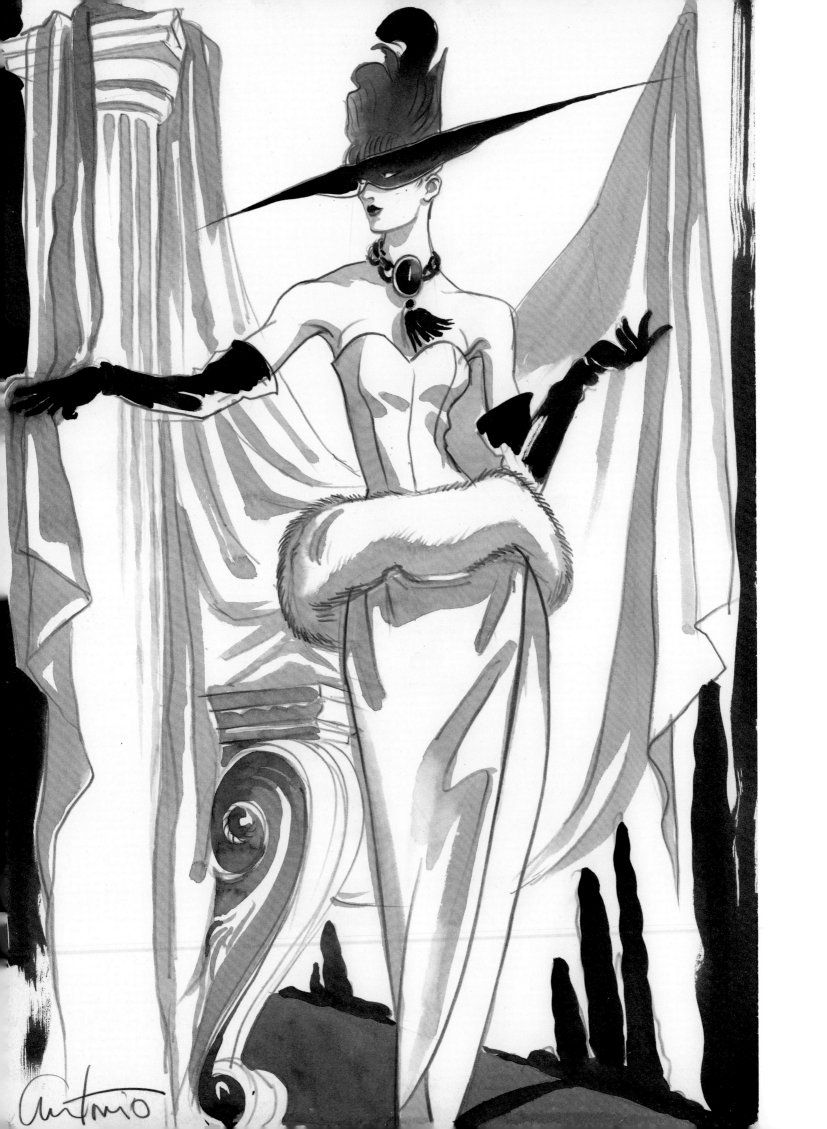

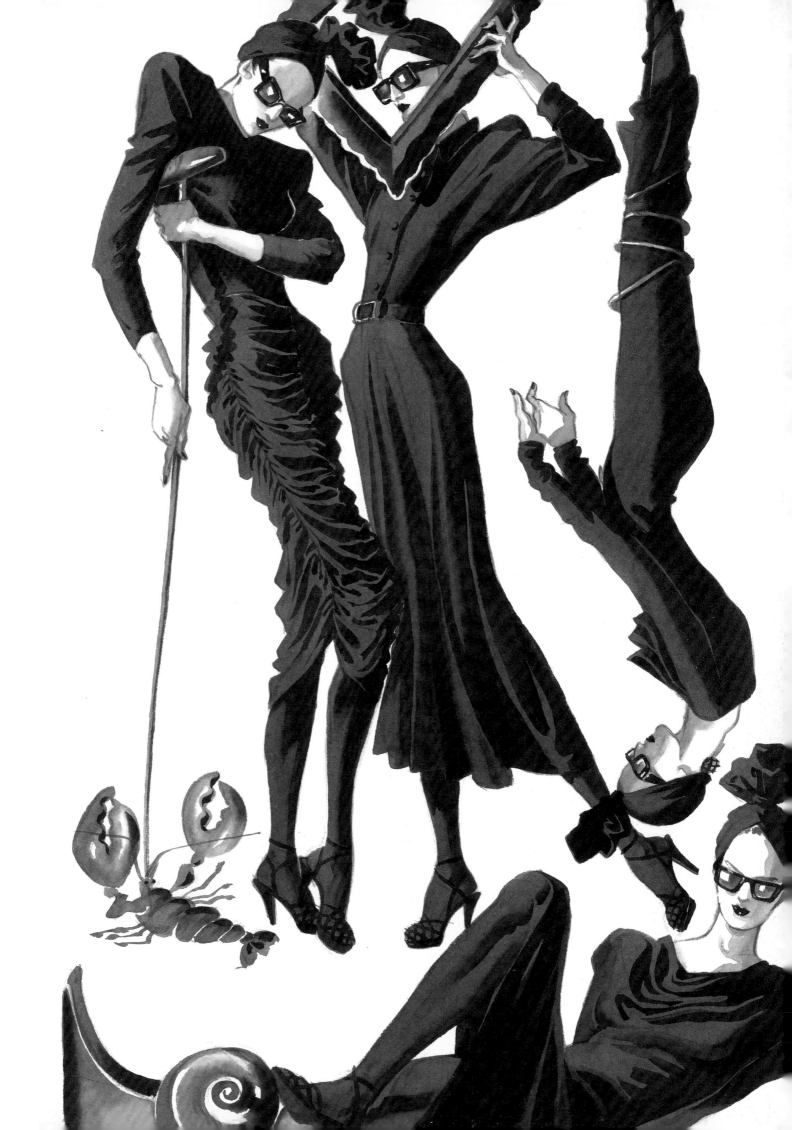

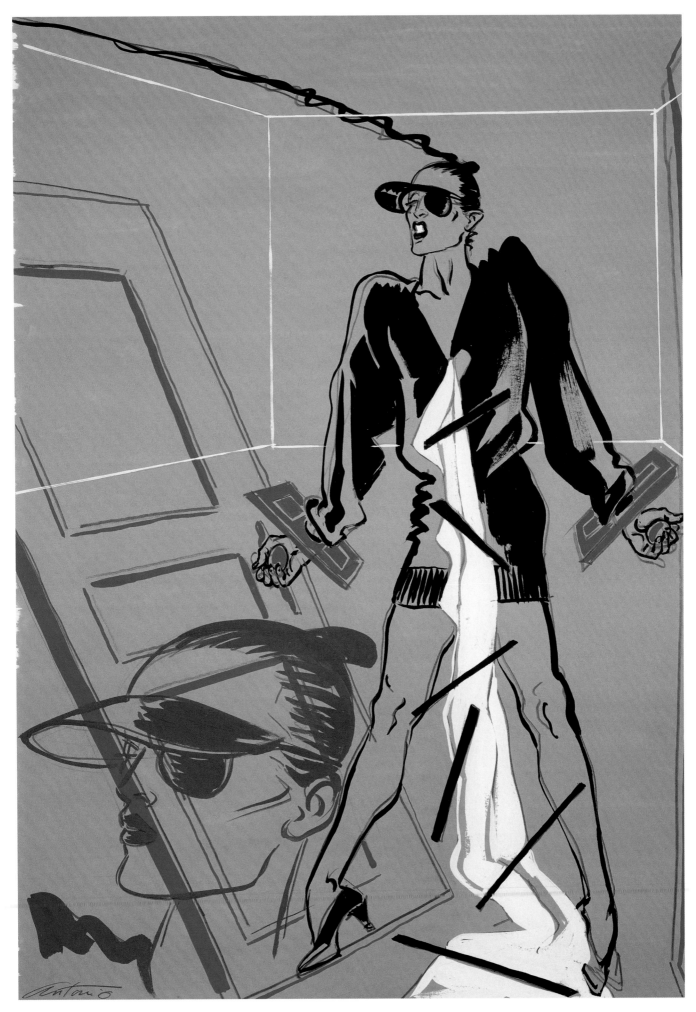

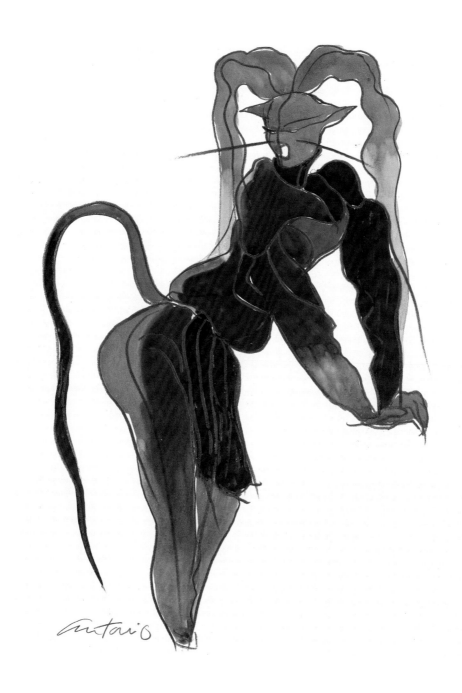

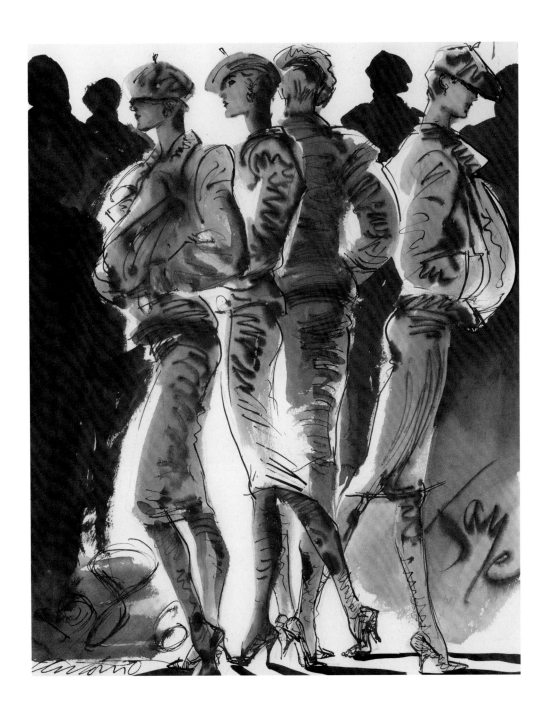

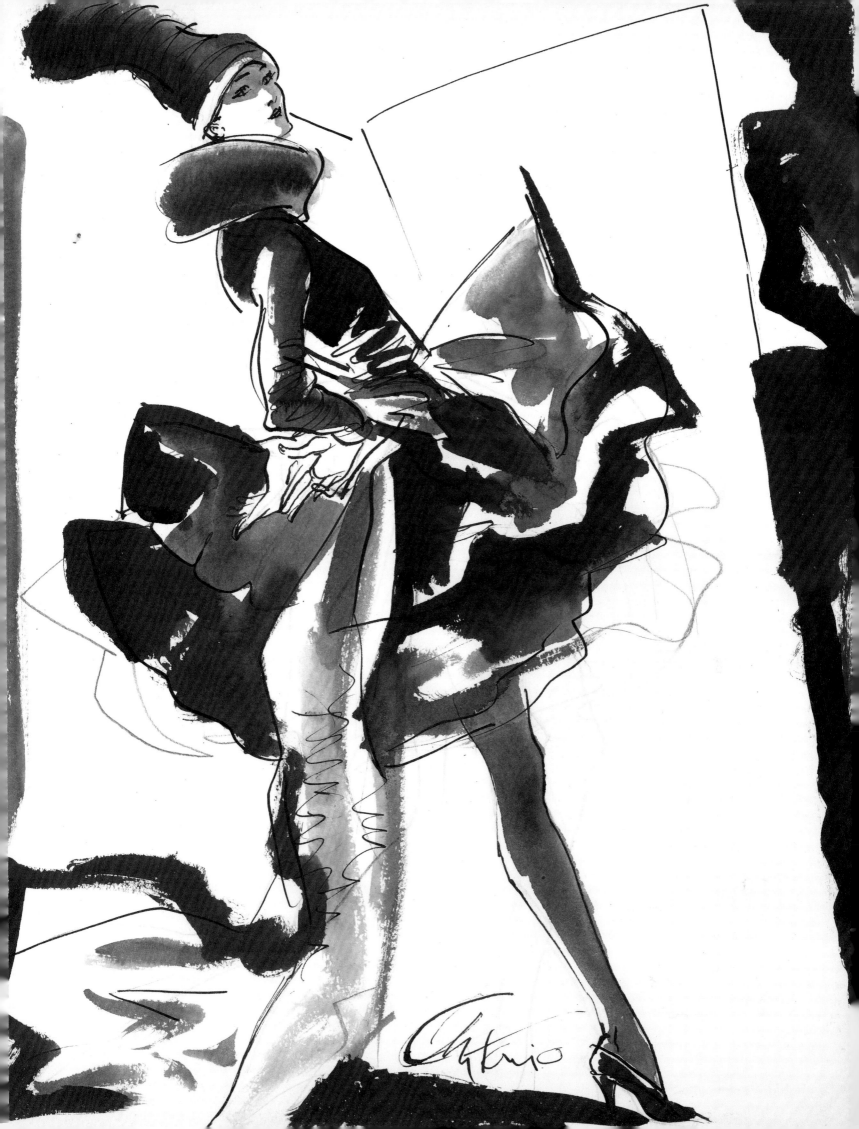

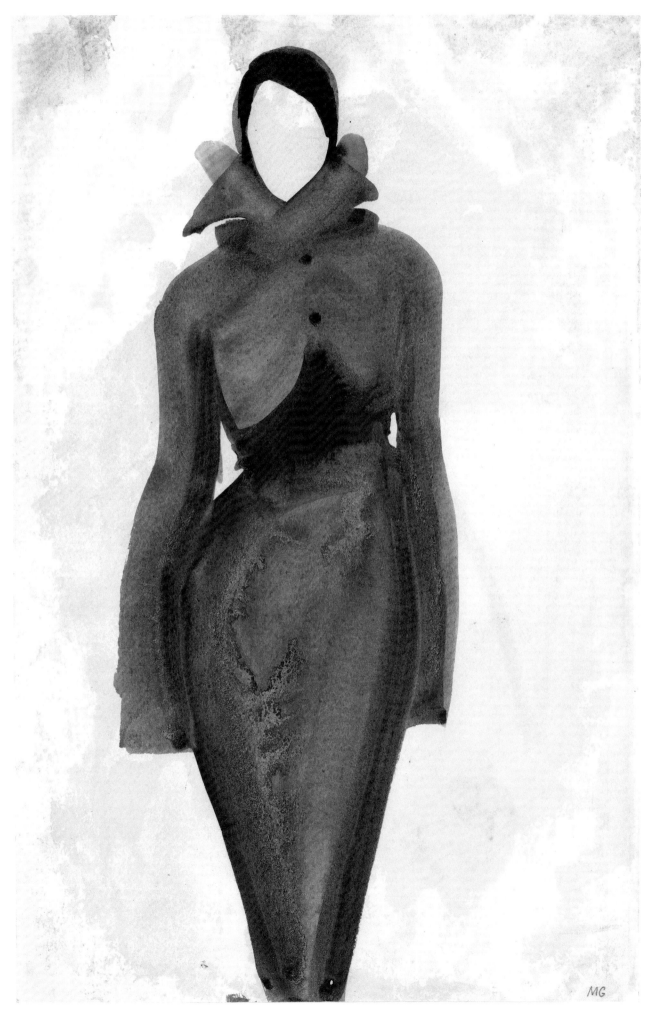

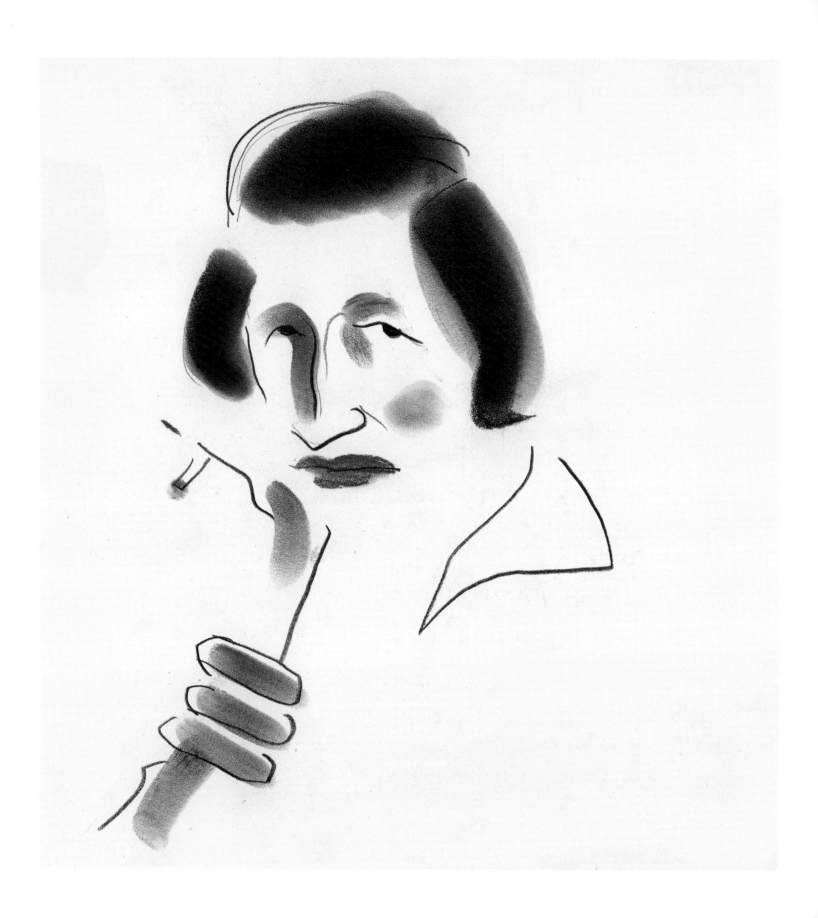

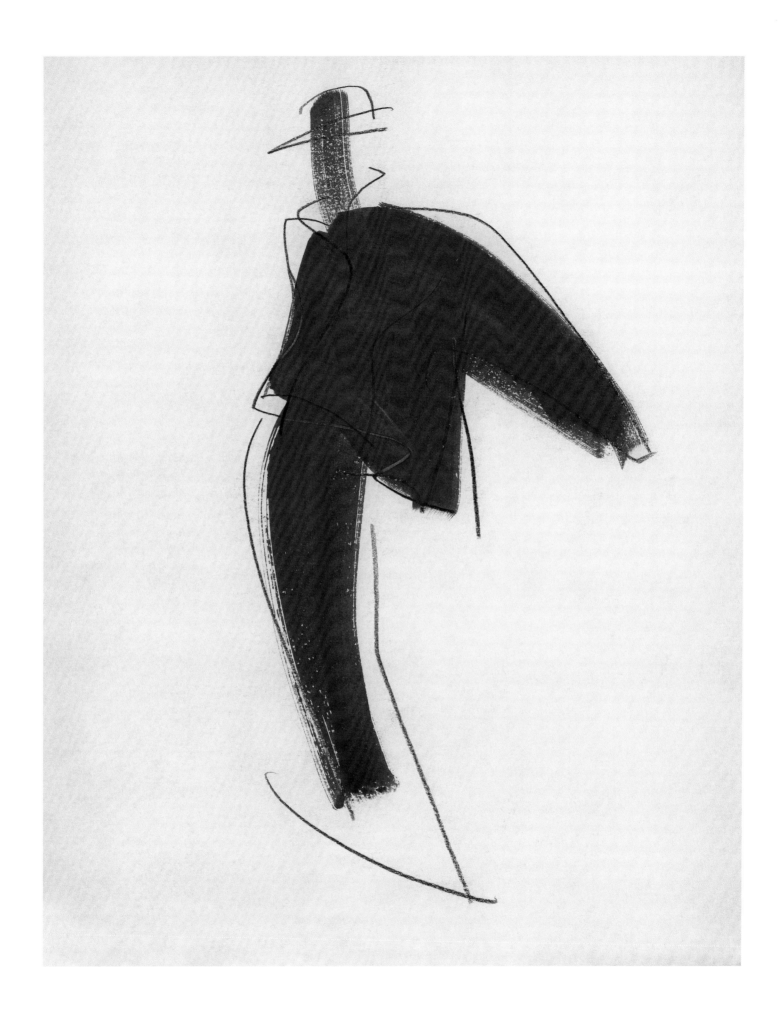

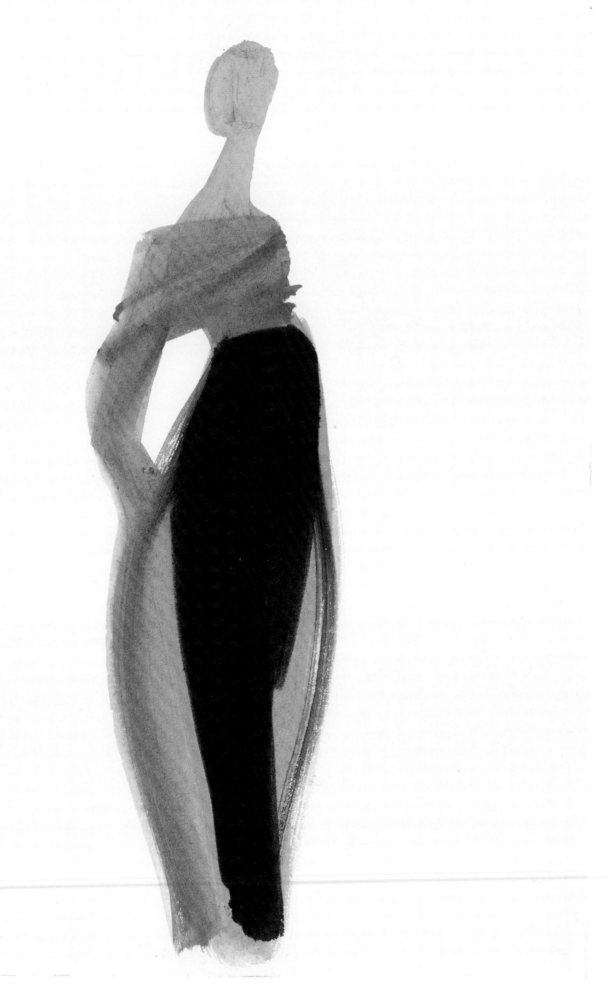

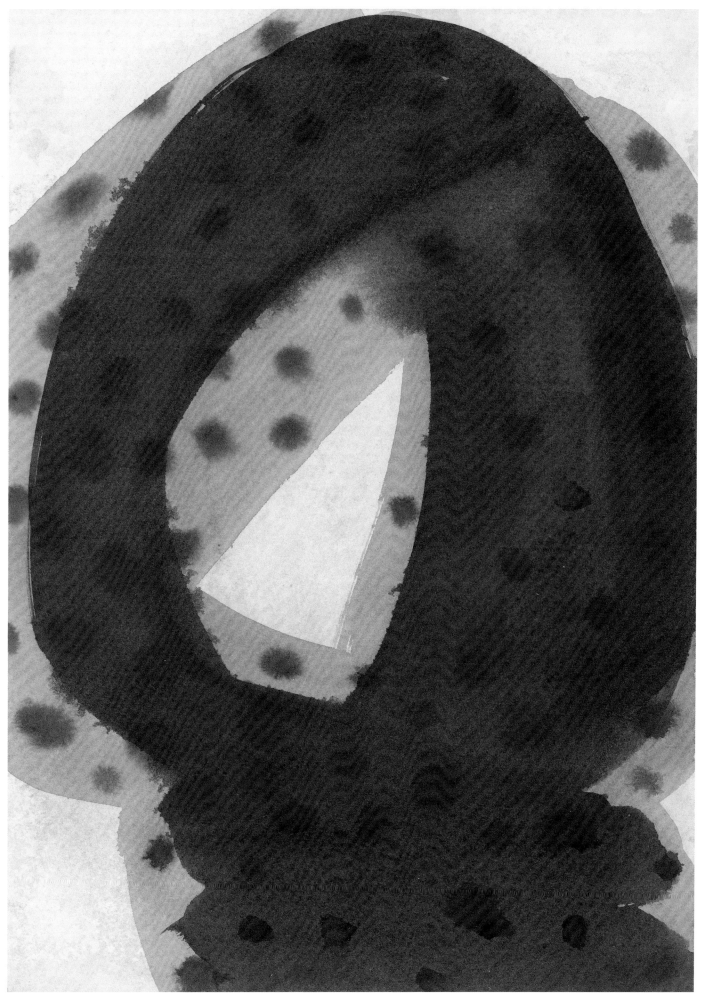

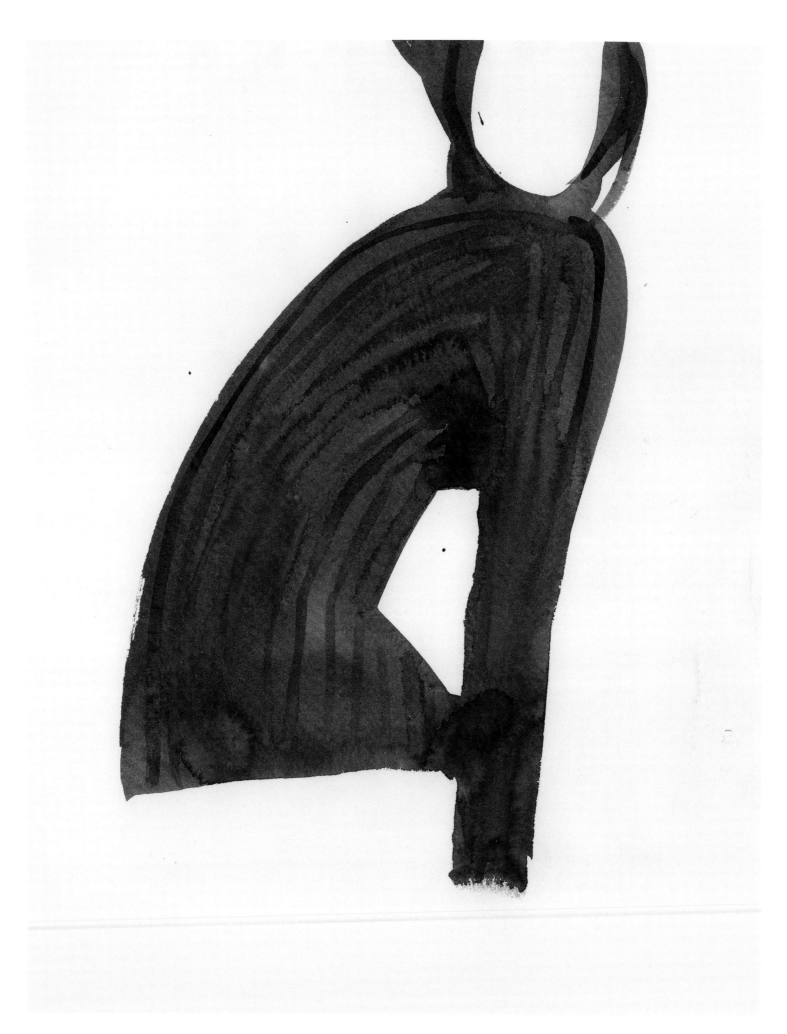

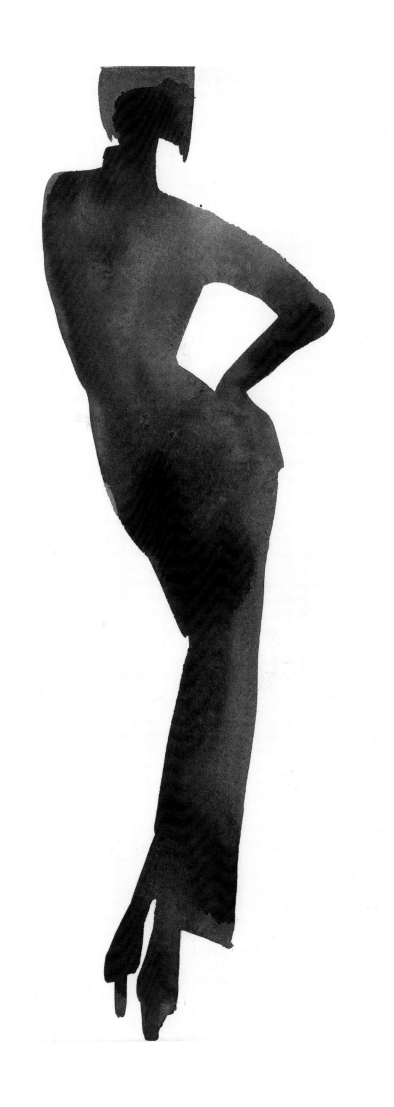

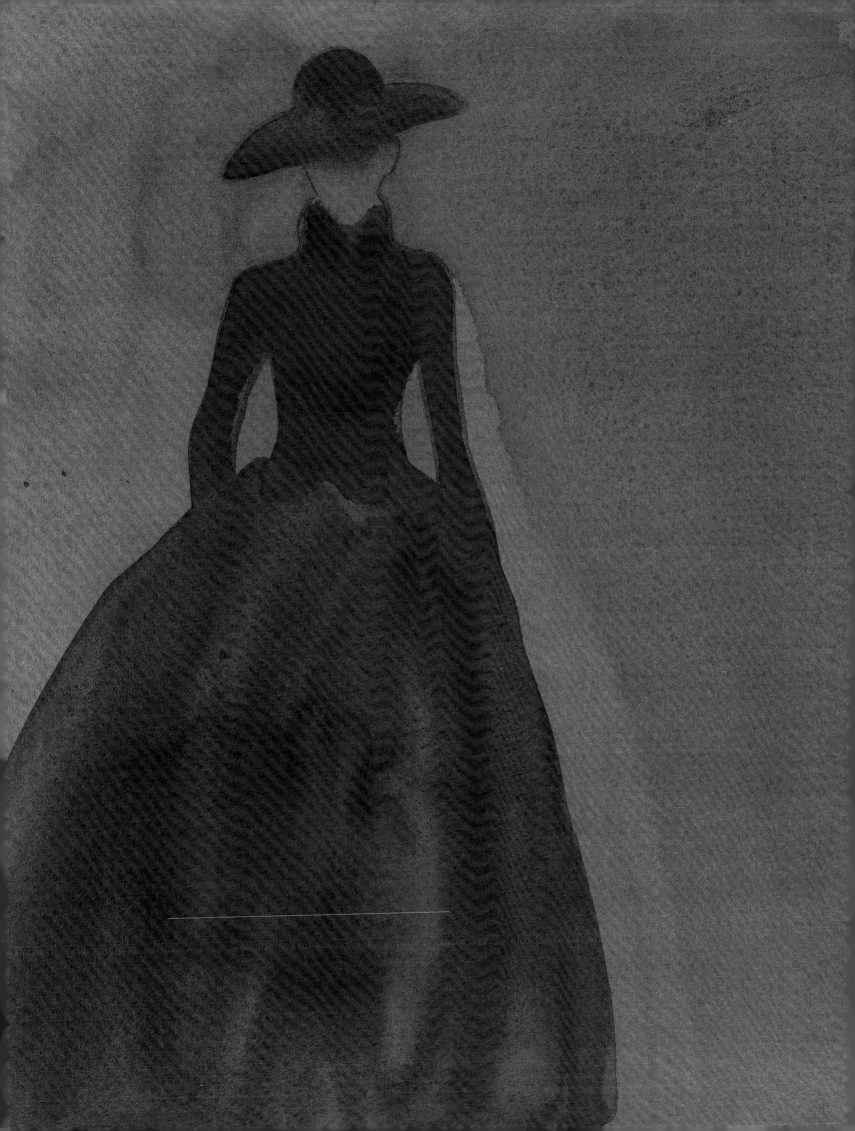

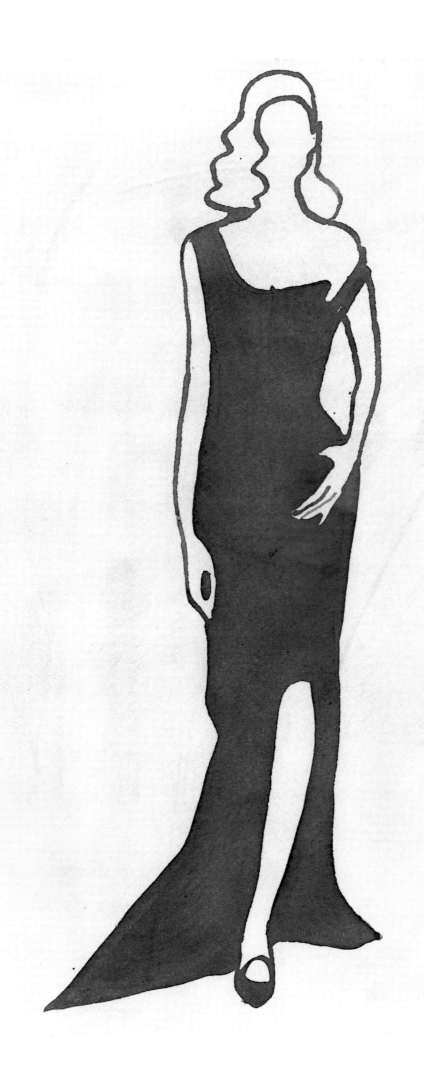

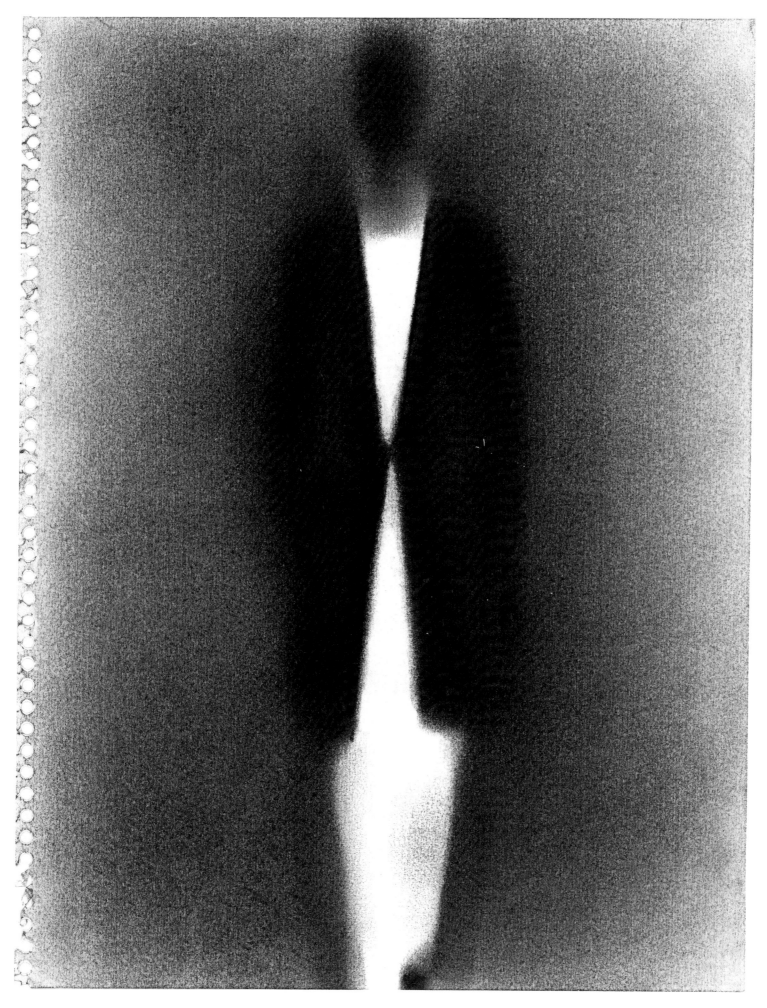

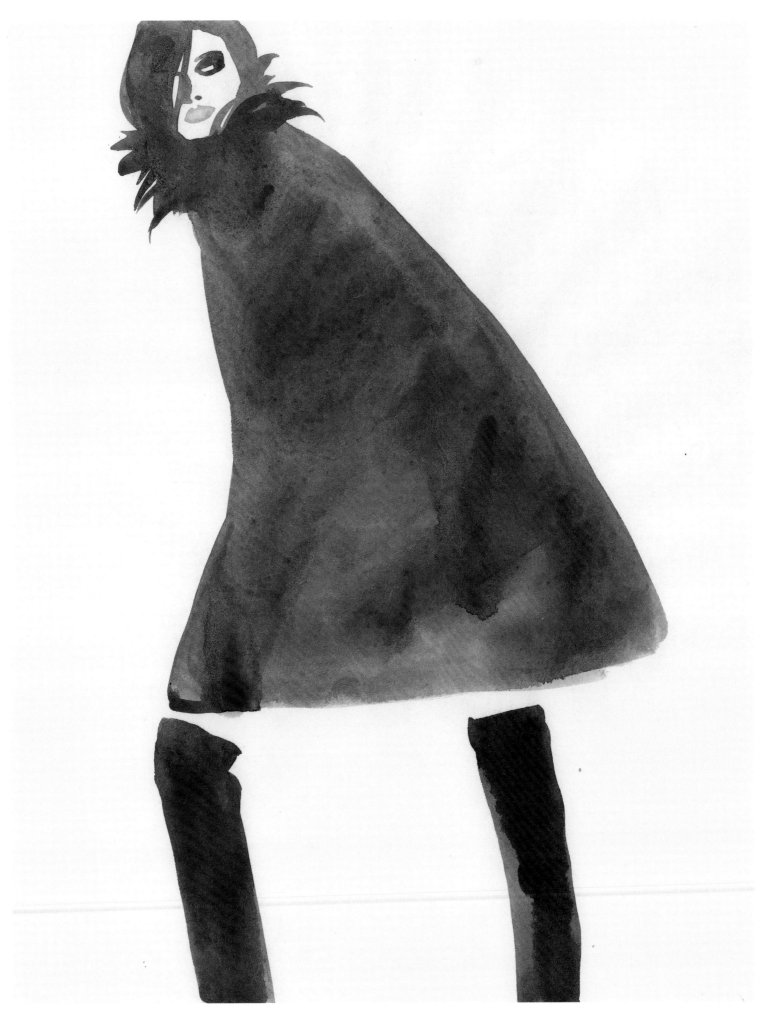

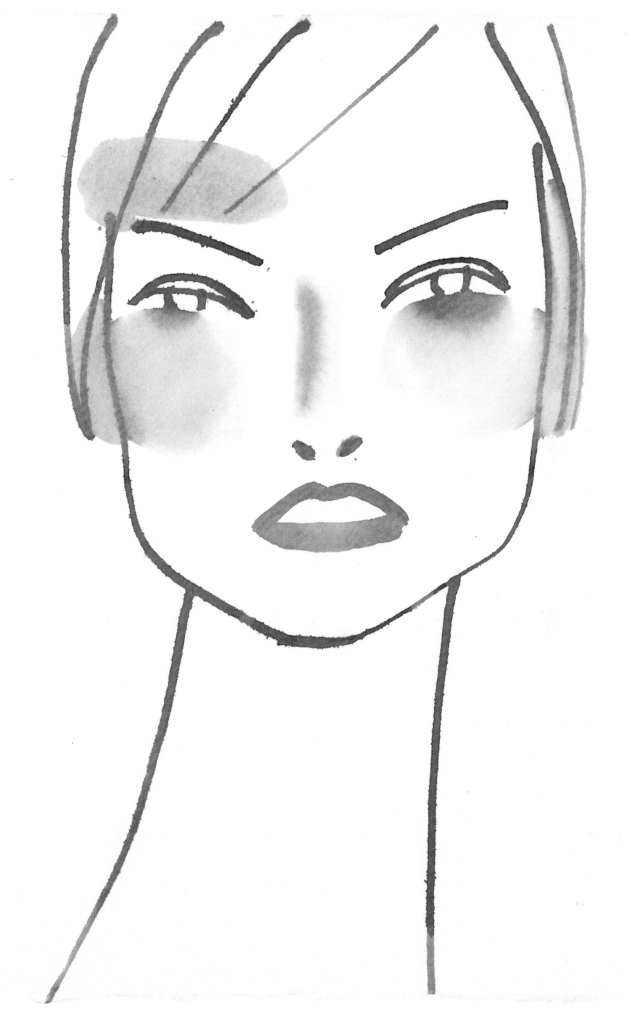

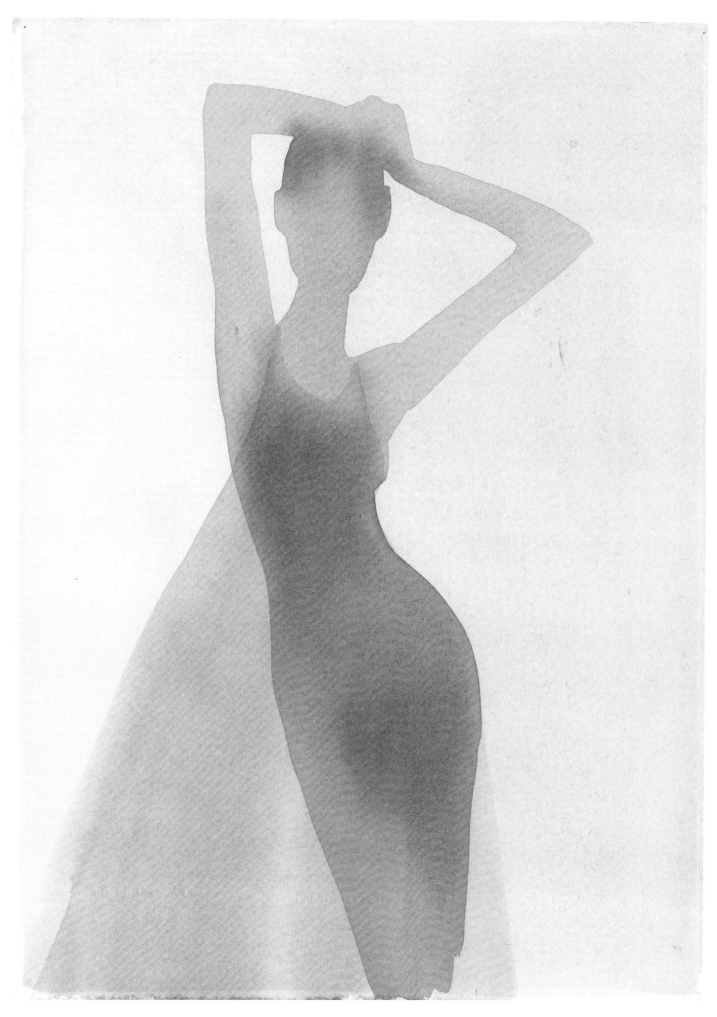

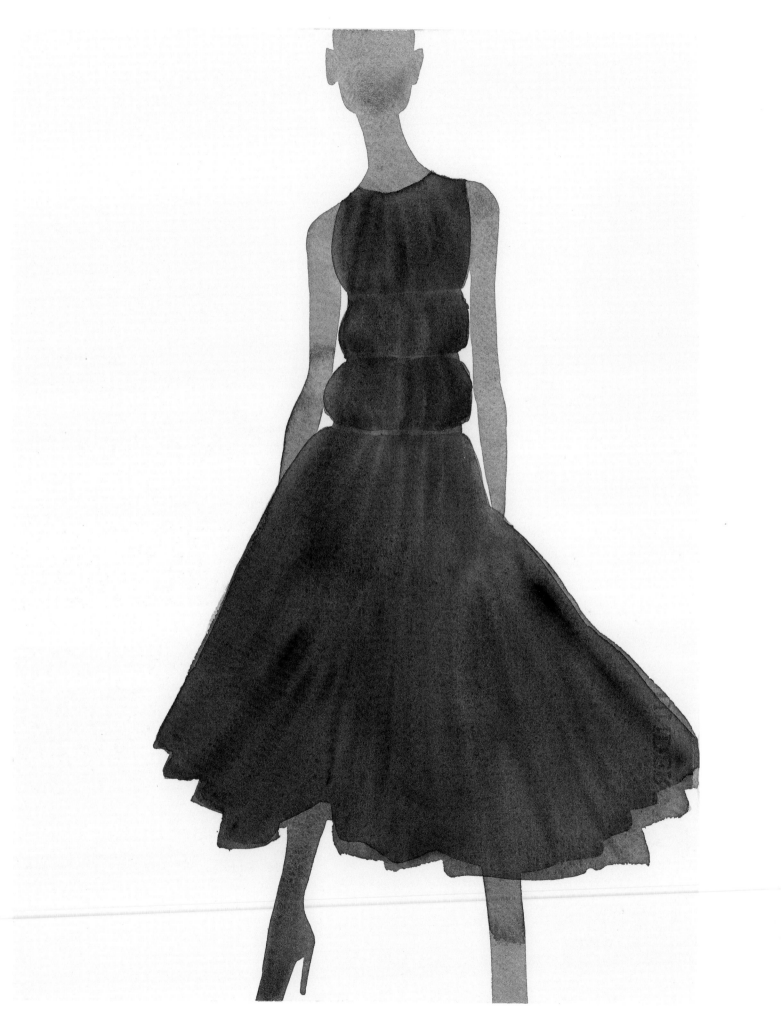

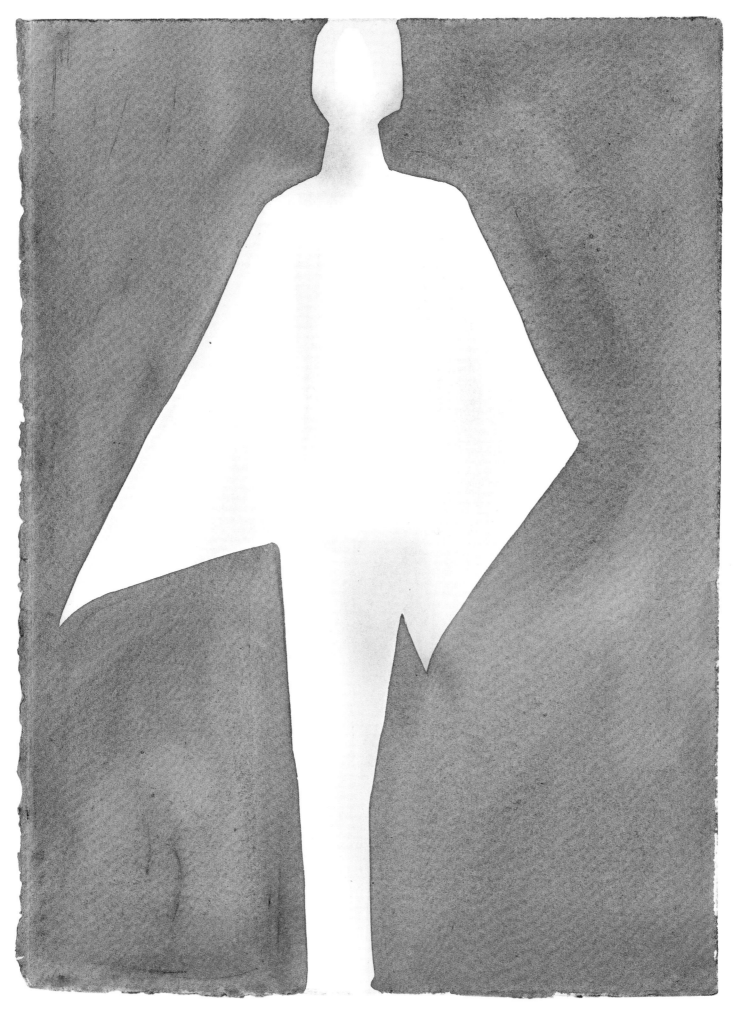

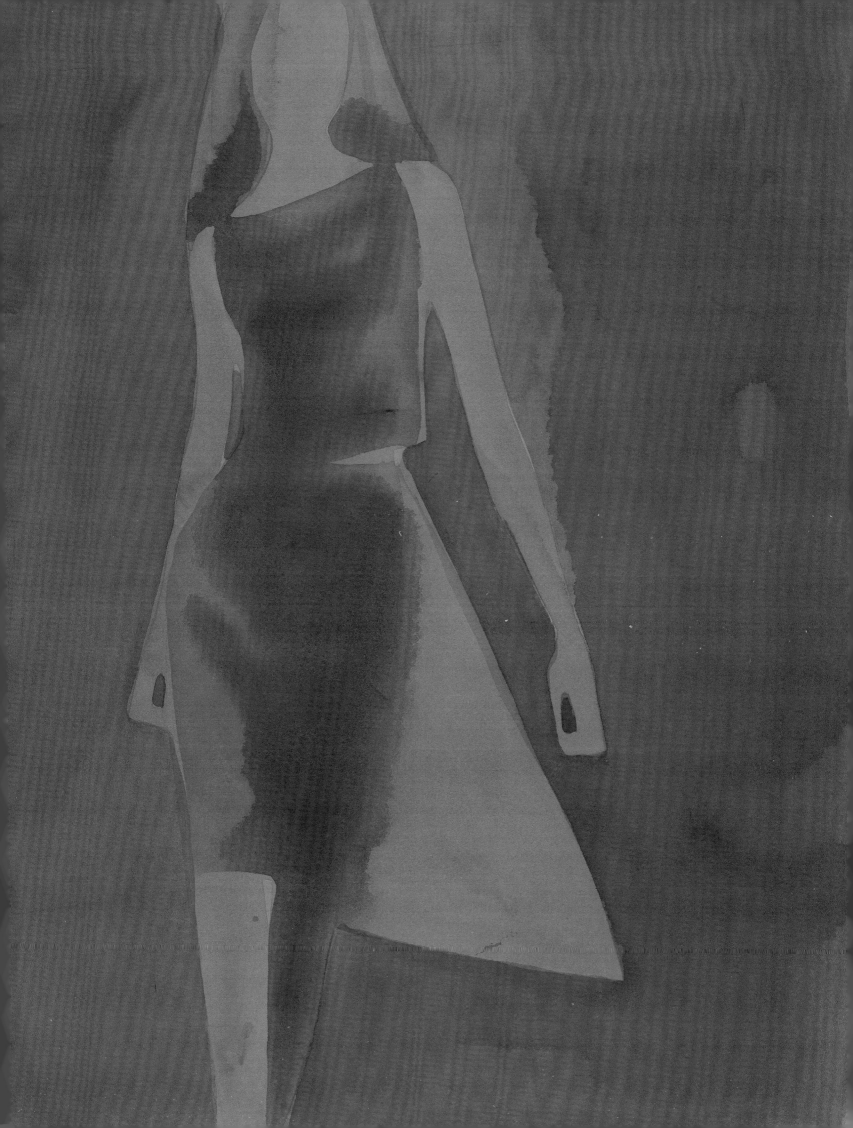

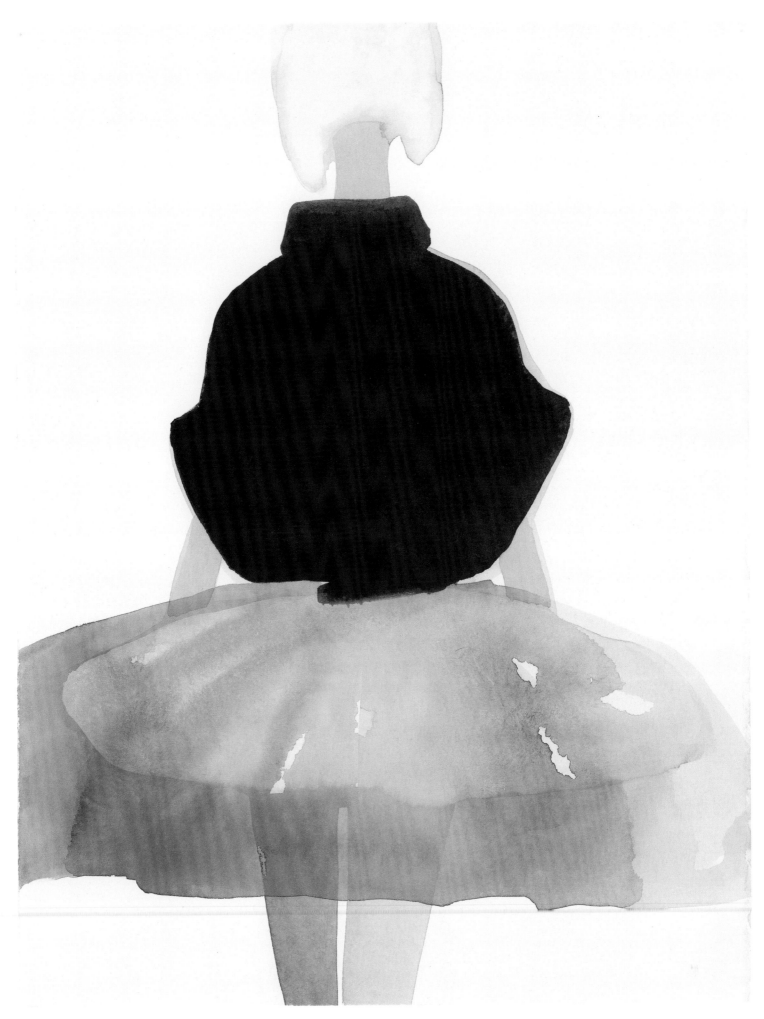

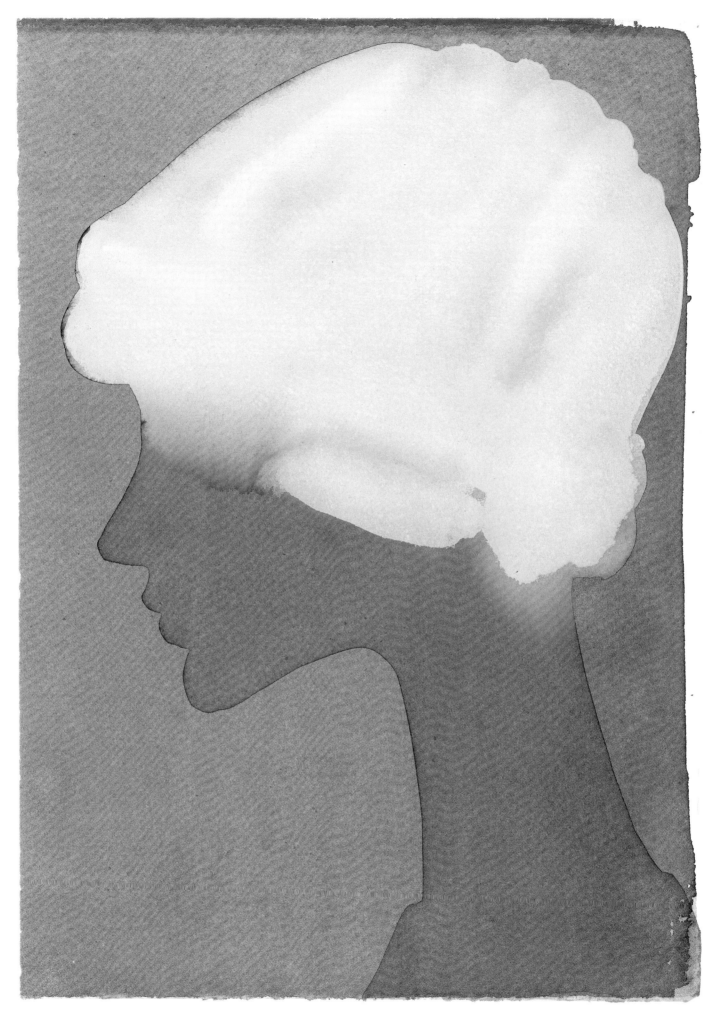

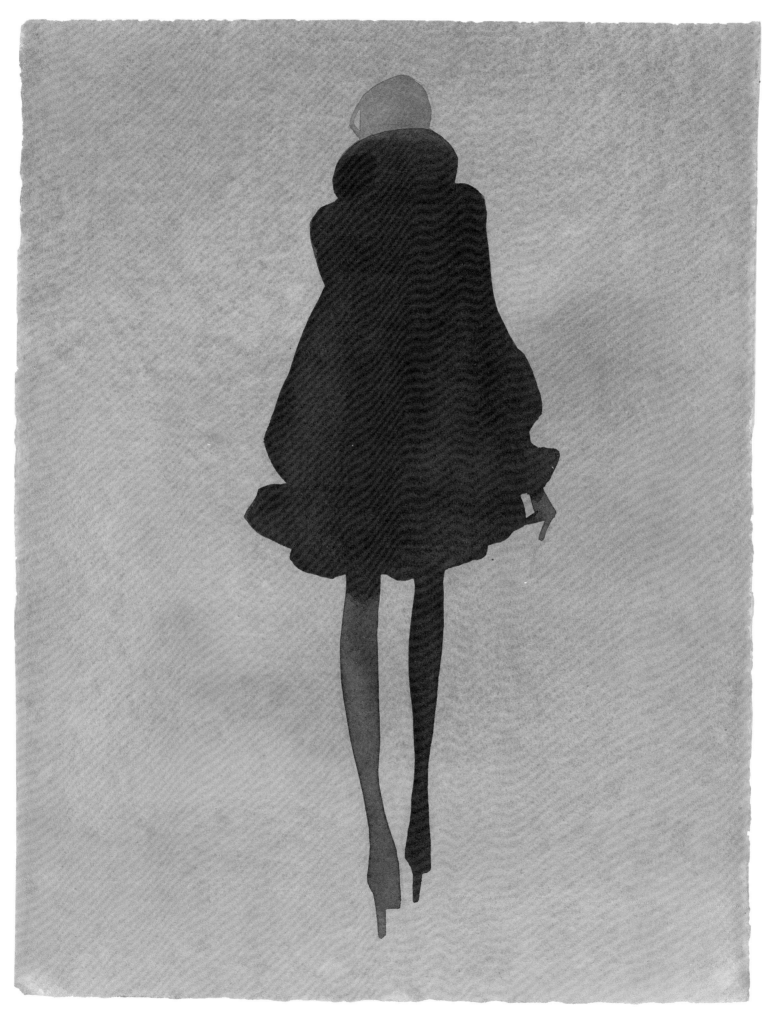

FRANÇOIS BERTHOUD

FRANÇOIS ANALYSES HIS SUBJECT IN DEPTH AND WITH AN ELEGANT SENSE OF DETACHMENT BEFORE RECREATING IT IN HIS ATELIER-LABORATORY. THE RESULT IS AN ULTRAMODERN FASHION X-RAY. ... HE EXPERIENCES FASHION WITH A SHARP SENSE OF IRONY AND A VISUAL CULTURE ROOTED IN CONCEPTUAL ART AND GERMAN EXPRESSIONISM. BUT HIS STYLE IS TOTALLY NOW.

— *Anna Piaggi*

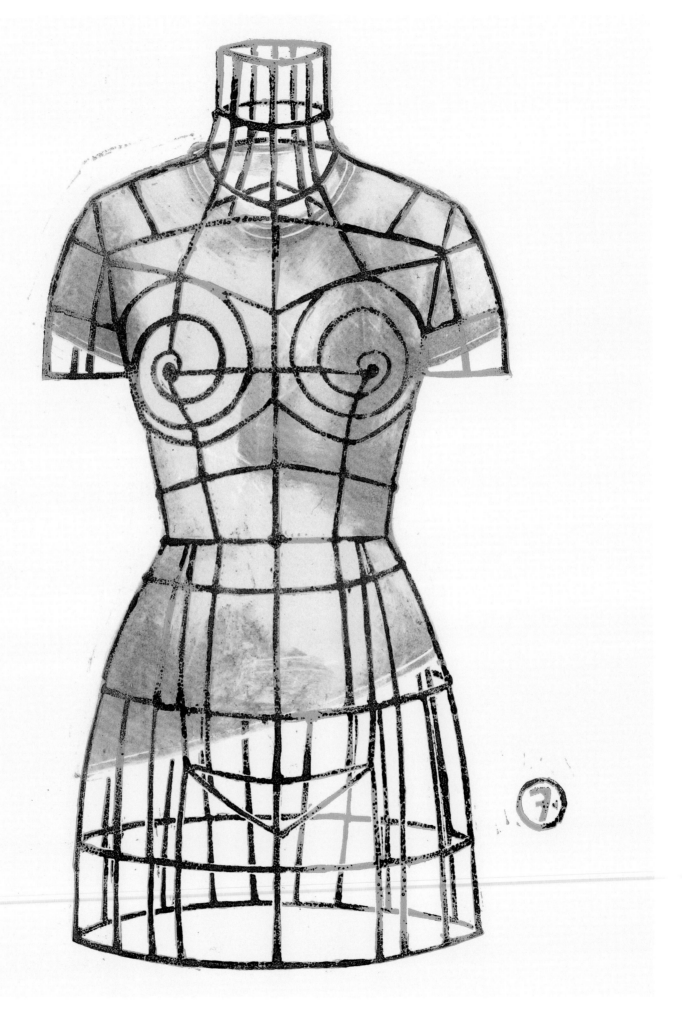

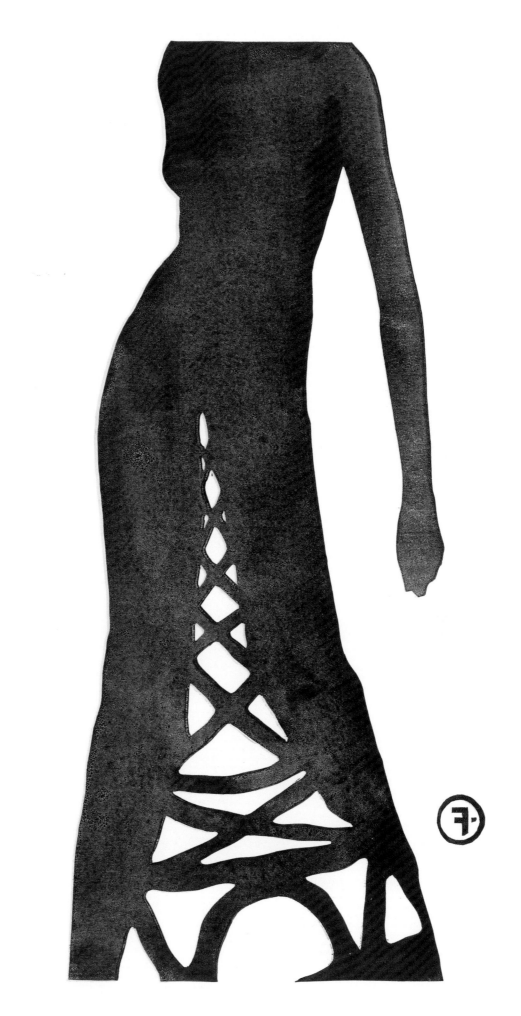

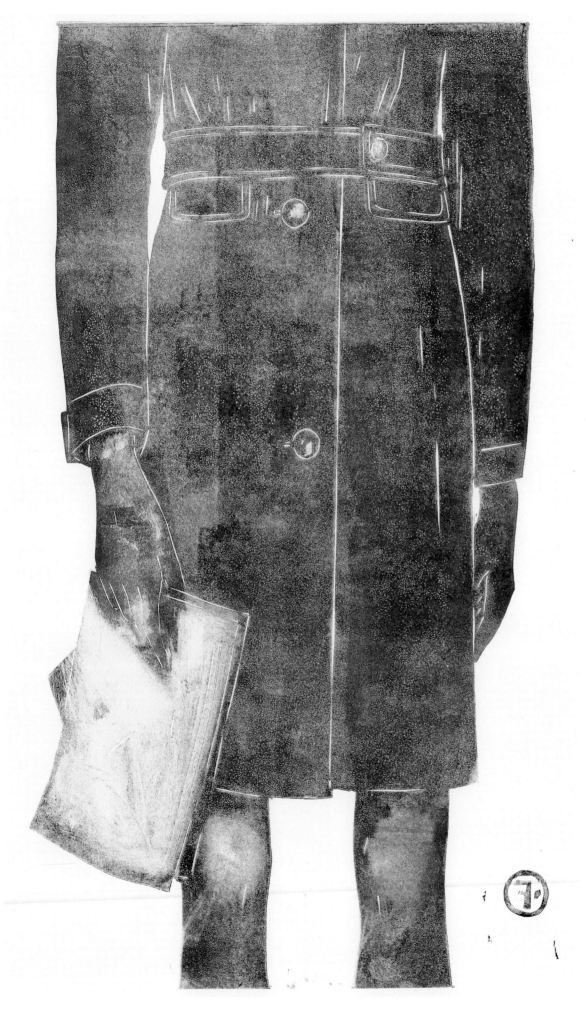

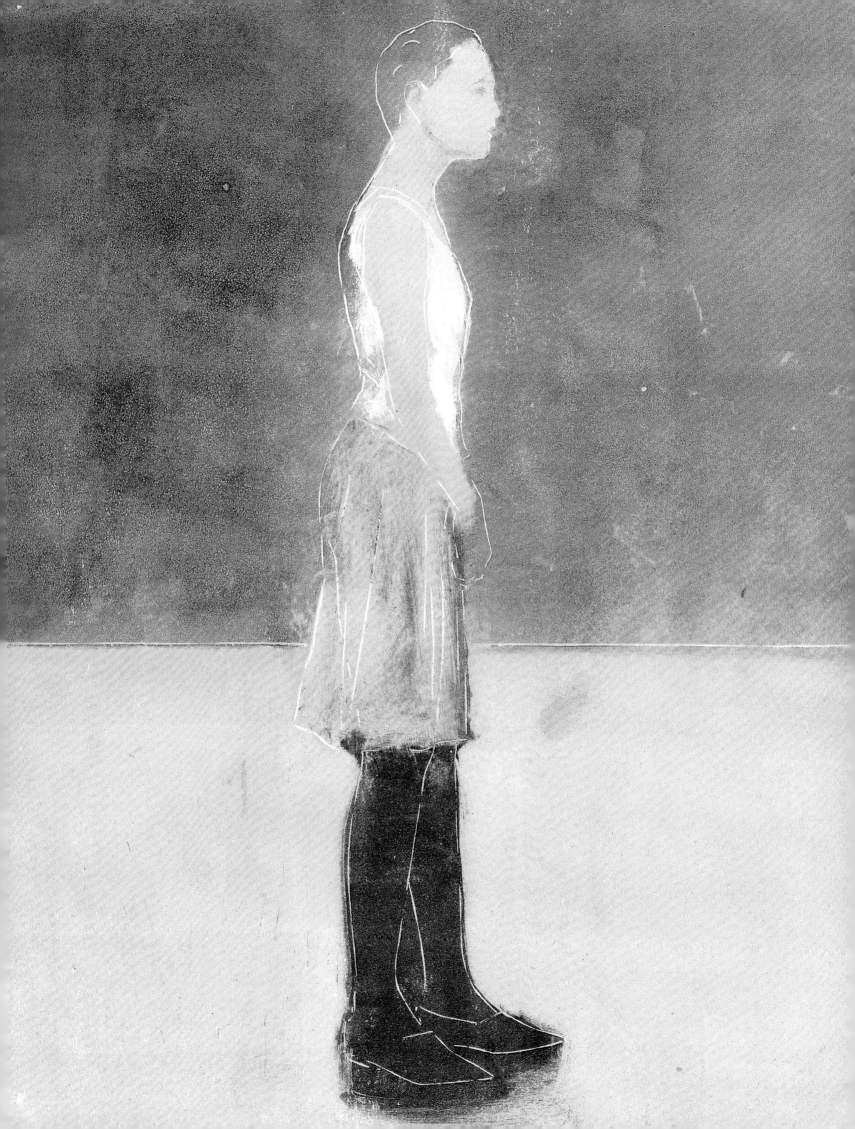

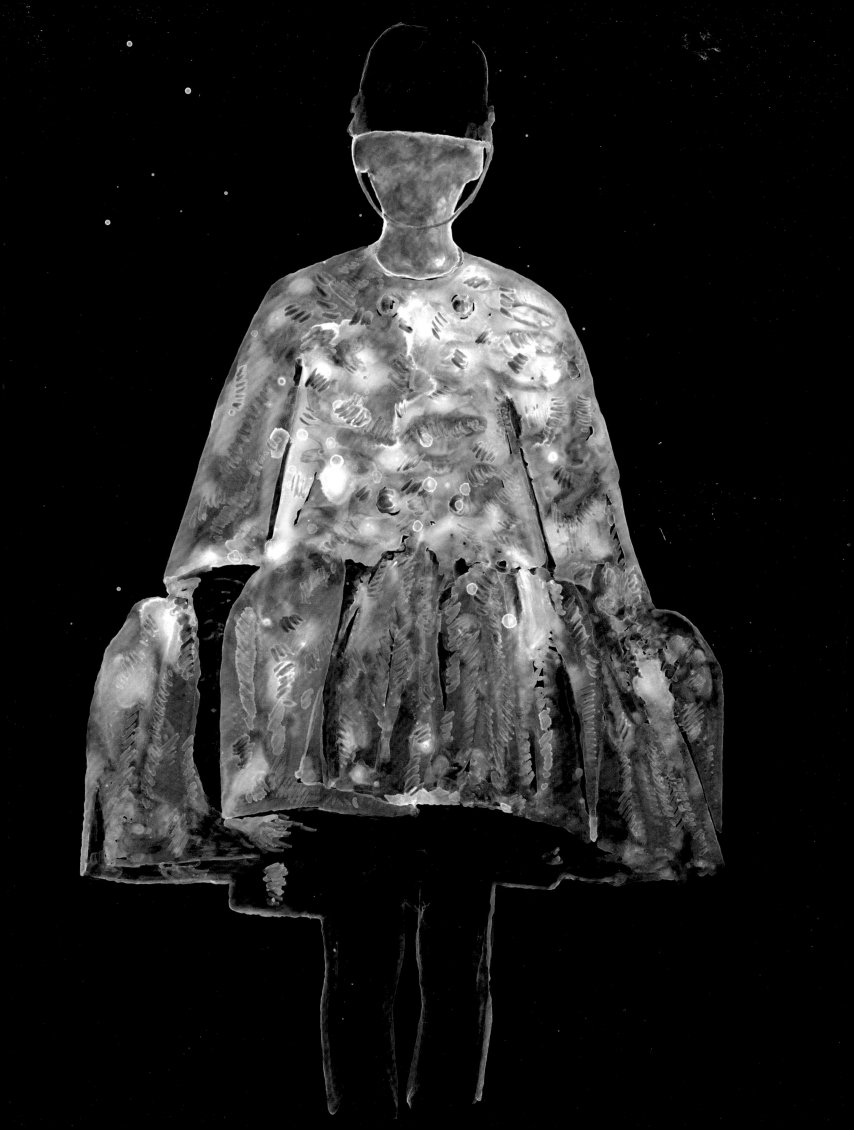

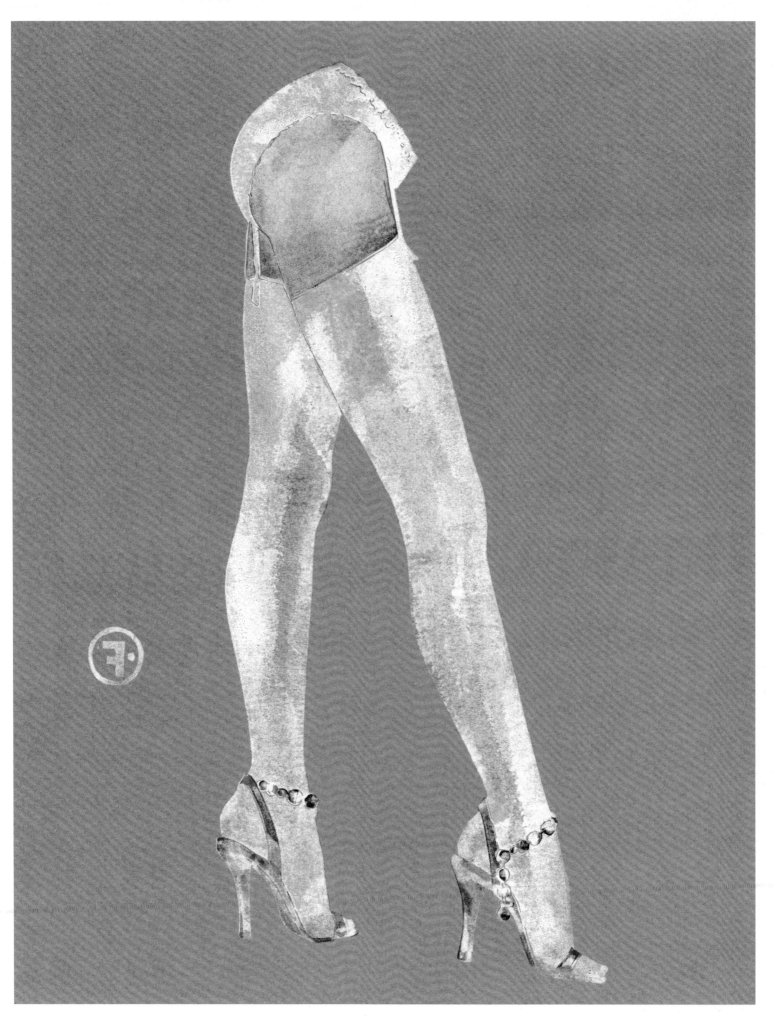

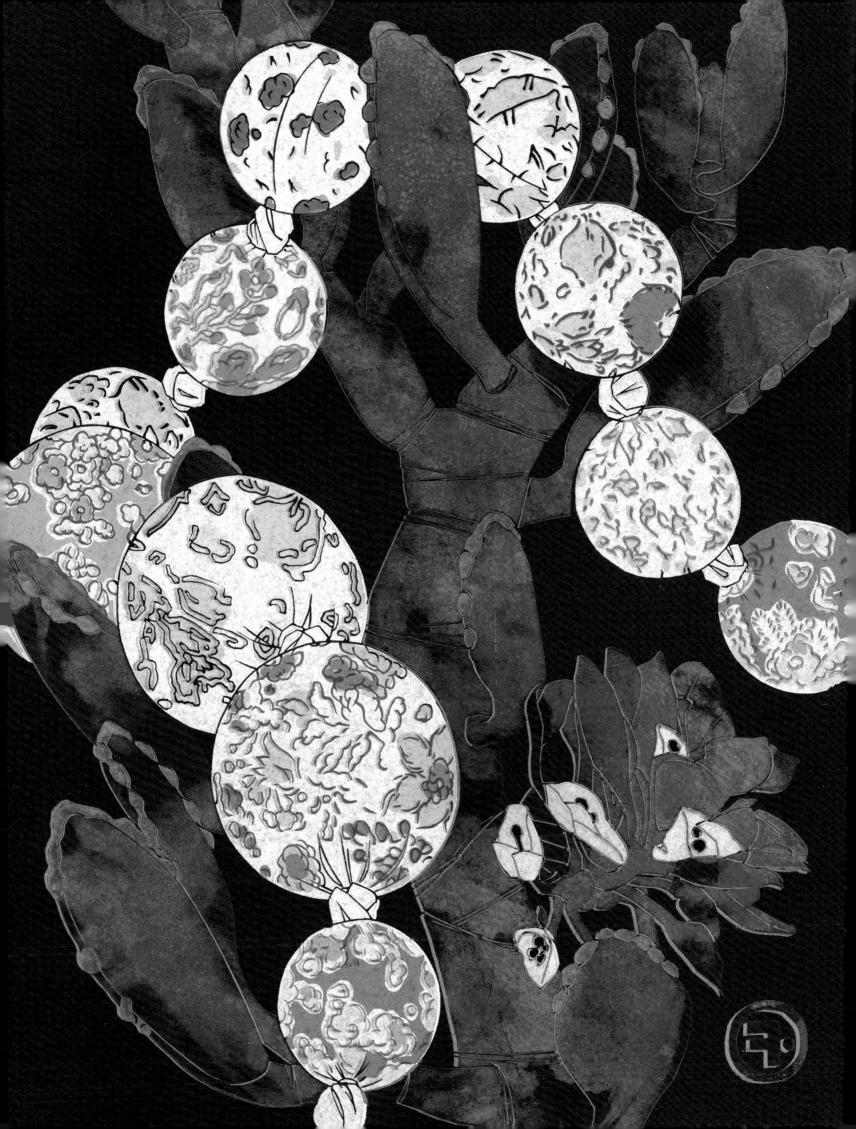

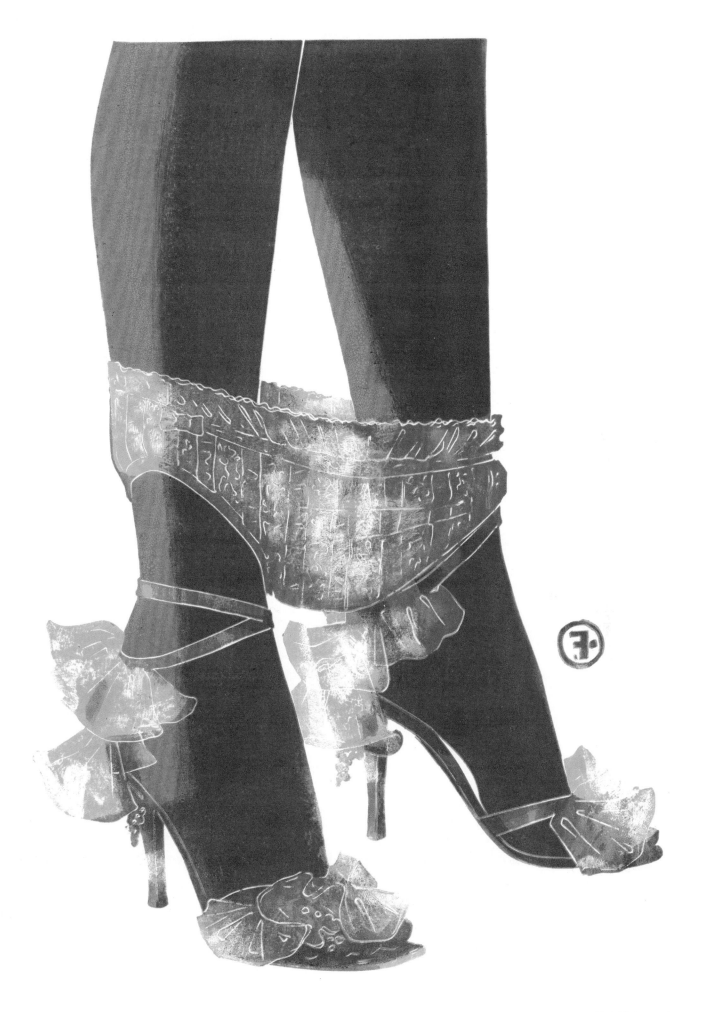

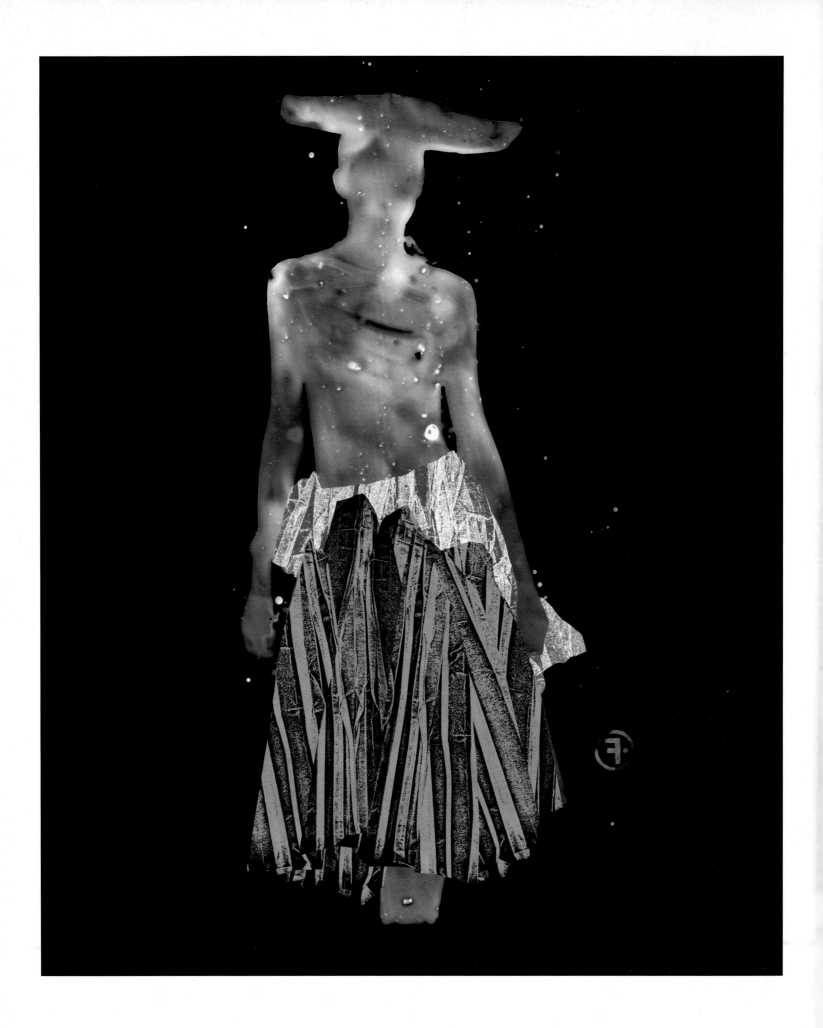

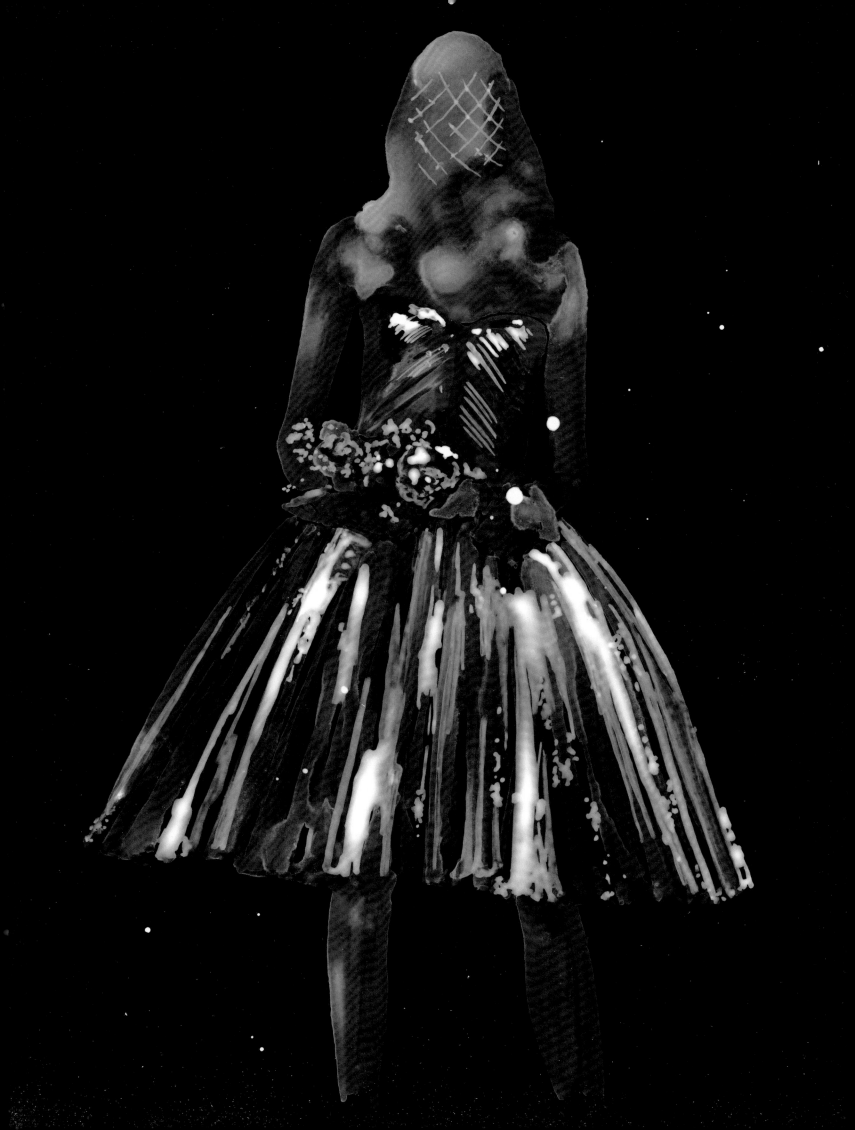

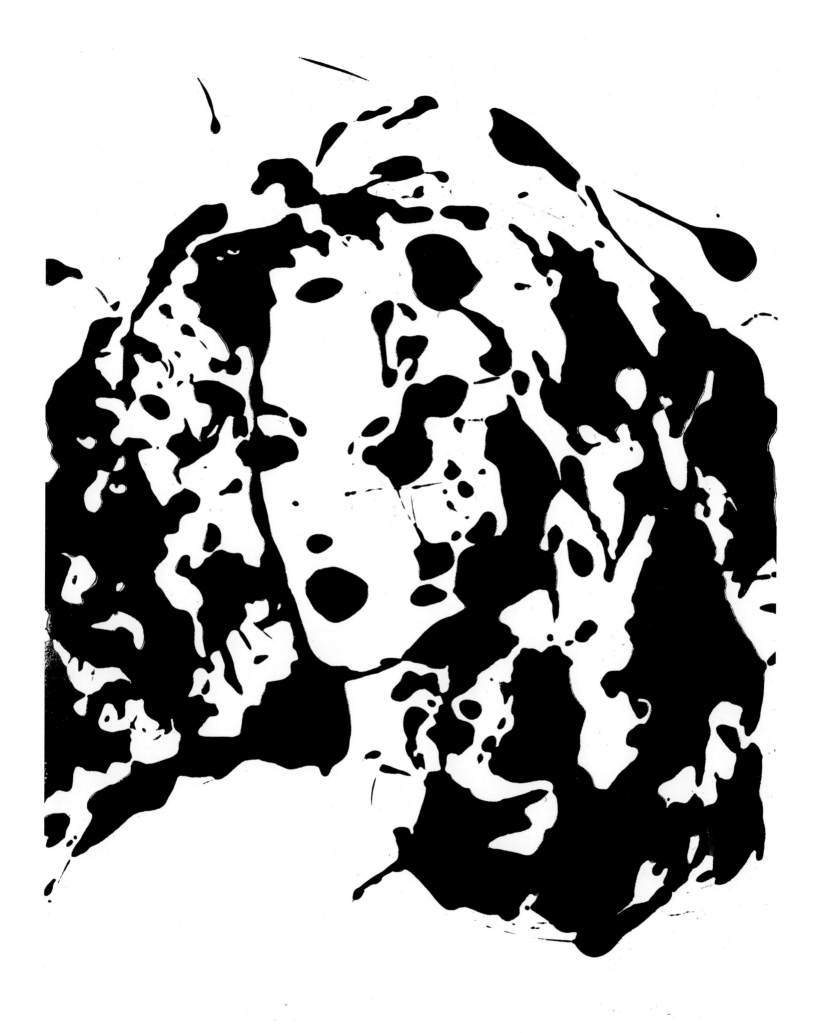

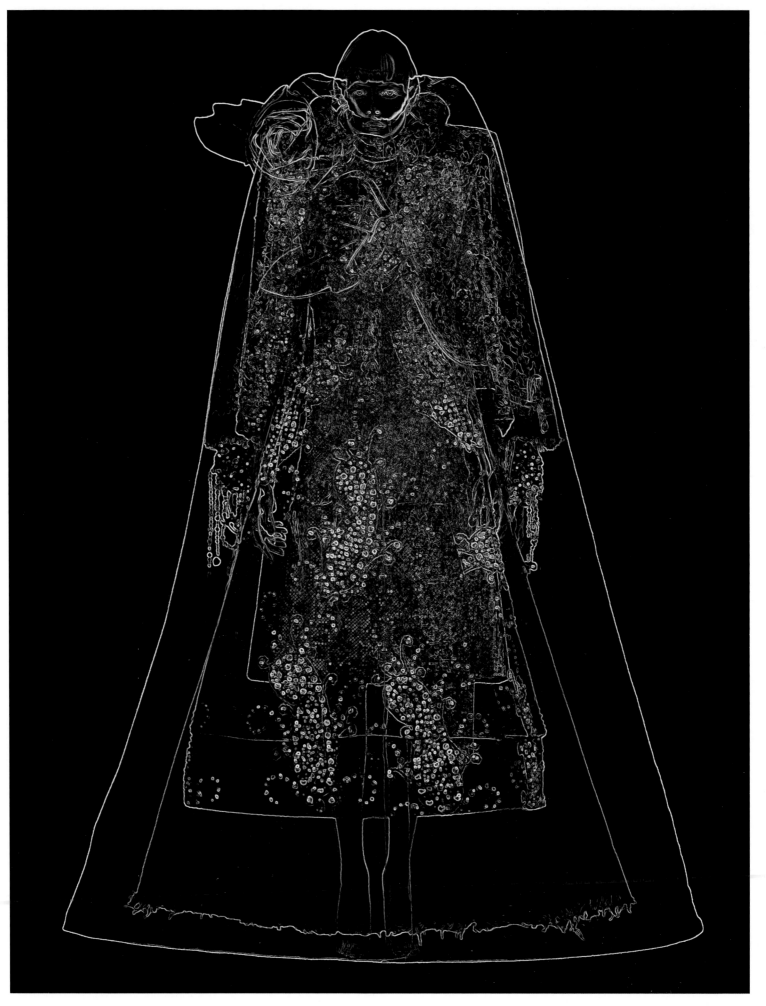

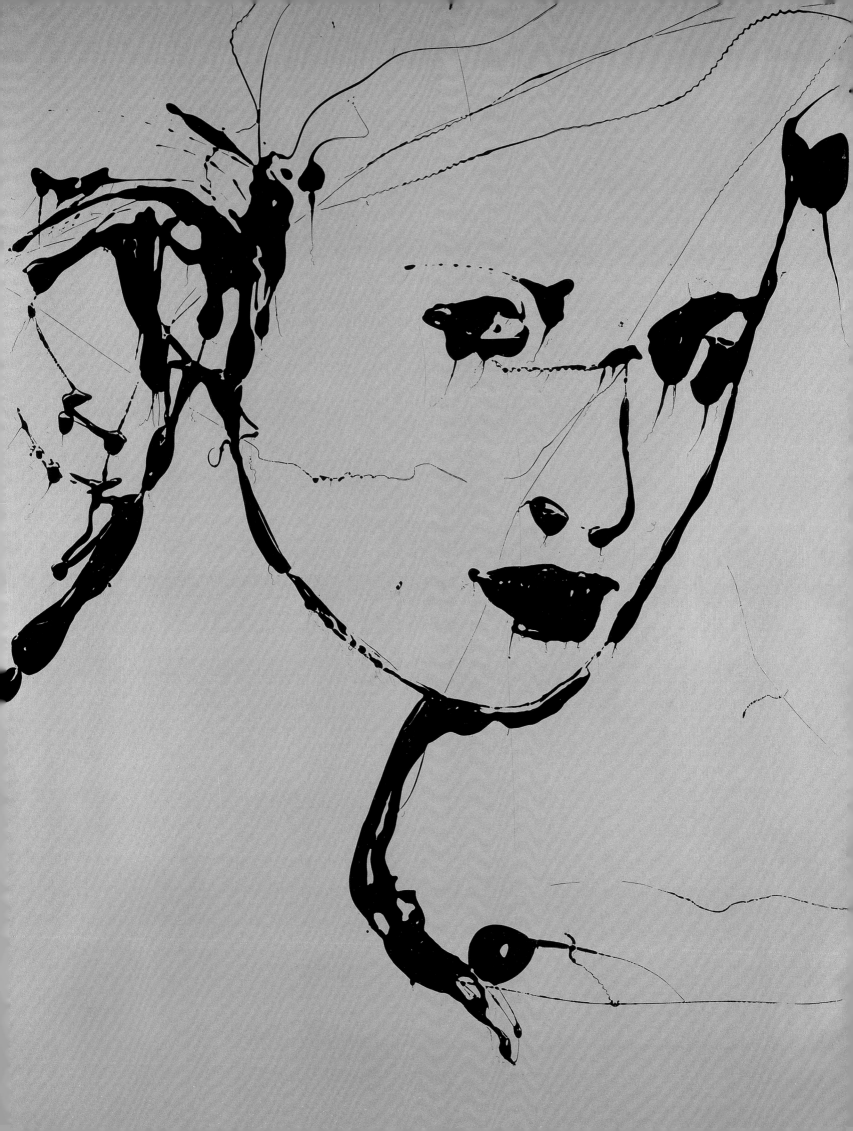

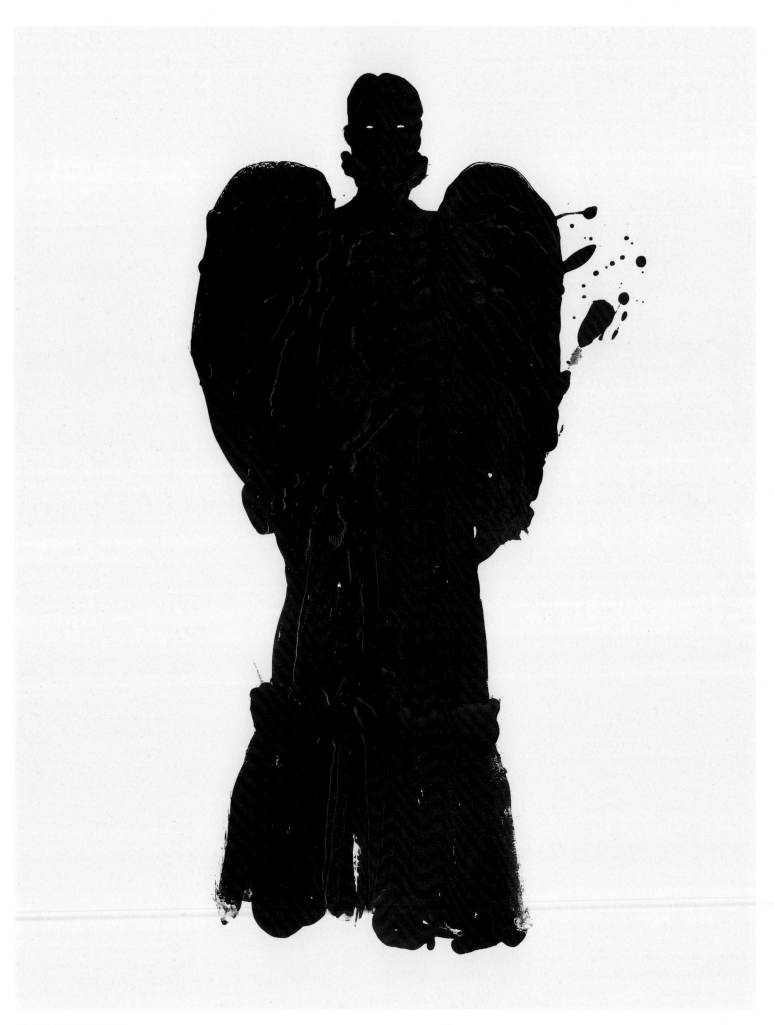

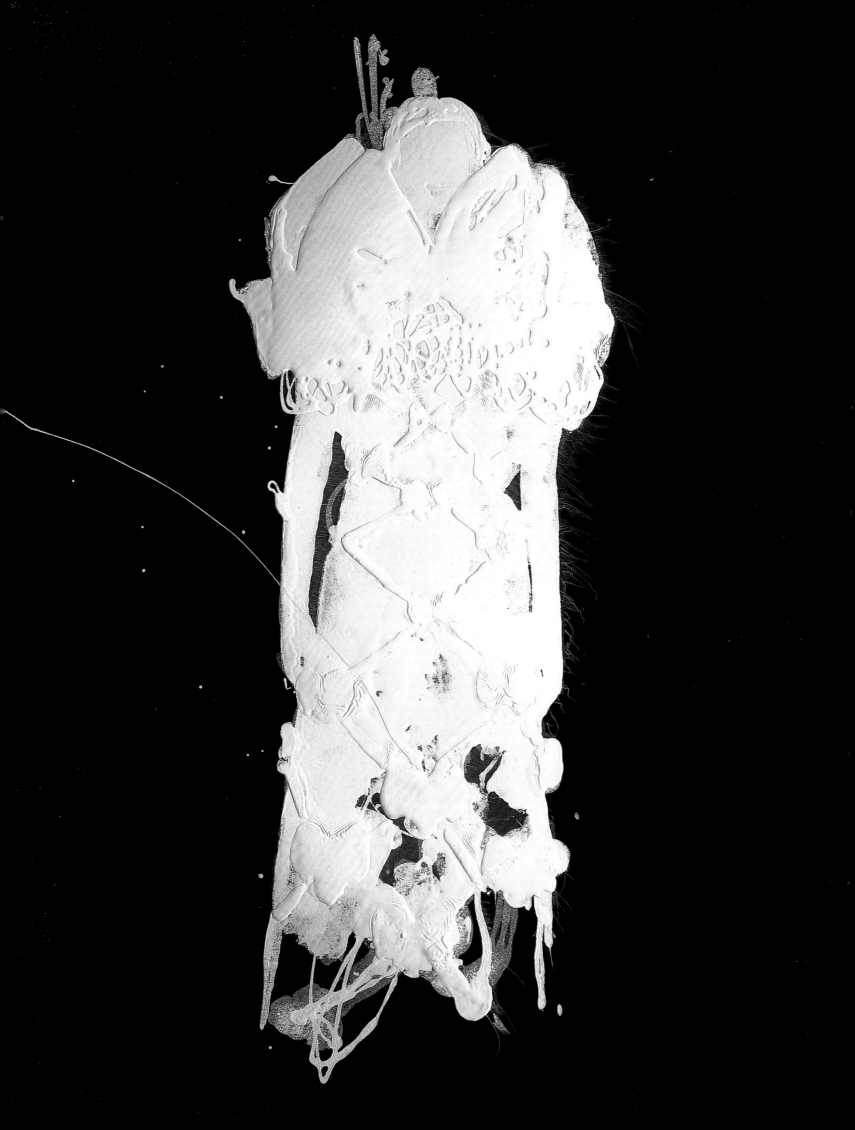

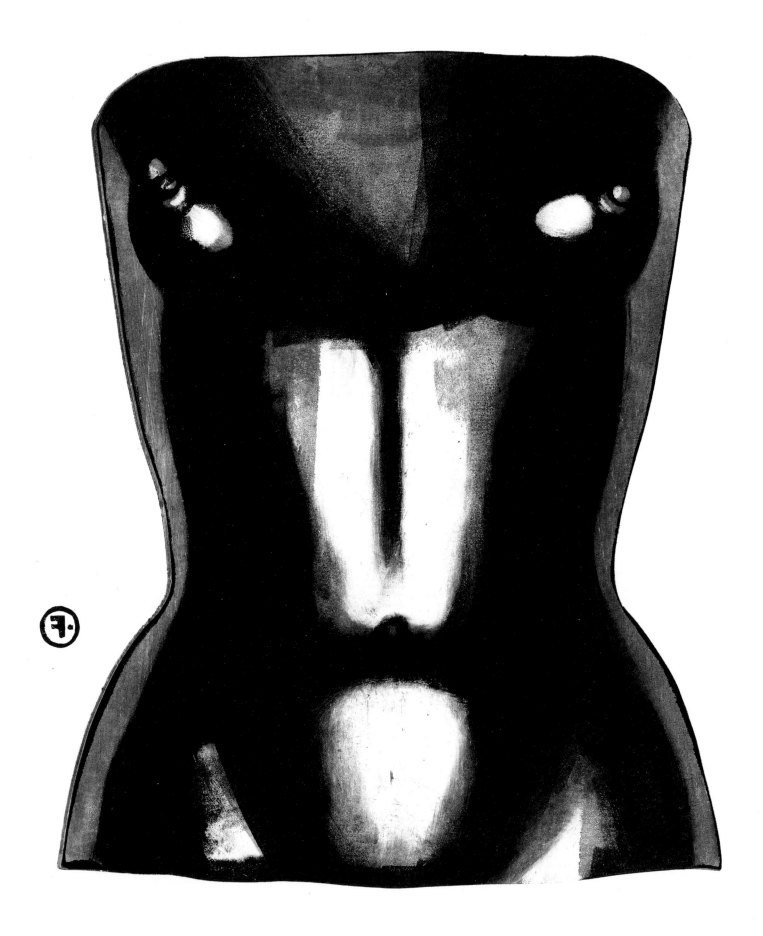

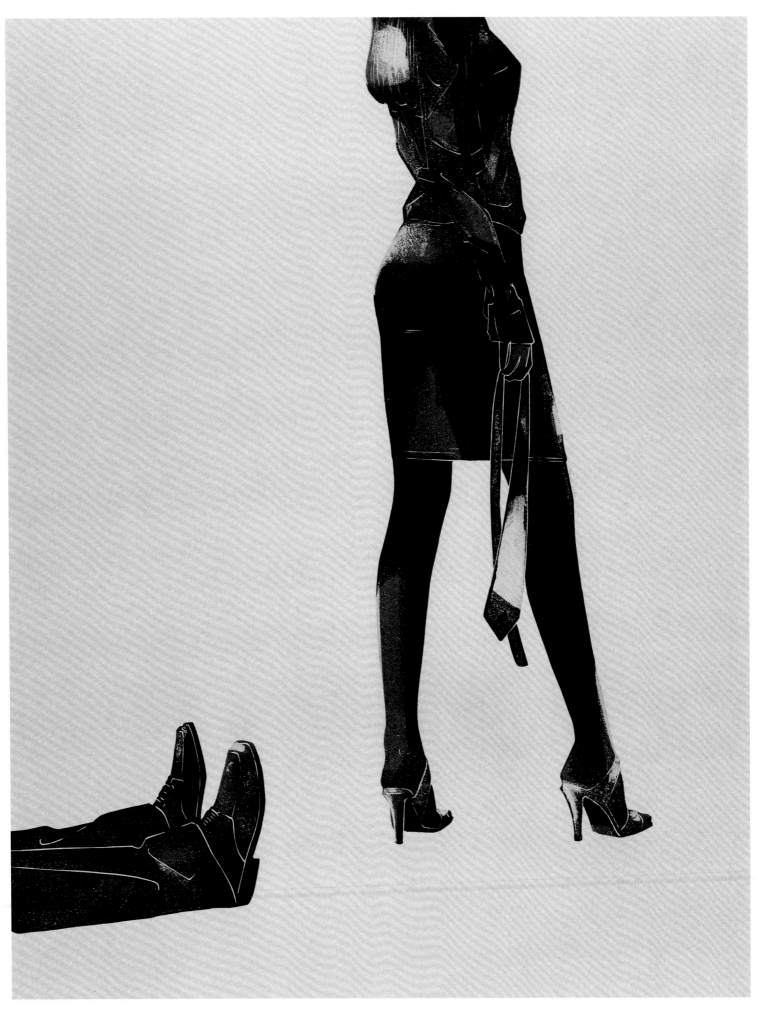

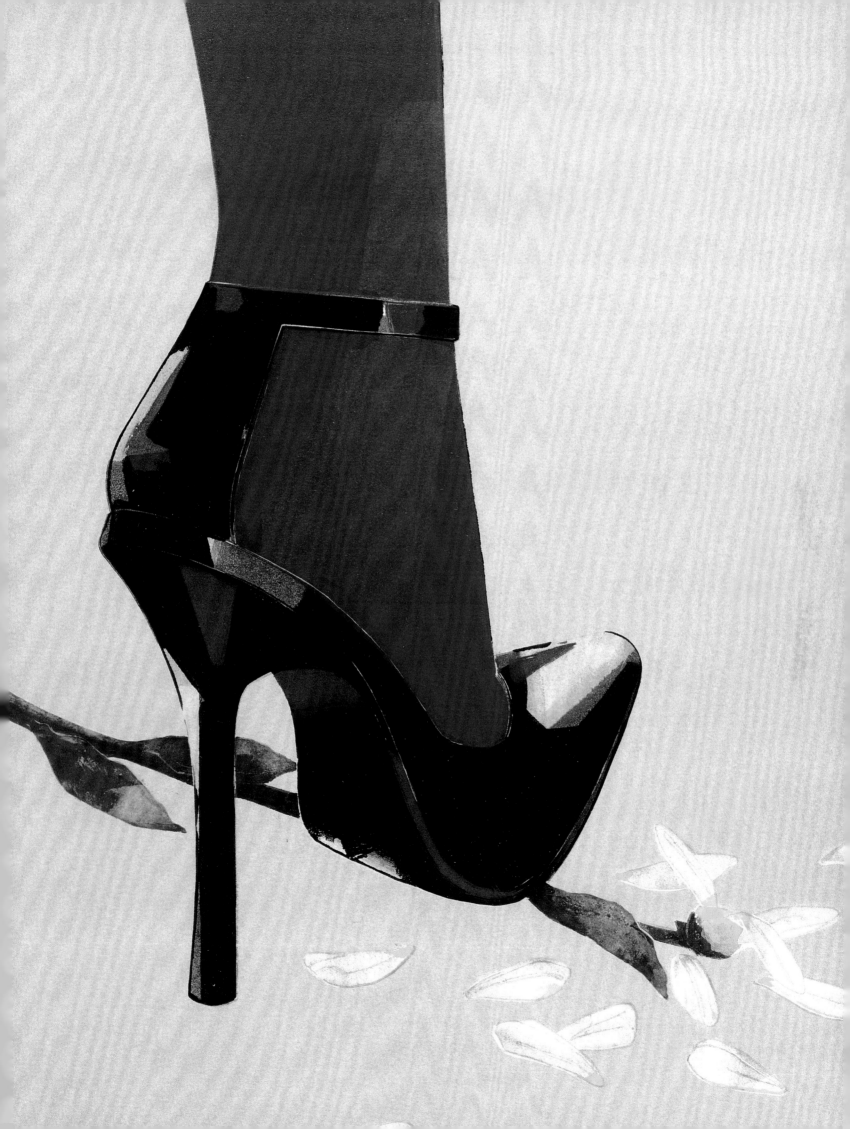

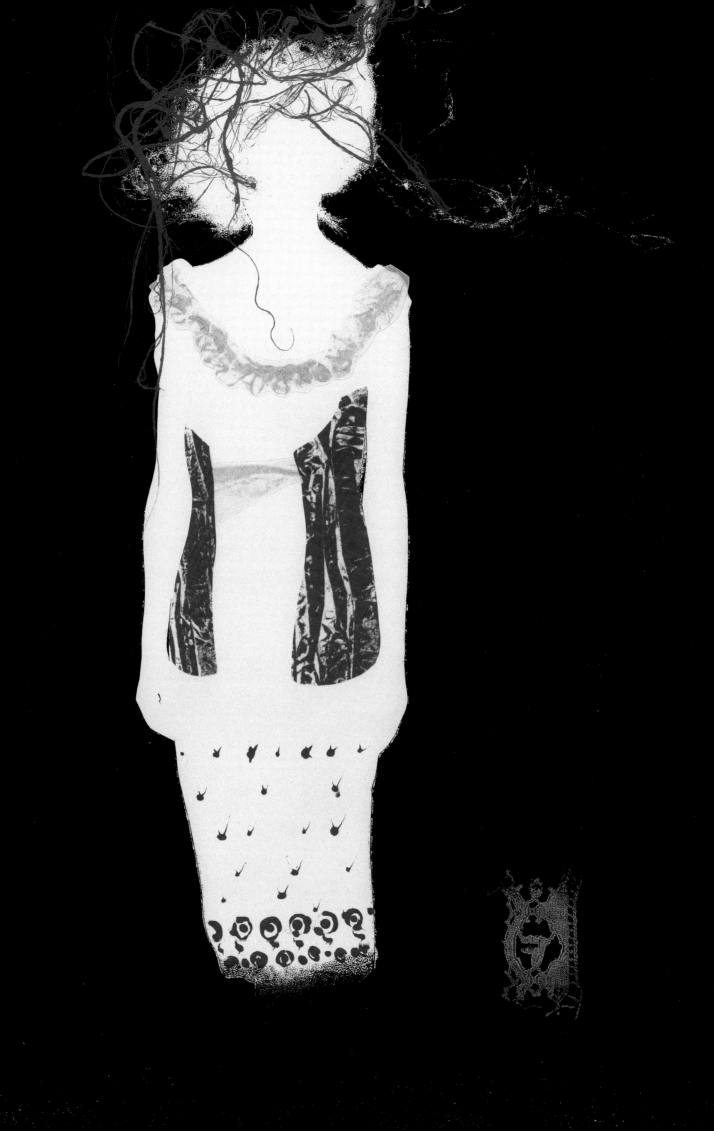

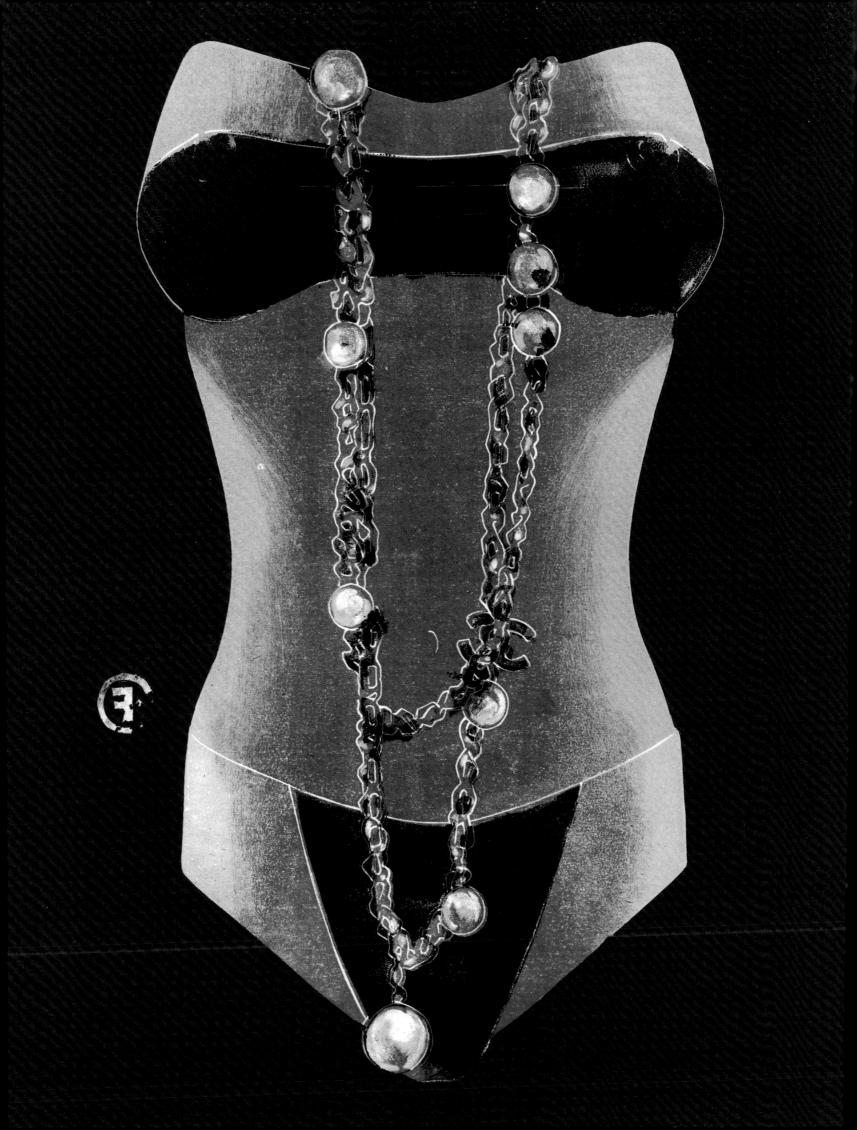

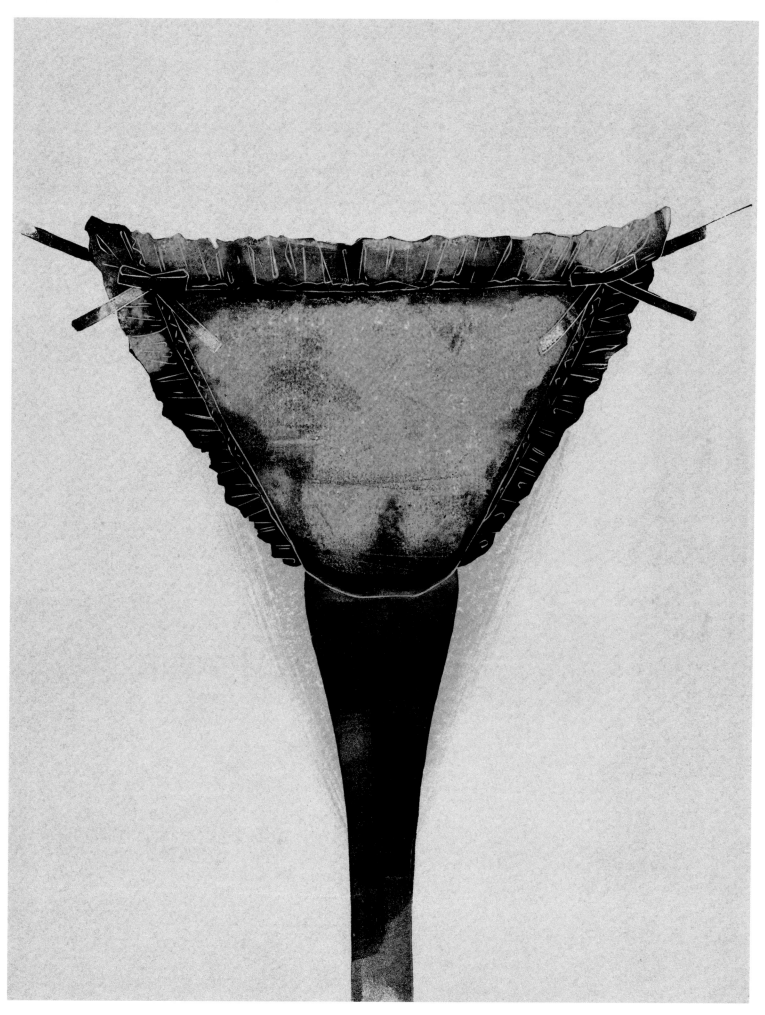

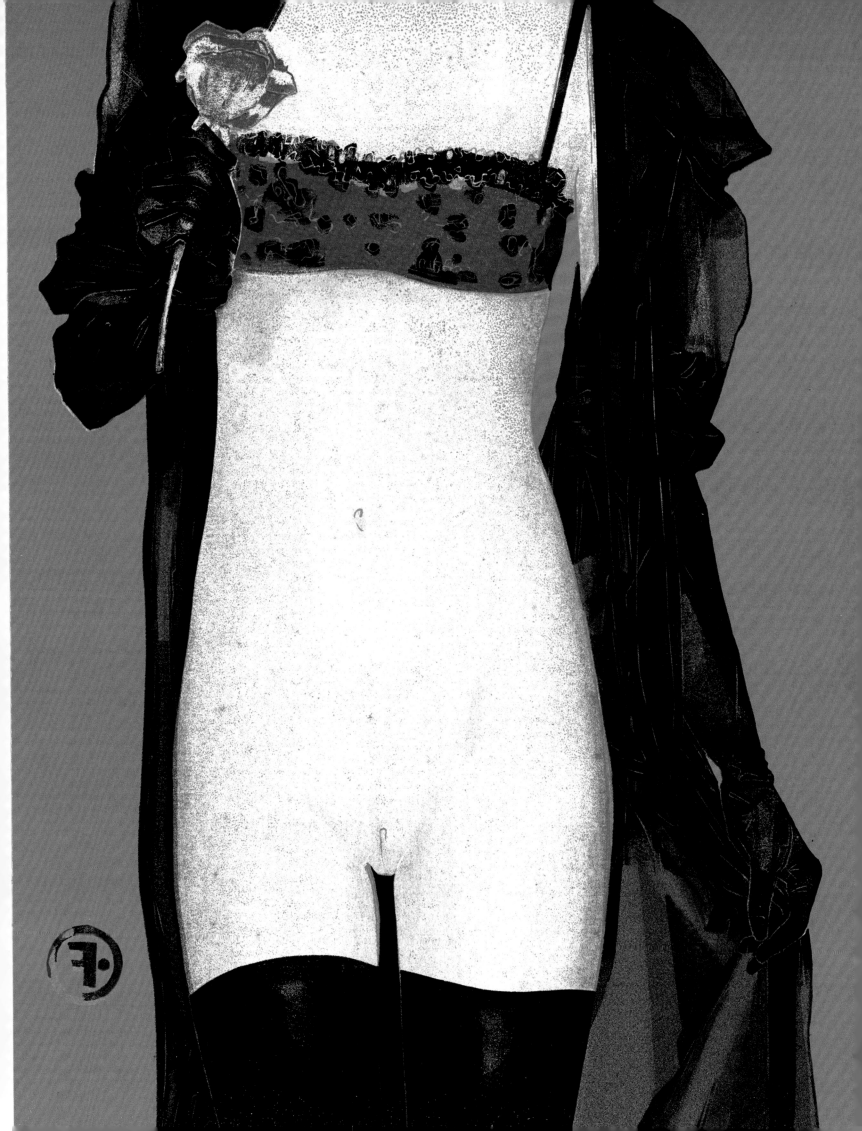

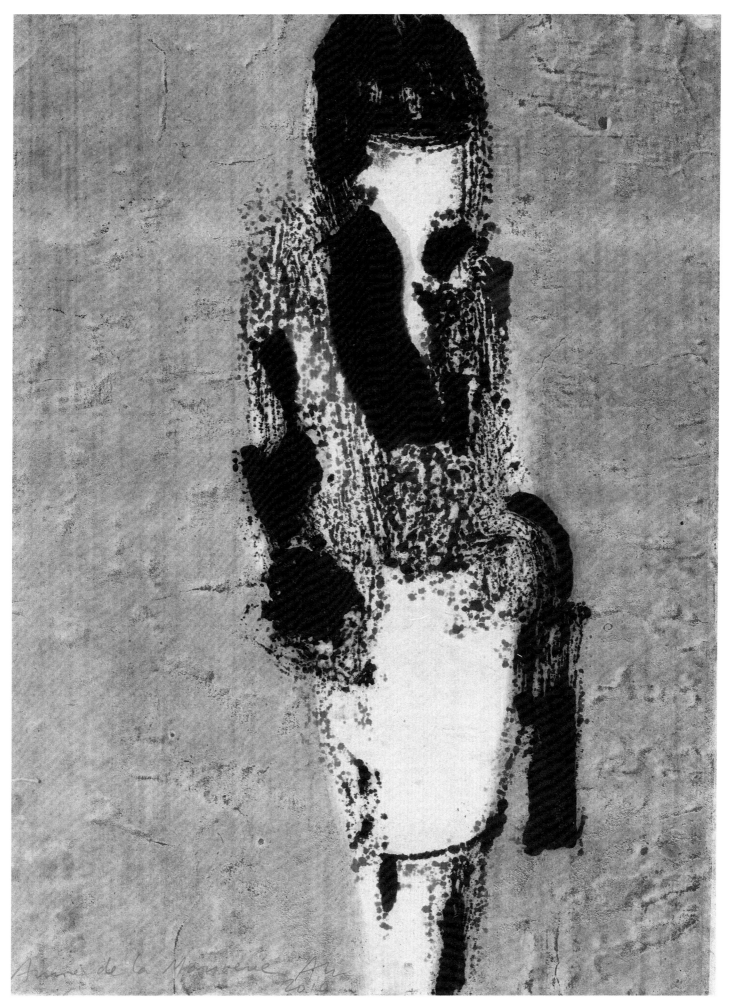

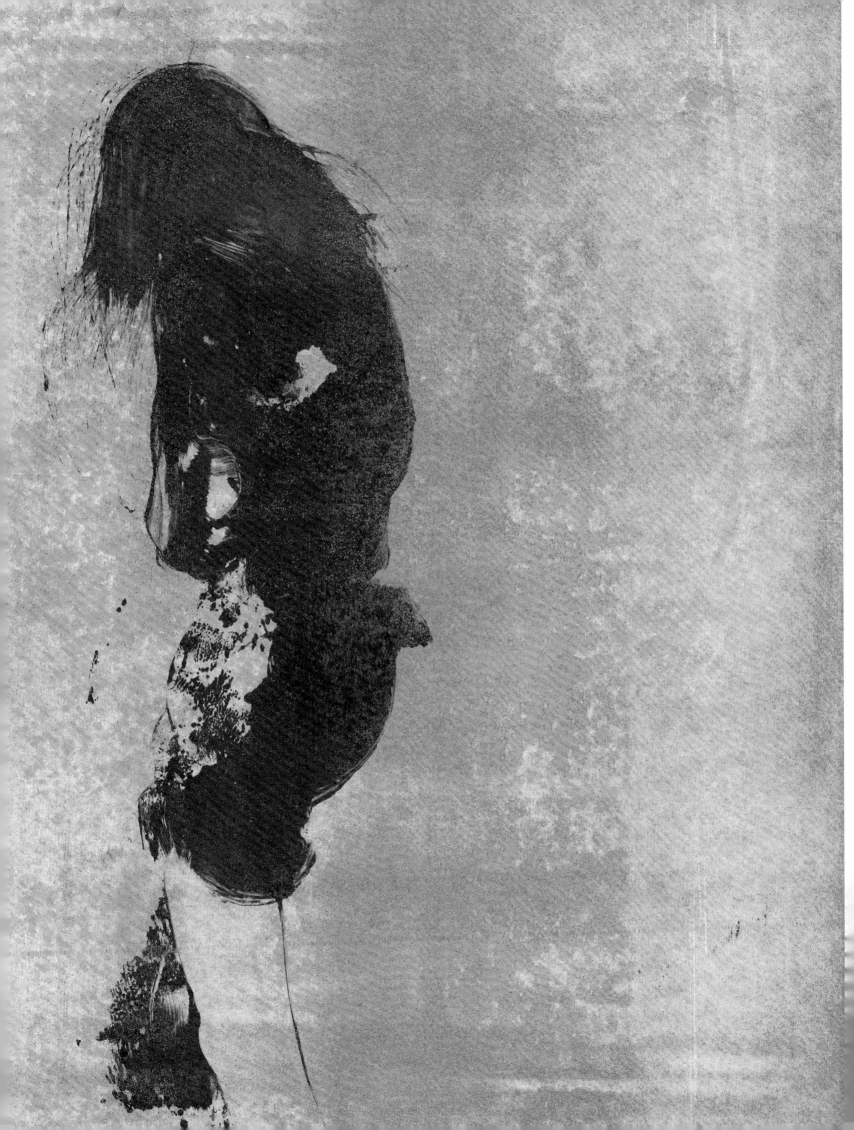

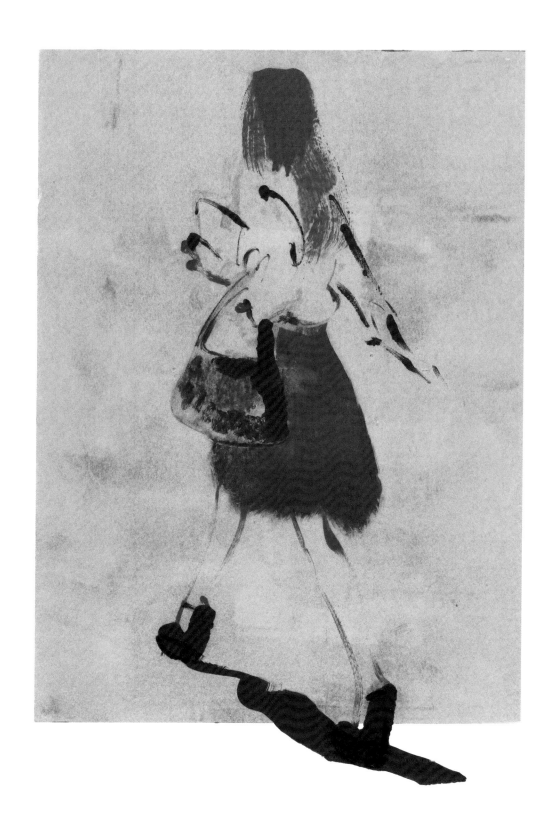

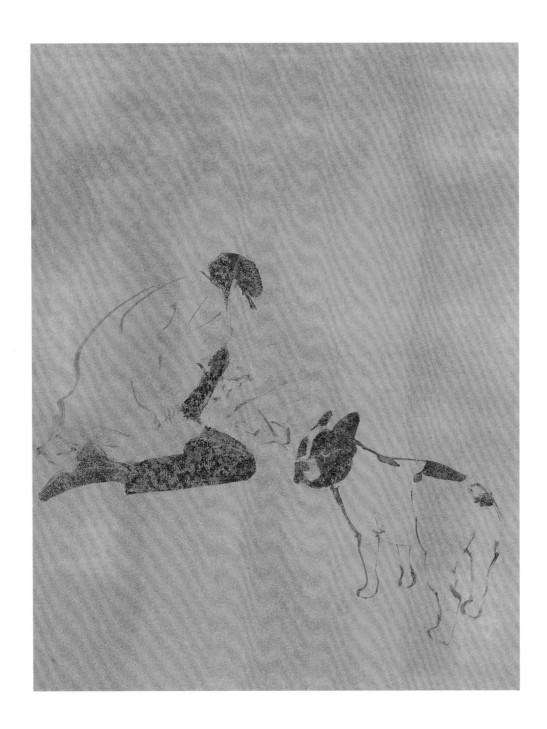

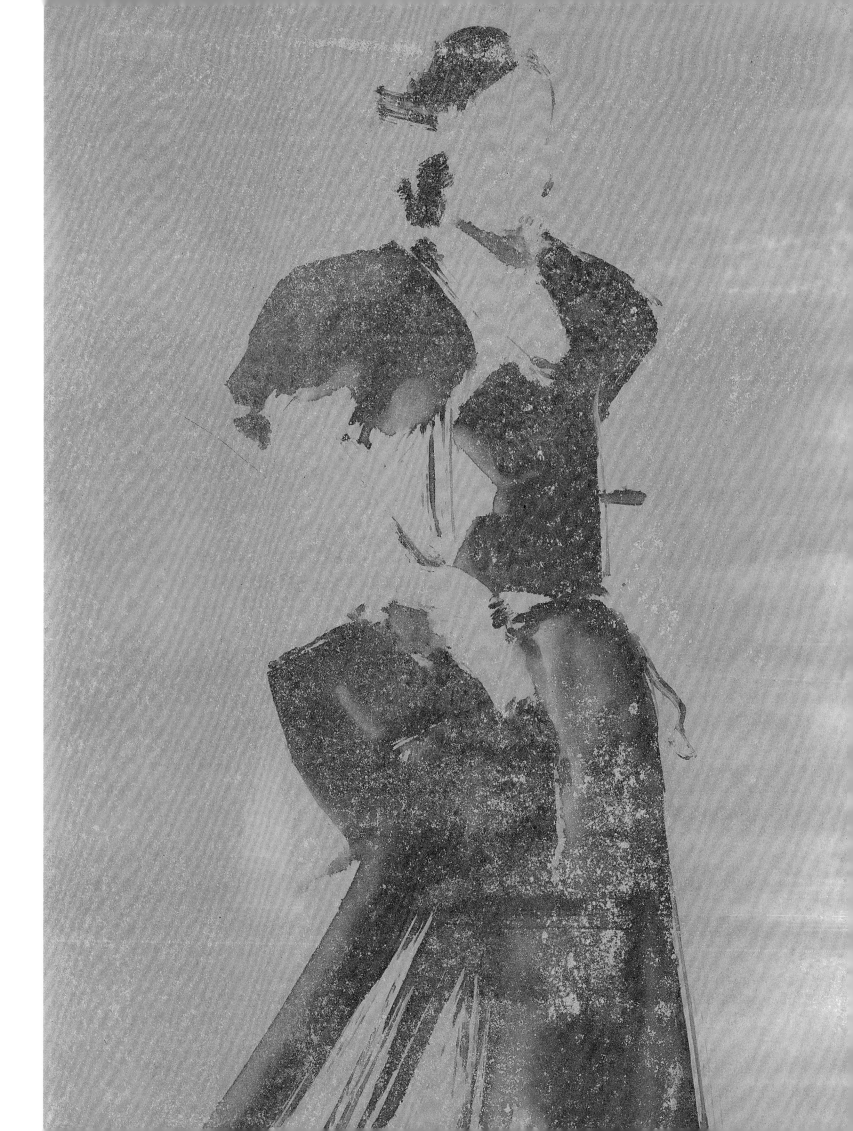

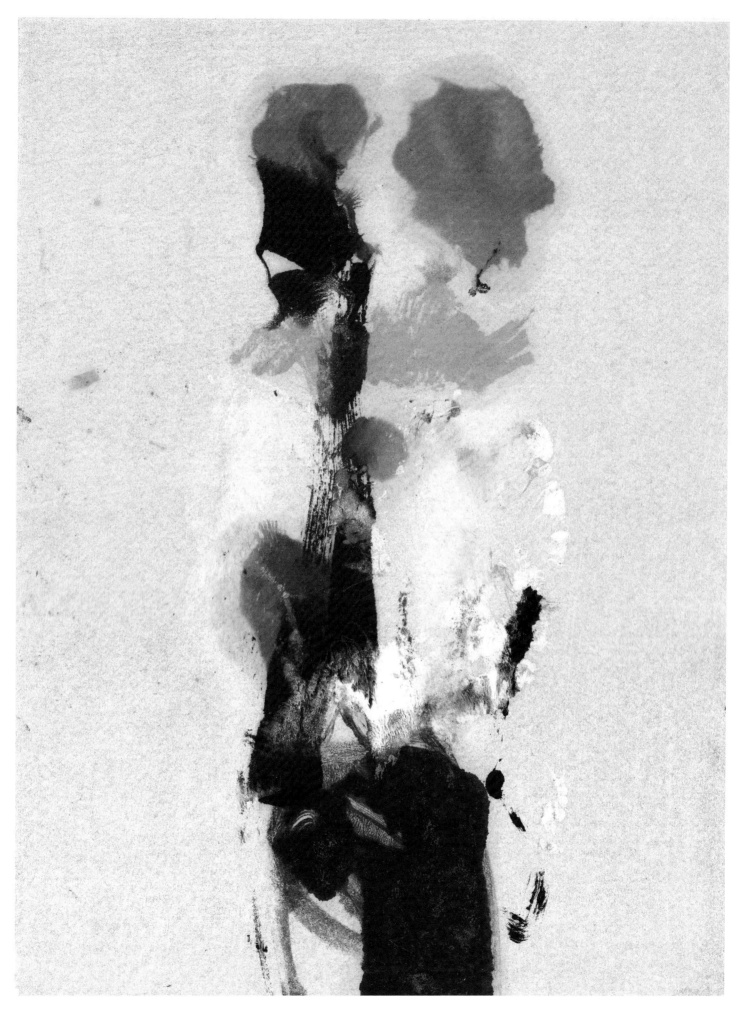

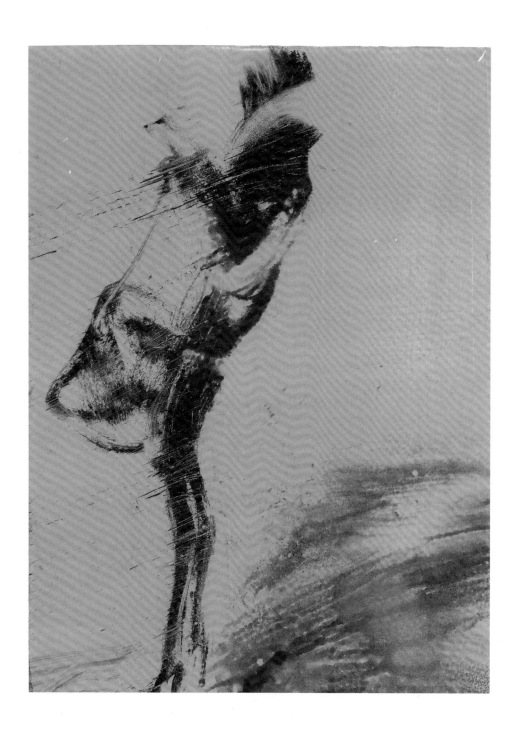

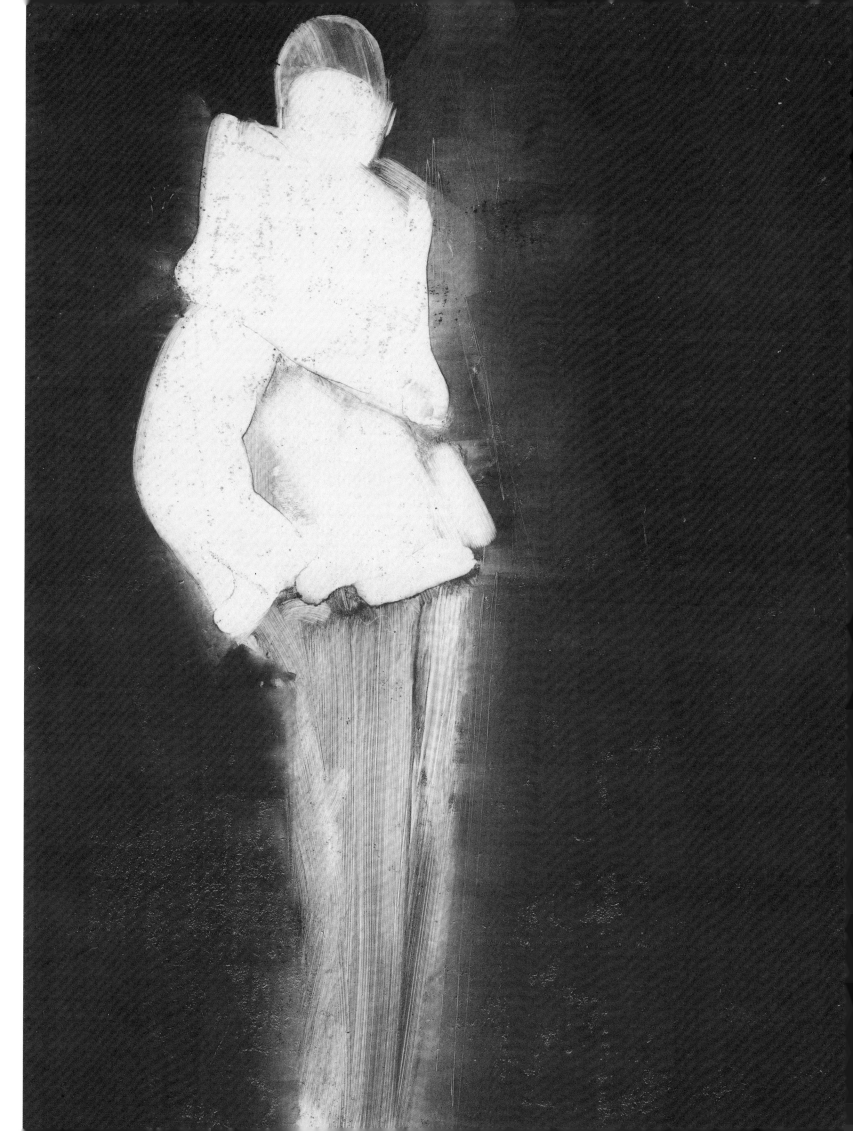

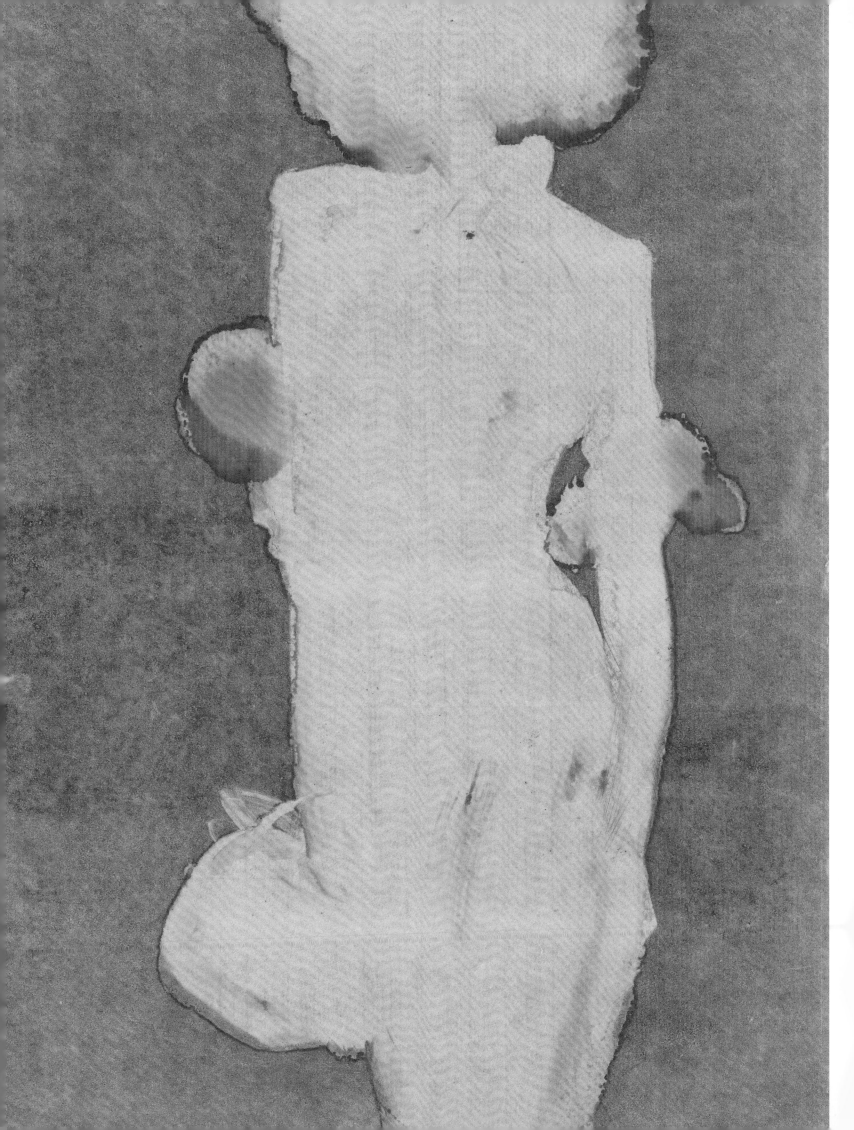

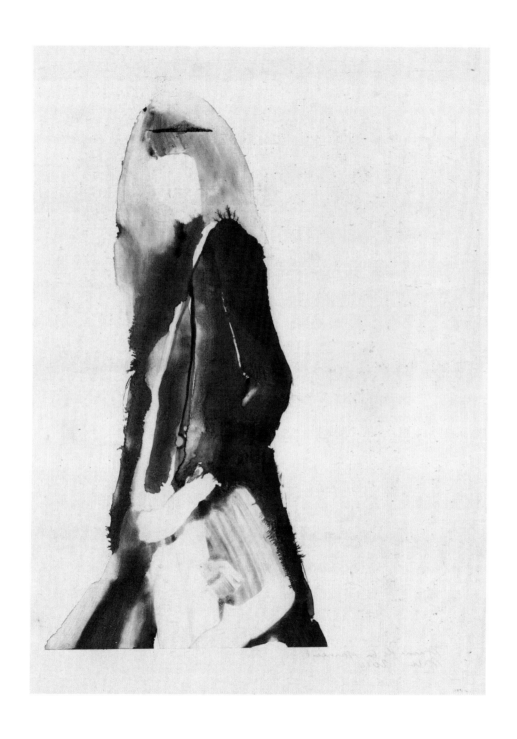

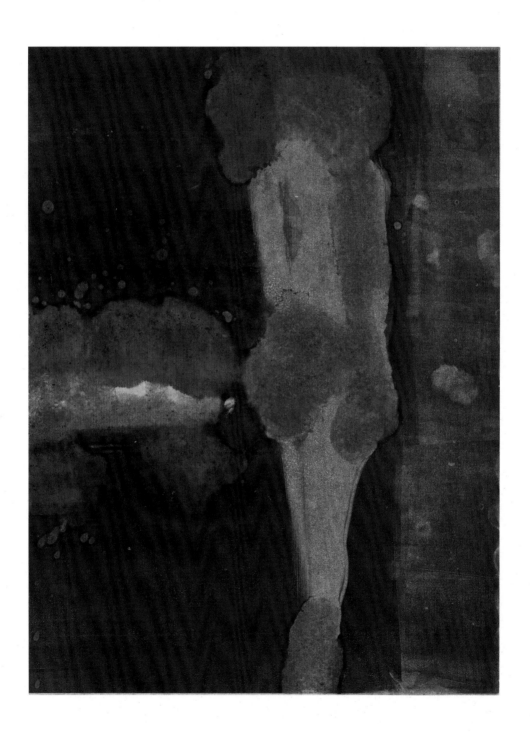

APPENDIX

LIST OF WORKS

Unless otherwise indicated, all the works in this publication are from the collection of Joëlle Chariau, Munich

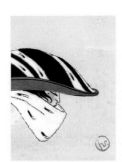

page 29
Georges Lepape
Chapeau de Poiret, 1912
Ink, pen and watercolour
12 x 19 cm
Published in *La Gazette du Bon Ton* (First Issue)

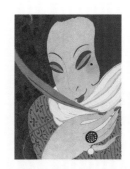

page 35
Georges Lepape
La Plume, 1913/14
Stencil and gouache
46.5 x 31 cm

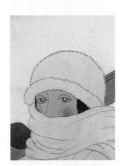

page 30
André Édouard Marty
Winter, 1913
Ink, pen and watercolour
14 x 11 cm
Published in *La Gazette du Bon Ton*

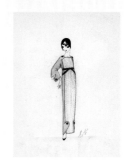

page 36
Erté
Untitled, 1915
Early design for the House of Poiret
Ink, pen and watercolour
32.5 x 25 cm

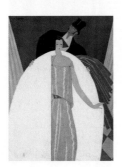

page 31
Georges Lepape
Untitled, 1922
Ink, pen, watercolour and gouache
37 x 28cm
Published in *Vogue UK* (Cover)

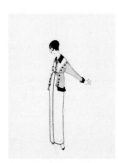

page 37
Erté
Untitled, 1915
Early design for the House of Poiret
Ink, pen and watercolour
32.5 x 25 cm

page 33
Georges Lepape
Chapeau et Parasol, 1913
Ink, pen and watercolour
25 x 18 cm
Published in *La Gazette du Bon Ton*

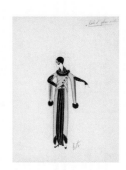

page 38
Erté
Untitled, 1915
Early design for the House of Poiret
Ink, pen and watercolour
32.5 x 25 cm

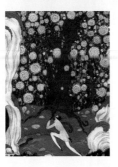

page 34
Georges Lepape
Untitled, 1916
Set Design for *Revue by Rip*
Stencil and heavy gouache
23 x 18 cm

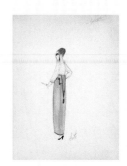

page 39
Erté
Untitled, 1915
Early design for the House of Poiret
Ink, pen and watercolour
32.5 x 25 cm

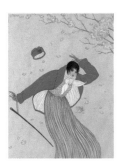

page 41

Georges Lepape

Untitled, 1915

Watercolour and gouache

32 x 24 cm

Published in *Harper's Bazaar* (Cover)

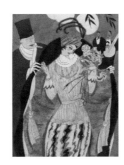

page 47

Charles Martin

La Vie Chère, 1920

Ink, pen and watercolour

22 x 16 cm

Published in *Fantasio*

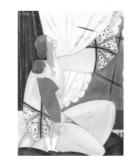

page 53

Georges Lepape

Untitled, 1922

Pencil, gouache and watercolour

34 x 26 cm

Published in *Vogue UK* (Cover)

page 42

Georges Lepape

Au Grand Jardin, 1922

Ink, pen and brush

25 x 20 cm

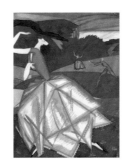

page 49

Georges Lepape

Untitled, 1916

Gouache and watercolour

34 x 26 cm

Published in *Feuillets d'Art*

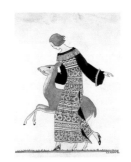

page 54

André Édouard Marty

La Biche, 1922

Ink and watercolour

33 x 25c

Published in *La Gazette du Bon Ton*

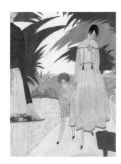

page 43

Georges Lepape

Le Bien-Aimé Absent, 1916

Ink, pen and watercolour

25 x 16 cm

Published in *Modes et Manières*

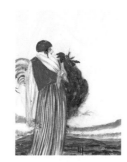

page 50

Georges Lepape

La France Vaincra!, 1914

Study for Poiret's new perfume: *Mam'zelle Victoire*

Watercolour, gouache and pencil

31 x 30 cm

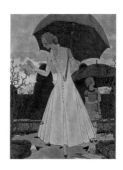

page 55

Pierre Brissaud

Untitled, 1922

Ink, pen and watercolour

32 x 25 cm

Published in *Vogue UK* (Cover)

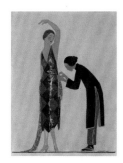

page 45

André Édouard Marty

La Servante Annamite, 1920

Ink and watercolour

24 x 21 cm

Published in *Gazette du Bon Ton*

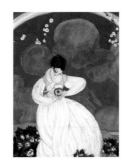

page 51

Georges Lepape

La Cocarde ou la fleur préférée, 1918

Pencil and gouache

40 x 35.5 cm

Published in *Femina*

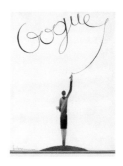

page 57

Georges Lepape

Untitled, 1929

Ink, pen and watercolour

34 x 26 cm

Published in Vogue US (Cover)

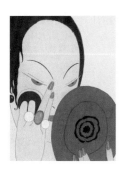

page 46

Georges Lepape

Le Miroir Rouge, 1919

Stencil

33 x 25 cm

Published in *Feuillets d'Art*

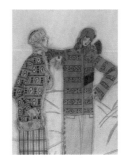

page 52

Georges Lepape

Adieu à la Neige, 1926

Ink, pen and watercolour

17 x 20 cm

Published in *Vogue US*

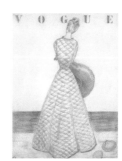

page 60

Georges Lepape

Untitled, 1938

Pencil and crayons

40 x 30 cm

Study for cover *Vogue UK*

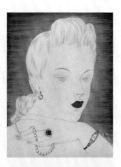

page 61
Georges Lepape
Untitled
Pencil, ink with pen and
watercolour
36 x 28 cm
Advertisement for Van
Cleef & Arpels

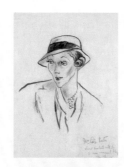

page 67
Cecil Beaton
Mrs. Cole Porter, 1930s
Ink, pen and brush
50 x 40 cm

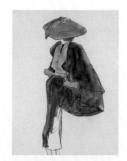

page 73
Bernard Blossac
Untitled, 1950
Pencil and watercolour
47 x 37 cm
Fashion by Christian Dior
Published in *L'Officiel*

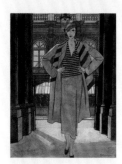

page 63
Pierre Mourgue
Untitled, 1931
Ink, pen and watercolour
35 x 25 cm
Published in *Vogue UK*
(Cover)

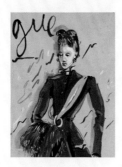

page 69
Christian Bérard
Untitled, 1938
Ink, brush and
watercolour
35 x 20 cm
Published in *Vogue*
(Cover)

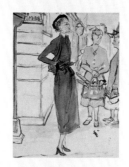

page 74
Eric
Untitled, 1947
Crayon and watercolour
59 x 44 cm
Fashion by Lucien Lelong
Published in *Vogue*

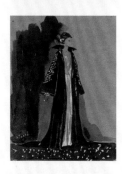

page 64
Christian Bérard
Lanvin, 1937
Crayon and watercolour
42 x 30 cm
Published in *Vogue France*

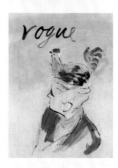

page 70
Eric
Hat, 1938
Ink, brush and
watercolour
35 x 30 cm
Fashion by Schiaparelli
Published *Vogue* (Cover)

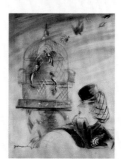

page 75
Jacques Demachy
Untitled, c. 1945
Crayon, watercolour and
gouache
41 x 31 cm

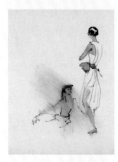

page 65
Christian Bérard
Robes d'été, 1935
Ink, brush and
watercolour
39 x 31 cm
Published in *Vogue France*

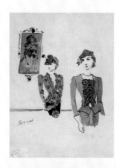

page 71
Christian Bérard
Untitled, 1935
Ink and watercolour
38 x 22 cm
Fashion by Schiaparelli
(Goya Collection)
Published in *Vogue France*

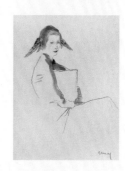

page 76
Bernard Blossac
Untitled, early 1950s
Pencil and watercolour
53 x 41 cm
Fashion by Maud et
Nanno
Published in *L'Officiel*

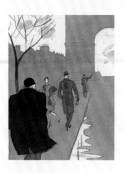

page 66
Charles Martin
Walking the Avenue,
1933
Ink and watercolour
26 x 21 cm
Published in *Harper's
Bazaar*

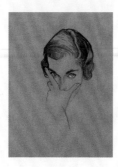

page 72
René Bouché
*Portrait of Mona
Bismarck*, 1940s
Pencil and white tempera
33 x 26 cm
Published in *Vogue*

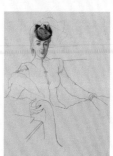

page 77
René Bouché
Untitled, 1940s
Pencil
60 x 45 cm

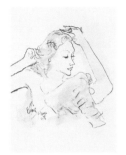

page 78
Eric
Portrait Sophie Litvak, 1948
Crayon and watercolour
Published in *Vogue*
(Cover)

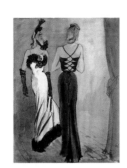

page 87
Eric
Evening dresses, 1945
Watercolour and
gouache
35 x 48 cm
Fashion by Schiaparelli
Published in *Vogue*
Collection Dr. Christian
Elleke

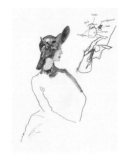

page 94
Bernard Blossac
Untitled, 1949
Pencil and watercolour
50 x 38.5 cm
Fashion by Maud et Nano
Published in *Chapeaux de Paris*

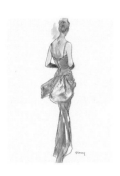

page 79
Bernard Blossac
Untitled, 1948
Crayon, charcoal and
pencil
53 x 41 cm
Fashion by Jacques Fath
Published in *L'Officiel*

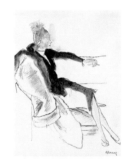

page 89
Bernard Blossac
Germaine Lecomte, 1953
Pencil and watercolour
33 x 48 cm
Published in *L'Officiel*
Collection Dr. Christian
Elleke

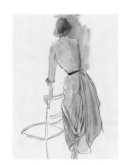

page 95
Bernard Blossac
Untitled, 1950s
Pencil and watercolour
50 x 35 cm
Fashion by Jean Desses
Published in *L'Officiel*
Collection Stephan von
Petersdorf-Campen

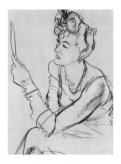

page 81
Eric
Untitled, 1943
Pencil
50 x 40 cm
Published in *Vogue*

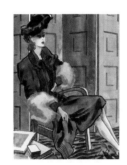

page 90
Pierre Louchel
Sygur and Maggy Rouff,
1940s
Ink and watercolour
31 x 19 cm
Collection Stephan von
Petersdorf-Campen

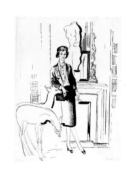

page 97
Cecil Beaton
Portrait of Coco Chanel,
1953
Ink
35 x 45 cm

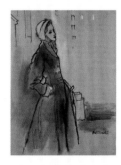

page 85
René Bouché
Untitled, c. 1948
Charcoal and watercolour
38 x 51 cm
Published in *Vogue*
Collection Dr. Christian
Elleke

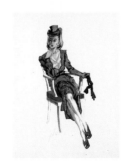

page 91
Pierre Louchel
War fashion, 1943
Ink and watercolour
30 x 48 cm
Collection Dr. Christian
Elleke

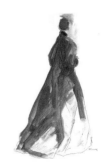

page 98
Bernard Blossac
Untitled, 1947
Pencil and watercolour
53 x 42 cm
Fashion by Jacques Fath
Published in *L'Officiel*

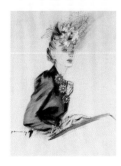

page 86
Jacques Demachy
Hat by Paulette, 1943
Mixed media
30 x 38 cm
Collection Dr. Christian
Elleke

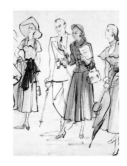

pages 92/93
René Bouët-Willaumez
*Before the Race in
Chantilly*, c. 1950
Ink and watercolour
61 x 48 cm
Published in *Vogue*
Collection Dr. Christian
Elleke

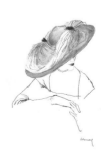

page 99
Bernard Blossac
Untitled, 1954
Pencil and watercolor
50 x 38.5 cm
Fashion by Legroux
Published in *L'Officiel*

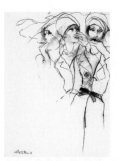

page 102
Antonio
Untitled, 1963
Charcoal
64 x 48 cm
Published in *Harper's Bazaar*

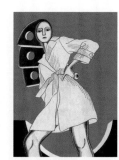

page 106 (right)
Antonio
Léger series, 1963
Mixed media
69 x 27 cm
Published in *The New York Times Magazine*

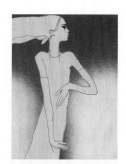

page 112
Antonio
Untitled, 1967
Ink with pen and paper collage
61 x 31 cm
Published in *The New York Times Magazine*

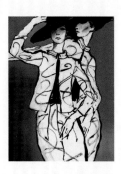

page 103
Antonio
Untitled, 1963
Mixed media collage
34 x 25 cm
Fashion by Chanel
For *Harper's Bazaar*

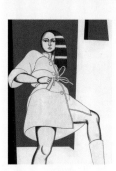

page 107
Antonio
Léger series, 1963
Mixed media
69 x 27 cm
Published in *The New York Times Magazine*

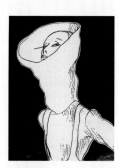

page 113 (left)
Antonio
Untitled, 1967
Ink, pen and collage
61 x 30 cm
Published in *The New York Times Magazine*

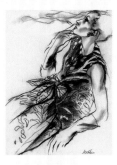

page 104
Antonio
Untitled, 1963
Charcoal
64 x 48cm
Published in *Harper's Bazaar*

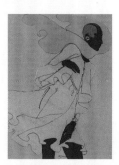

page 108
Antonio
Untitled, 1966
Mixed media
56 x 22 cm
Published in *The New York Times Magazine*

page 113 (right)
Antonio
Untitled, 1967
Ink, pen and collage
61 x 30 cm
Published in *The New York Times Magazine*

page 105
Antonio
Untitled, 1963
Charcoal
64 x 48cm
Published in *Harper's Bazaar*

page 109
Antonio
Ingeborg, 1966
Mixed media
56 x 22 cm
Published in *The New York Times Magazine*

page 114 (left)
Antonio
Kimberley, 1965
Mixed media
56 x 28 cm
Published in *The New York Times Magazine*

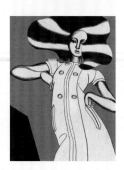

page 106 (left)
Antonio
Léger series, 1963
Mixed media
70 x 27 cm
Published in *The New York Times Magazine*

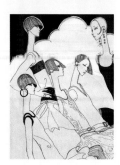

pages 110/111
Antonio
Flapper Frugs, 1965
Mixed media and pen
85 x 61 cm
Published in *The New York Times*

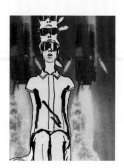

page 114 (right)
Antonio
Untitled, 1965
Ink and collage
61 x 30 cm
Fashion by Samuel Robert
Published in *The New York Times Magazine*

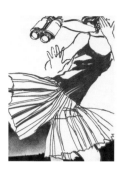

page 115 (left)
Antonio
Untitled, 1965
Mixed media
56 x 28 cm
Published in *The New York Times Magazine*

pages 120/121
Antonio
Joanne Landis, Carnegie Hall Studio, 1967
Ink, pen and collage
61 x 48 cm
Published in *The New York Times Magazine*

page 127
Antonio
Untitled, 1979
Gouache
63 x 51 cm
Fashion by Silvano Malta
Published in *Vogue Italia*

page 115 (right)
Antonio
Untitled, 1965
Mixed media
56 x 28 cm
Fashion by Bill Smith
Published in *The New York Times Magazine*

page 122
Antonio
Une Nouvelle Vague I, 1969
Pentel and collage
64 x 48 cm
Published in *Elle France*

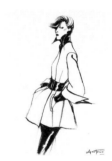

page 128
Antonio
Untitled, 1972
Black chalk
65 x 50 cm
Fashion by Karl Lagerfeld
Published in *Vogue France*

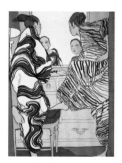

page 117
Antonio
Untitled, 1967
Charcoal and collage
61 x 46 cm
Published in *The New York Times Magazine*

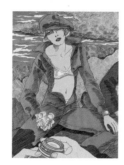

page 123
Antonio
Une Nouvelle Vague II, 1969
Pentel and collage
64 x 48 cm
Published in *Elle France*

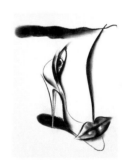

page 129
Antonio
Surrealist Shoe, 1978
Black chalk
68 x 55 cm

page 118
Antonio
At Home, 1967
Mixed media
56 x 22 cm
Published in *The New York Times Magazine*

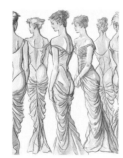

page 124
Antonio
Jane Thorvaldson, 1982
Ink with pen and watercolour
38 x 56 cm
Fashion by Charles James
Published in *Vanity Italia*

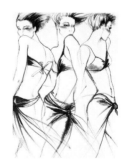

page 130
Antonio
Italian Collections, 1974
Chalk
64 x 65 cm
Published in *Harper's Bazaar Italia*

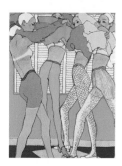

page 119
Antonio
Lingerie, 1966
Ink, pen and collage
64 x 48 cm
Published in *Elle France*

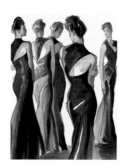

page 125
Antonio
Jane Thorvaldson, 1982
Ink with pen and watercolour
38 x 56 cm
Fashion by Charles James
Published in *Vanity Italia*

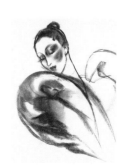

page 131
Antonio
Portrait of Pat Cleveland, 1983
Black, red and brown chalk
50 x 40 cm

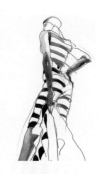

page 132
Antonio
Untitled, 1983
Pencil and watercolour
50 x 35 cm
Fashion by Laura Biagiotti
Published in *Vanity Italia*

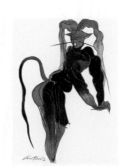

page 137
Antonio
Untitled, 1981
Pencil and watercolour
36 x 28 cm
Fashion by Silvano Malta
Published in *Vanity Italia*

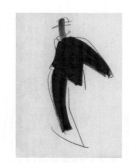

page 145
Mats Gustafson
Untitled, 1983
Pencil and gouache
35 x 28 cm
Fashion by Perry Ellis
For *Vogue US*

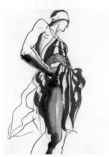

page 133
Antonio
Japanese Stripes, 1982
Pencil and watercolour
50 x 35 cm
Fashion by Enrica Massei
Published in *Vanity Italia*

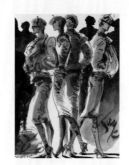

page 138
Antonio
Jane Thorvaldson, 1986
Pencil and watercolour
47.5 x 38 cm

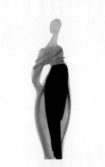

page 146
Mats Gustafson
Untitled, 1990
Watercolour and ink
38 x 28 cm
Fashion by Romeo Gigli
For *Vogue Italia*

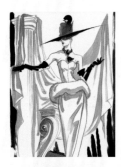

page 134
Antonio
Untitled, 1982
Pencil and watercolour
56 x 38 cm
Campaign for Nordstrom

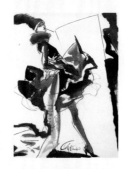

page 139
Antonio
Untitled, 1986
Pencil and watercolour
47.5 x 38 cm
Fashion by Christian
Lacroix
Council of Fashion
Designers of America
Award, New York

page 147
Mats Gustafson
Scarf, 1991
Watercolour and ink
38 x 28 cm
Fashion by Romeo Gigli

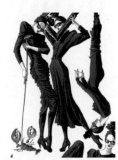

page 135
Antonio
Untitled, 1986
Pencil and watercolour
57 x 38 cm
Campaign for Norma
Kamali

page 143
Mats Gustafson
Untitled, 1990
Watercolour and ink
50 x 33 cm
Fashion by Romeo Gigli

page 148
Mats Gustafson
Purple Sweater, 1992
Watercolour
38 x 30.5 cm
For *Vogue España*

page 136
Antonio
Yo and Koi, 1983
Gouache and
watercolour
70 x 50 cm
Published in *Vanity Italia*

page 144
Mats Gustafson
Diana Vreeland, 1982
Pencil and pastel
35 x 33 cm

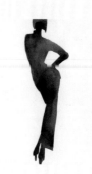

page 149
Mats Gustafson
Long Skirt, 1992
Watercolour
38 x 30 cm
For *Vogue España*

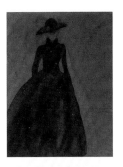

page 150
Mats Gustafson
Untitled, 1997
Watercolour
38 x 33 cm
Fashion by Yohji
Yamamoto

page 157
Mats Gustafson
Linda Evangelista, 1999
Ink
38 x 28.5 cm
For *Harper's Bazaar*

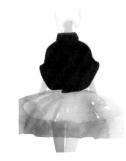

page 164
Mats Gustafson
Black Jacket and Tutu,
2005
Watercolour and ink
37 x 28 cm
Fashion by Comme des
Garçons

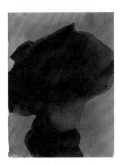

page 152
Mats Gustafson
Hat, 1997
Watercolour
38 x 28.5 cm
Fashion by Yohji
Yamamoto
For *Vogue Nippon*

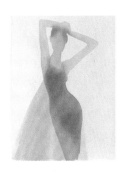

page 159
Mats Gustafson
Green Dress, 2001
Watercolour
38 x 28 cm
For Tiffany & Co

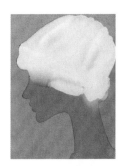

page 165
Mats Gustafson
Head Piece, 2005
Watercolour
33 x 24 cm
Fashion by Comme des
Garçons

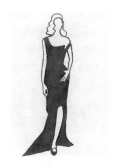

page 153
Mats Gustafson
Untitled, 1997
Watercolour and ink
38 x 28.5 cm
Fashion by Yohji
Yamamoto
For *Vogue Italia*

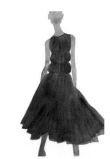

page 160
Mats Gustafson
Black Dress, 2002
Watercolour
28 x 38 cm
For *Vogue Italia*

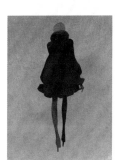

page 167
Mats Gustafson
Black Coat, 2010
Watercolour
44 x 34 cm
Fashion by Alexander
McQueen
For *Vogue China*

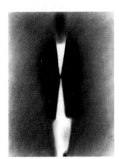

page 155
Mats Gustafson
Untitled, 2002
Pastel
35.5 x 28 cm
Fashion by Giorgio
Armani
For *Vogue Italia*

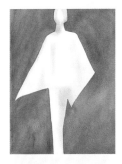

page 161
Mats Gustafson
White Cape, 2000
Watercolour
37 x 28 cm
For *Vogue Nippon*

page 171
François Berthoud
African Figure, 1997
Monotype and oil
70 x 50 cm
Fashion by Comme des
Garçons
Published in *Vogue Italia*

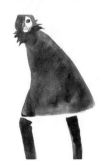

page 156
Mats Gustafson
Brown Cape, 2001
Watercolour
27.5 x 35 cm
For *Vogue Italia*

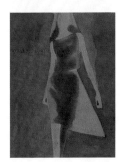

page 163
Mats Gustafson
Red Dress, 1999
Watercolour
40 x 38 cm

page 172
François Berthoud
Wire Dummy, 1994
Monotype and oil
70 x 50 cm
Published in *The New
York Times Magazine*

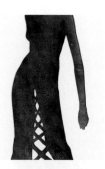

page 173
François Berthoud
Madame Eiffel, 1998
Monotype and oil
35 x 50 cm
Published in *Modem France* (Cover)

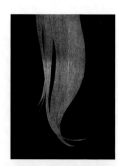

page 179
François Berthoud
Hair I, 1998
Monotype and oil
35 x 50 cm
Published in *Amica Italia*

page 185
François Berthoud
Allure, 2001
Enamel
50 x 35 cm
Published in *Rebel France*

page 174
François Berthoud
Untitled, 1996
Monotype and oil
50 x 35 cm
Fashion by Jil Sander
Published in *Interview USA*

page 180
François Berthoud
Still life with Cactus and Necklace, 2009
Monotype and oil
39 x 30 cm
Fashion by Louis Vuitton
Published in *NUMERO France*

page 186
François Berthoud
Preparation I, 2001
C-Print
122 x 160 cm
Fashion by Victor & Rolf
Published in *Dazed & Confused UK*

page 175
François Berthoud
Girl in a room, 1996
Monotype and oil
50 x 35 cm
Published in *Interview USA*

page 181
François Berthoud
Panties, 2004
Monotype and oil
52 x 40 cm
Fashion by Dior
Published in *NUMERO France*

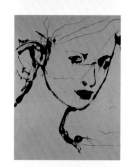

page 187
François Berthoud
Marni, 2001
Enamel
50 x 35 cm
Published in *Rebel France*

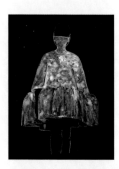

page 177
François Berthoud
Balenciaga Runway, 2006
C-Print
45 x 35 cm
Published in *AD France*

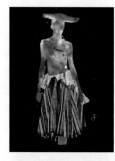

page 182
François Berthoud
Comme des Garçons Runway, 2004
C-Print
45 x 35 cm
Published in *10 Magazine UK*

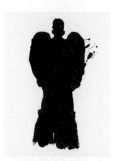

page 188
François Berthoud
Black Angel, 2001
Enamel
70 x 50 cm
Fashion by Victor & Rolf
Published in *Dazed & Confused UK*

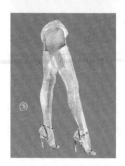

page 178
François Berthoud
She walks, 2004
Monotype and oil
54 x 44 cm
Published in *NUMERO France*

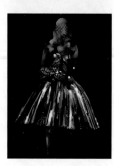

page 183
François Berthoud
Victor & Rolf Runway, 2006
C-Print
45 x 35 cm
Published in *AD France*

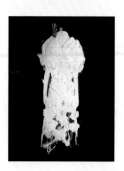

page 189
François Berthoud
White Angel, 2001
Enamel
70 x 50 cm
Fashion by Victor & Rolf
Published in *Dazed & Confused UK*

page 191
François Berthoud
Bustier YSL, 2001
Monotype and oil
70 x 50 cm
Published in *Vogue Nippon*

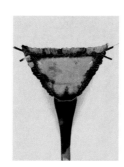

page 197
François Berthoud
Calice, 2004
Monotype and oil
42 x 32 cm
Fashion by La Perla
Published in *NUMERO France*

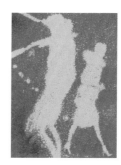

page 206
Aurore de La Morinerie
Défilé, 2009
Monotype
42 x 32 cm
Fashion by Hermes

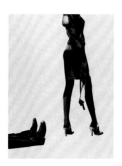

page 192
François Berthoud
Bad girl, good girl, 2001
Monotype and oil
54 x 44 cm
Campaign for Myla, UK

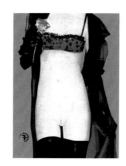

page 199
François Berthoud
In the Mirror, 2009
Monotype and oil
50 x 42 cm
Fashion by Chantal Thomas
Published in *NUMERO France*

page 207
Aurore de La Morinerie
Allure II, 2009
Monotype
43 x 33 cm

page 193
François Berthoud
Love me or love me not, 1999
Monotype and oil
54 x 44 cm
Campaign for Myla, UK

page 203
Aurore de La Morinerie
Impression I, 1910
Monotype on Japan paper
44 x 35 cm

page 208
Aurore de La Morinerie
Yves Saint Laurent and his dog, 2010
Monotype
44.5 x 34.8 cm

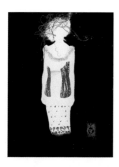

page 195
François Berthoud
Untitled, 2001
Monotype and collage
50 x 35 cm
Fashion by Comme des Garçons
Published in *Vogue Nippon*

page 204
Aurore de La Morinerie
Petite Robe Noire, 2010
Monotype
42 x 32 cm

page 209
Aurore de La Morinerie
Untitled, 2008
Monotype
43.5 x 34.9 cm
Fashion by Yves Saint Laurent

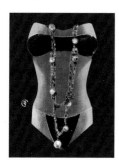

page 196
François Berthoud
With a Chanel Necklace, 2004
Monotype and oil
54 x 44 cm
Fashion by Eres, necklace by Chanel
Published in *NUMERO France*

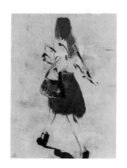

page 205
Aurore de La Morinerie
Shopping I, 2001
Monotype, brush and ink
65.3 x 48.6 cm

page 211
Aurore de La Morinerie
Untitled, 2008
Monotype
45 x 33 cm
Fashion by Christian Lacroix
Published in *Süddeutsche Zeitung Magazin*

page 212
Aurore de La Morinerie
Bourrasque, 2009
Monotype
42 x 32 cm

page 217
Aurore de La Morinerie
Untitled, 2010
Monotype
42 x 32 cm

Fashion by Christian
Lacroix

page 213
Aurore de La Morinerie
Silhouette I, 2010
Monotype on Japan
paper
42 x 32 cm

page 218
Aurore de La Morinerie
Silhouette II, 2009
Monotype on Japan
paper
42 32 cm

page 214
Aurore de La Morinerie
Allure II, 2010
Monotype on Japan
paper
42 x 32 cm

page 219
Aurore de La Morinerie
Silhouette III, 2010
Monotype on Japan
paper
42 x 32 cm

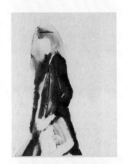

page 215
Aurore de La Morinerie
Impression II, 2010
Monotype on Japan
paper
42 x 32 cm

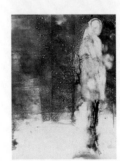

page 221
Aurore de La Morinerie
Impression III, 2010
Monotype on Japan
paper
42 x 32 cm

page 216
Aurore de La Morinerie
Dans la Nuit, 2010
Monotype on Japan
paper
42 x 32 cm

THE ARTISTS

ANDRÉ ÉDOUARD MARTY (1882–1974)

A student of philosophy as well as an artist, André Marty graduated from the École des Beaux-Arts in Paris. He had the most delicate and refined style of all the artists of *La Gazette du Bon Ton,* to which he contributed regularly between 1912 and 1925. He also worked for *Femina, Vogue, L'Illustration des Modes* and *Harper's Bazaar* and designed many stage sets and posters (including the very first poster for the Ballets Russes in 1910, posters for the Paris Opera and a number of Parisian theatres). Many of his design ideas were copied for vases, bowls and enamel jewellery. Among the numerous books he illustrated are *Comœdia Illustré* in 1909, *Constance dans les Cieux,* 1925 and *L'Oiseau Bleu,* 1945.

CHARLES MARTIN (1884–1934)

Born in Montpellier, Charles Martin belonged to the team of talented French artists that Condé Nast was able to win for his *Vogue* magazine from *La Gazette du Bon Ton.* The designer and illustrator attended the art academies of Montpellier and Paris as well as the Académie Julian and is perhaps most noted for his drawings depicting the extravagance of haute couture with a touch of irony. Along with many contributions to *Vogue,* his works were later also seen in *Femina, Le Journal des Dames et des Modes, Vanity Fair* and *Harper's Bazaar.* In addition he also illustrated numerous books and established himself designing posters, stage sets and costumes, furniture, wallpaper, fashion, fabrics and perfume bottles.

PIERRE BRISSAUD (1885–1964)

After studying at the Académie des Beaux-Arts in Paris, Brissaud joined Cormon and his uncle Bernard Boutet de Montvel as an apprentice where he quickly demonstrated his manifold talents as an illustrator, etcher, press and advertising artist. In 1907 he exhibited his works for the first time at the Parisian Salon des Indépendants and Salon d'Automne. He became one of the main collaborators of the *Gazette du Bon Ton, Vogue* and *Monsieur.* His drawings are remarkable for their affectionate observations and their sense of humour. Simultaneously he also drew for *Comœdia Illustré,* various satirical papers, and advertising catalogues for Peugeot and Galeries Lafayettes as well as illustrating countless books, including Gustave Flaubert's novel *Madame Bovary.*

GEORGES LEPAPE (1887–1971)

Georges Lepape was the greatest artist to emerge from the group of young graduates of the École des Beaux-Arts who rose to prominence immediately before World War I. From the very beginning, his work was a model of refinement, simplicity and visual wit.

During this pivotal moment in Paris Picasso and Braque were deep in their cubist adventure, and the first expressionist abstractions of Kandisky, Matisse, Léger and Modigliani surfaced. This was also the moment of the young Stravinsky and Diaghilev's Ballets Russes. All this movement and splendour, music, lavish colours and artistic avant-garde penetrated deep into the public consciousness and enormously extended the pictorial opportunities available to other artists of all kinds. In 1911, Paul Poiret, the radically experimental couturier to the more adventurous among "le Haut Monde", issued a limited edition of a slim volume of his work called *Les Choses de Poiret,* illustrated by the young Georges Lepape who became famous overnight.

Between 1912 and 1925, Lepape produced his most inspired work for *La Gazette du Bon Ton,* an exquisitely refined and luxurious work which was to have a very strong influence despite its short lifespan. He also contributed to *Modes et Manières d'Aujourd'hui* (1911), *Les Feuillets d'Arts* (1919), *Femina, French Vogue,* etc. In the early 1920s, his drawings began to appear in America, in *Harper's Bazaar, Vanity Fair* and especially in *Vogue.* It can be said that the 1920s in *Vogue* belonged to Lepape, who between 1920 and 1930 contributed well over 70 covers, more than twice as many as

any of his colleagues. Seen as a whole, this body of work stands as a splendid and remarkable achievement, a sustained demonstration of graphic resource, invention and technique of the highest order. Lepape consistently produced memorable and striking images which immediately revive the spirit of the artistically richest years of this century.

ERIC (1891–1958)

Born Carl Erickson in Joliet, Illinois of Swedish parents, he later called himself simply Eric. He attended the Academy of Fine Arts in Chicago and moved to New York in 1914 to work as a freelance illustrator. In 1916, his first drawings appeared in *Vogue* but it was not until 1925, after his marriage to Lee Creelmann, a *Vogue* staff member, and their move to Paris, that he became a regular artist for *Vogue*. At first, he was mainly responsible for illustrating society events. Then in the 1930s he was able to establish himself increasingly as a fashion artist. In direct competition with his rival René Bouët-Willaumez, he began to influence the image of the magazine.

Eric's style reflects a wonderful perception of colours combined with lively and fluid strokes and a keen sense of observation. Between 1935 and 1955, Eric's drawings dominated the pages of *Vogue* and became the essence of the current *Vogue* style. It was said of Eric that he only drew what he saw – but he saw what was essential and he filled it with life.

ERTÉ (1892–1990)

Born Romain de Tirtoff in St. Petersburg as the son of an admiral, Erté is undoubtedly one of the greatest designers, graphic artists and stage designers of the twentieth century.

Before leaving for Paris age 20, he received ballet lessons from the daughter of the great Petipa and studied painting under Ilja Repin, the most important Russian artist of the time. In Paris he proceeded with his studies and was discovered by fashion czar Paul Poiret. He designed costumes

for Mata Hari and after his book with Poiret started designing collections for the department store Henri Bendel in New York.

He drew for *La Gazette du Bon* Ton and as of 1916 for *Vogue* for a six-month period before signing an exclusive contract with *Harper's Bazaar*, for whom he created virtually all covers for the next 25 years. In 1920 he went to Hollywood as a costume designer and was employed by the Ziegfeld Follies. During the next years he not only designed costumes but also sets for world-renowned theatres – very often for the choreographer Roland Petit and shortly before his death for the Broadway musical *Stardust*.

From the late 1930s little was heard of Erté as an illustrator but in 1967 an Erté revival took place and exhibitions of his work celebrated triumphant successes in London and New York.

JACQUES DEMACHY (1898–?)

Son of the famous photographer, Robert Demachy, Jacques Demachy made a career for himself as a multi-talented fashion, advertising and poster artist. He started his career in his twenties working for the *Gazette du Bon Ton* and then worked for *Marie Claire* and *Elle* until the 1950s. As a book illustrator he is best known for his work for *Manon Lescaut* by Abbé Prévost.

RENÉ BOUËT-WILLAUMEZ (1900–1974)

René Bouët-Willaumez began studying engineering at the Ecole Polytechnique and drew in his free time. Encouraged and supported by Mainbocher, publisher of French *Vogue*, he decided to devote himself entirely to drawing. In 1929, his first drawings appeared in *Vogue*. As of 1931, his own style became evident and is characterised by soft fluid lines and nervous energy. By the mid 30s he had become the main illustrator for *Vogue* apart from his great rival Eric. He moved to New York and only after having terminated his long association with *Vogue* in 1958 did he return to France.

CHRISTIAN BÉRARD (1902–1949)

Bérard descended from a family of well-known architects. He studied art at the Académie Ranson and the Académie Julian and belonged to the leaders of a new generation of French illustrators. He became Jean Cocteau's assistant for ballet, film and theatre, co-founder of the "Neo-Humanistic Group" and was also known widely as a highly colourful figure of the Parisian Café Society.

Bérard was primarily an excellent and highly original painter, and so rejected numerous invitations from *Vogue* before eventually deciding to work also as a fashion illustrator. However, his romantic expressionist/surrealist style quickly influenced the trend of fashion illustration of the period. He remains famous predominantly for his excellent portraits and epoch-making set and costume designs for theatre and film – for example *La Belle et la Bête* by Cocteau. Like many artists of the time he had a passion for interior design and decorated numerous homes including those of Jean-Michel Frank and Syrie Maugham.

Over the years, he has become a cult figure, idolised by a new generation of young aesthetes and decorators.

CECIL BEATON (1904–1980)

Cecil Beaton first appeared in *Vogue* in 1926 as an author and illustrator, but it was not until later that he began his 50-year association with the magazine as a photographer. For many decades his drawings, portraits, fashion photographs and essays filled the pages of *Vogue*. In addition he worked as a set and costume designer for the Ballets Russes, *Chochans Revue*, *Apparitions* and *Le Pavillon* at Covent Garden. As a successful society photographer and with his contacts to the international rich and famous, Beaton became a sought-after society darling who was a very welcome guest everywhere. It was this luxury lifestyle that he often would capture in his quick and sometimes malicious sketches.

RENÉ BOUCHÉ (1906–1963)

René Bouché was already in his thirties when he succeeded in convincing *Vogue* to give him a chance. In 1939 his work started appearing in the French and British issues. As a Czechoslovakian immigrant he joined the army at the outbreak of World War II and was taken prisoner. He fled to New York in 1941 and started working for the US edition of *Vogue*. His free expressive style, his keen sense of observation and witty margin commentaries soon made him to one of the favourite artists of the magazine. When the liner Queen Elizabeth II left New York on her maiden voyage in 1946, he was on board as a special correspondent. He became and remained a much sought-after society portraitist until his sudden death in 1963.

PIERRE LOUCHEL (1906–1988)

After studying at various private art academies, Pierre Louchel worked primarily for the fashion journal *La Femme Chic*, owned by his parents.

PIERRE MOURGUE (1907–1963)

Like most illustrators of his time, Pierre Mourgue started his career in the mid twenties by collaborating with *La Gazette du Bon Ton*. He created numerous covers for the US edition of *Vogue*, which allowed him to travel to New York regularly and absorb fresh impressions of the New World. With his gift for affectionate observation, strong and lively delineation and emphatic colour usage, he ensured a vitality in the art of drawing and the upkeep of French illustration tradition.

RENÉ GRUAU (1909–2004)

Gruau's name has been synonymous with exquisite refinement and seductive flair for the past 50 years. In the 1940s and 50s, he led the art of fashion illustration to a new Belle Epoque and became the favoured artist of the Haute Couture world. Combining a free and expressive use of line with a classical sense of restraint, Gruau created subtle, sensual works of art.

Gruau was born in 1909 as Count Renato Zavagli-Riciardelli delle Caminate and published his first drawing at the age of 14. At 18, he was being commissioned by Italian, French and English magazines. In the early 1930s, his mother moved to her native Paris where he took her family name, Gruau. For René Gruau, his mother would always remain the embodiment of the values and charms of society, of elegance and aristocracy of manners. Through his close friendship with Christian Dior, Gruau entered the world of advertising graphics. Gruau's classic style was a perfect complement to Dior's designs, and very soon he became instrumental in developing the brand image not only for Dior Perfumes but for many famous luxury products, including "Rouge Baiser", "Bas Scandale" etc.

From the late 1940s onward, the "Gruau Style" blazed a trail across the covers and pages of the world's leading fashion magazines: *Silhouette, Vogue, l'Officiel, Le Magazine du Figaro, International Textiles, Flair* etc. Gruau's designs, advertising campaigns and drawings define the graphic art of the forties and fifties as no other works have done. The widespread reproduction of these works and Gruau's remarkable productivity magnified their impact. The era had found its true artist.

Retrospective exhibitions of his art have been held at museums in Paris, Rome, Munich, Cologne, New York and Tokyo.

Note: The René Gruau s.a.r.l. is engaged in a dispute with the son and sole heir of Gruau and has prevented the publication of the Gruau pictures in this book which belong to this collection (up until the time of production, 27th September 2010).

BERNARD BLOSSAC (1917–2001)

Bernard de la Bourdonnaie-Blossac was born in Neuilly-sur-Seine and studied at various art academies including Collard and La Grande Chaumière and in the atelier of Paul Colin before the fashion designer Robert Piguet discovered him. He soon started publishing drawings in

Vogue, L'Officiel, L'Art et la Mode, Harper's Bazaar and *International Textiles*.

His postwar drawings convey a sense of aristocratic elegance. He is a wonderful painter of mondaine Parisian life.

ANTONIO (ANTONIO LOPEZ) (1943–1987)

Born in Puerto Rico and raised in New York, Antonio studied at the renowned Fashion Institute of Technology. Before the age of 22, he had already published his drawings in the most important fashion magazines worldwide: *Women's Wear Daily, Vogue, Harper's Bazaar* and *Elle*. In 1969 he moved to Paris and made Pop Art into a fashion and illustration trend. He not only established himself as the foremost fashion illustrator of the time but also discovered and guided such fashion models as Grace Jones, Jerry Hall, Pat Cleveland and Jessica Lange from beginners to catwalk and modelling stars. With his circle of friends including Karl Lagerfeld, Paloma Picasso and Andy Warhol he influenced the 'look' of the 60s and 70s.

His highly distinctive style was one of open sensuality. He took the previous ideal of female elegance which had been depicted by fragile and ethereal women and changed it to a modern, vital, muscular and erotic being of various ethnic backgrounds.

Upon returning to New York his career took off a second time with books, prizes, films and exhibitions in American and Japanese museums, at the Musée de la Mode in the Paris Louvre and at the London Royal College of Art.

MATS GUSTAFSON

Mats Gustafson (Swedish, b. 1951) began his career as an illustrator in the late 1970s, a time when editorial illustration was eclipsed by photography, and watercolour as a conceptual medium had barely been explored. A graduate of Dramatiska Institutet (University College of Film, Radio, Television and Theatre) in Stockholm, he first applied his graphic sensibility to the art of

stage design. This experience translated into illustration when he began publishing his work in eminent international fashion publications. The elegant and subtly expressive character of Gustafson's watercolour, pastel and cut-out paperworks expanded the possibilities of fashion illustration and nearly single-handedly reinvigorated the genre.

Gustafson's fashion and portrait illustrations have been included in editorial publications such as French and Italian *Vogue*, *The New Yorker*, and *Visionaire*, and he has created advertising art for Hermès, Tiffany & Co., Yohji Yamamoto, and Comme des Garçons. His work has been exhibited internationally in solo and group shows. Gustafson lives in New York.

FRANÇOIS BERTHOUD

François Berthoud was born in 1961 in Switzerland of an Italian mother and Swiss father.

After finishing his studies in graphic design in 1982, he went to Milan, from where he worked as art director for Conde Nast. His first publications included drawings and comics. In 1985, he produced his first fashion drawings for *Vanity Fair*, which brought him instant recognition. From then on, based in Milan, Paris and New York, his work started appearing in *La Mode en Peinture*, *The New Yorker*, various editions of *Vogue*, *Interview*, *Visionaire*, *Numero*, and *The New York Times Magazine*. He has produced advertising drawings for fashion brands.

François Berthoud is now recognised as one of the most original fashion artists of his time. Domenico Lucchini has written about him: "Through his art and his imagination, François Berthoud is an interpreter of our culture who makes use of an iconic, subversive and metaphoric language to describe our time and its anthropological changes. Proceeding obsessively, but without overstrained technical perfection, and shunning all stereotypes, formal and otherwise, he gives us a chance to interpret the visible and the invisible."

AURORE DE LA MORINERIE

Aurore de La Morinerie was born 1962 in Saint-Lô. She began her career as a fashion designer after graduating from The École Supérieure des Arts Appliqués Duperré. She then spent two years studying Chinese calligraphy, which taught her concentration, strength and rapidity of execution and was to become the most formative influence on her style. Extended travels in China as well as in India, Japan and Egypt followed. Since then, she has been pursuing a career as a fashion artist, working for Hermès, *Le Monde*, and various fashion magazines, with advertisement commissions from clients like Sofitel, Le Printemps etc., and a parallel career as a fine artist whose main subject is the study of nature: landscapes, plants and animals.

THE AUTHORS

HOLLY BRUBACH

Holly Brubach is a journalist specialising in fashion, architecture, and design. She has written for *Vogue*, *The New Yorker*, *Atlantic Monthly* and has been the Style Editor of *The New York Times Magazine*. She has also authored three books, including *A Dedicated Follower of Fashion*, a collection of her essays.

COLIN McDOWELL

Colin McDowell is one of the world's top fashion commentators. He is known particularly for his *many years as The Sunday Times'* chief fashion writer and for his role as the founder of the influential *Fashion Fringe*, a major initiative supporting young designers. During his career McDowell has interviewed just about all great fashion designers and many key figures in the art world. He is the author of numerous books on fashion and fashion-related subjects, including the seminal *McDowell's Directory of Twentieth Century Fashion*. Colin McDowell was appointed MBE in 2008 and is a Senior Fellow of the Royal College of Art and Fellow of the Royal Society of Arts.

RENATE STAUSS

Renate Stauss is a lecturer in Cultural Studies and Fashion Theory & History at the Royal College of Art and The University of the Arts London. The emphasis in her writing and teaching lies on the sociology and politics of fashion and dress, covering subjects as varied as the relationship between fashion and socialism, identity aspects of dress, globalisation and sustainability of the fashion and textiles industries, or the sensory significance of dress. She is currently completing her PhD on working with dress on concepts of self in therapeutic settings.